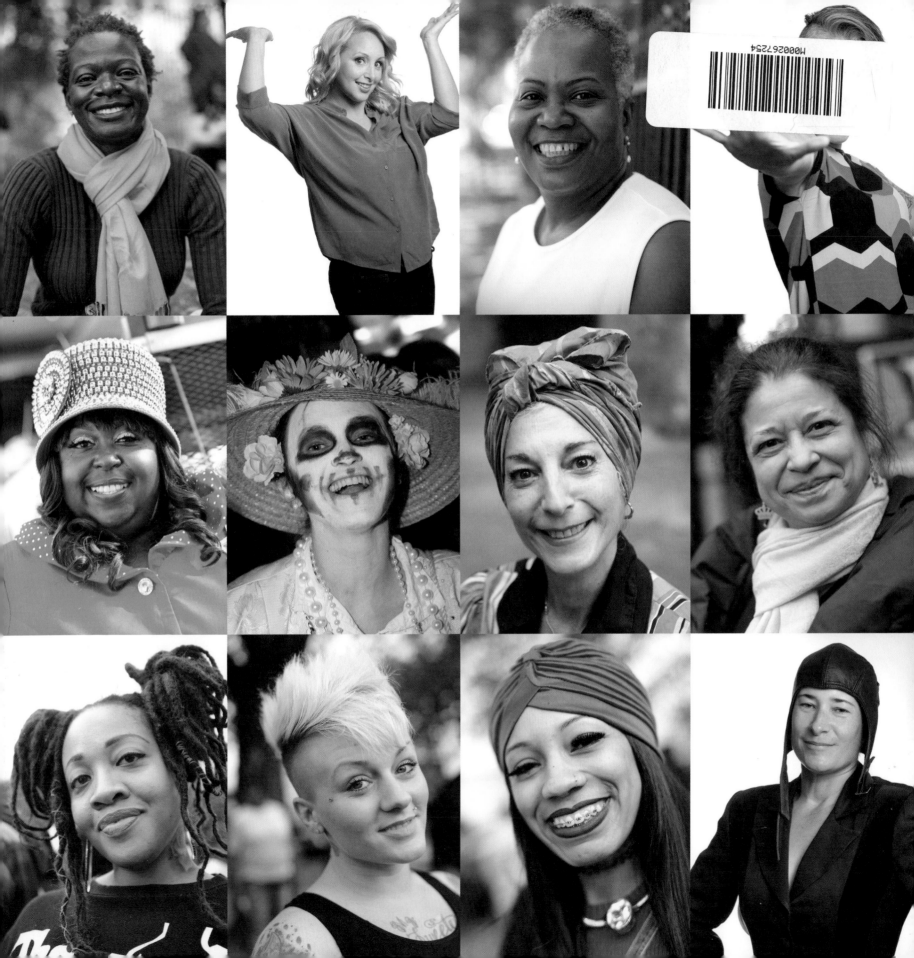

Cherchez la Femme

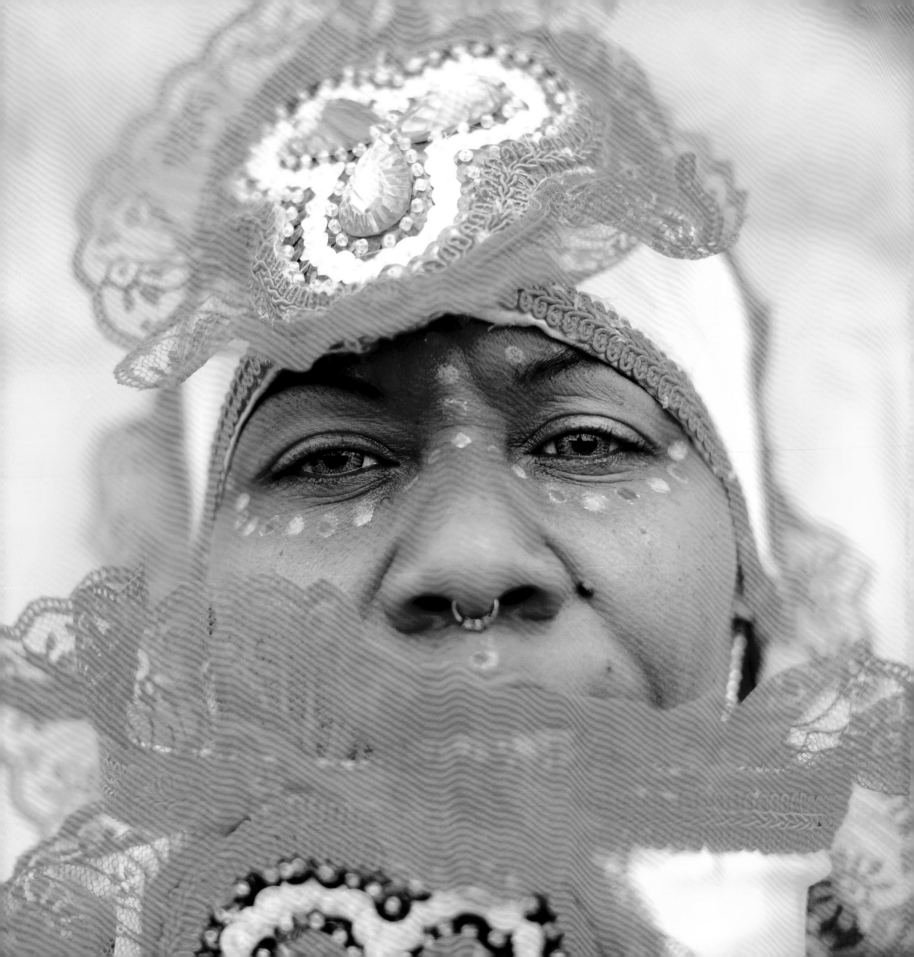

Cherchez la Femme

NEW ORLEANS WOMEN

Cheryl Gerber

University Press of Mississippi / Jackson

The production of this book has been supported by a grant from
the Goldring Family Foundation.

The essays were funded by the Louisiana Endowment for the Humanities and
the Threadhead Cultural Foundation.

The University Press of Mississippi is the scholarly publishing agency of
the Mississippi Institutions of Higher Learning: Alcorn State University,
Delta State University, Jackson State University, Mississippi State University,
Mississippi University for Women, Mississippi Valley State University,
University of Mississippi, and University of Southern Mississippi.

www.upress.state.ms.us

Designed by Peter D. Halverson

The University Press of Mississippi is a member of the Association of University Presses.

First printing 2020
∞

Library of Congress Cataloging-in-Publication Data

Names: Gerber, Cheryl, author, photographer.
Title: Cherchez la femme : New Orleans women / Cheryl Gerber.
Description: Jackson : University Press of Mississippi, [2020] | "First
 printing 2020." | Includes bibliographical references and index.
Identifiers: LCCN 2019018114 (print) | LCCN 2019022345 (ebook) | ISBN
 9781496825209 (hardcover : alk. paper)
Subjects: LCSH: Women—Louisiana—New Orleans. | New Orleans
 (La.)—Pictorial works. | New Orleans (La.)—Social life and
 customs—Pictorial works. | New Orleans (La.)—Social
 conditions—Pictorial works. | City and town life—Louisiana—New
 Orleans—Pictorial works.
Classification: LCC F379.N543 G458 2020 (print) | LCC F379.N543 (ebook) |
 DDC 305.409763/35—dc23
LC record available at https://lccn.loc.gov/2019018114
LC ebook record available at https://lccn.loc.gov/2019022345

British Library Cataloging-in-Publication Data available

www.leh.org

This book is dedicated to Bonnie Warren, the grand dame of the Pleasant Ladies Club, my mentor, my colleague, my friend, and my surrogate mother. I will forever be thankful to her for bringing me inside her circle of amazing New Orleans women.

CONTENTS

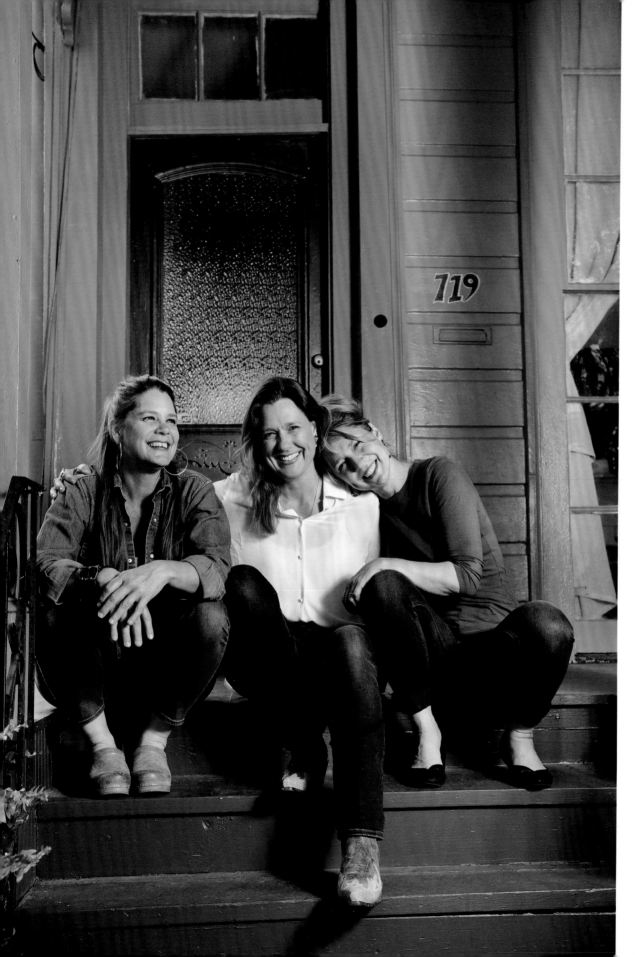

Sisters Susan Gisleson,
Kristin Gisleson Palmer,
and Anne Gisleson, 2018

Sisters

ANNE GISLESON

For several years in the 1980s, all five of my sisters and I walked together under a solid canopy of oaks in blue plaid uniform skirts and Peter Pan collars to Ursuline Academy, a female stronghold along Claiborne Avenue wedged between State and Nashville. There were tiled galleries and courtyards for the nuns to pace and tall chain link fences for young fingers to grasp. In one high-ceilinged hallway, lined with nearly a century of class photos, our grandmother's face smiled from the early thirties, with a wry and unknowable softness. Weekly mass in the Shrine of Our Lady of Prompt Succor and each class began with bowed heads and the supplication, "Our Lady of Prompt Succor, hasten to help us." Through mumbled repetition and familiarity, the plea lost meaning, became part of the liturgical scaffolding of Catholic education, something kicked at, clung to, or effortlessly dodged.

But the historical lore of the Ursuline nuns was as vibrant and alluring as the stained-glass windows of the refectory. Founded in 1727, in the city's infancy, the Ursulines' school educated black, white, native girls, all comers, all together. Many of them were "casket girls" from France who crossed an ocean to step into an underpopulated malarial colony overly populated by dubious men, with only a small chest ("casquette") and enormous uncertainty. As a result of the Ursulines' influence, there were soon more educated young women than men in the fledgling colony. About a hundred years later, when the Jesuits arrived and wanted to build a school, they asked the Ursulines for money. Our brothers ended up there. Reputedly the Jesuits never paid the Ursulines back.

Our Lady of Prompt Succor at Ursuline Convent, 2009

The initials "AP" for Micaela Almonaster, Baroness de
Pontalba, can be seen in the wrought iron of the historic
Pontalba building, 2018

Running hospitals and schools, they were the ones offering nonstop aid. But famously, as the British drew near the city during the War of 1812, women gathered within the stucco walls of the original Ursuline Convent in the French Quarter and assumed an age-old position: skirts gathered, heads bowed, once again on their knees, asking Our Lady, the most venerated of women, for Prompt Succor *to deliver us from whatever insane, bloody mess the men have inflicted upon us this time.* Amen.

Though my sophomore year I left my sisters to the Sisters and dove into the wilds of public co-ed education, I'd often been proud to be part of that continuum, tied to the legacy of women who shaped the foundation of the city within the double patriarchal confines of the Catholic church and the eighteenth century. Maybe growing up with a distant patriarch and an extraordinary matriarch had magnified for me the importance of women to the evolution of New Orleans, but my gratitude for this place is always aligned with their work and their lives. Women have always had a slant relationship to recorded history, essential yet underrepresented, their achievements explicitly or implicitly qualified by a *nevertheless* or *in spite of*.

Reading Christine Vella's *Intimate Enemies: The Two Worlds of Baroness de Pontalba*, back in the late nineties changed my relationship to the French Quarter. Not only were the most iconic and influential buildings in the city's historic core conceived, built, and financed by a woman, Micaela Pontalba, but she did so *in spite of* being tormented her whole adult life by the men in her family and legal systems on two continents. Born to tremendous wealth

Ursuline Academy, 2017

in New Orleans, she was married off as a teen to a fortune-seeking French baron. Not satisfied with her dowry, her father-in-law and husband sued her repeatedly for decades to try to control her inheritance back in Louisiana, slandered her, and imprisoned her in their chilly ancestral manor in France. Finally, her father-in-law shot her, and when he realized she'd survived, he turned the gun on himself. With most fingers on one hand blown off, one functioning lung, and prosthetic padding for her chest, she returned to New Orleans to fulfill her vision of those magnificent buildings, an innovative amalgamation of styles and material, the construction of which she micromanaged from foundation to fixtures. Building and shaping a city has long been the purview of men, but Micaela's monuments to female strength, originality, and will radiate from the heart of the city and the one-time seat of colonial power.

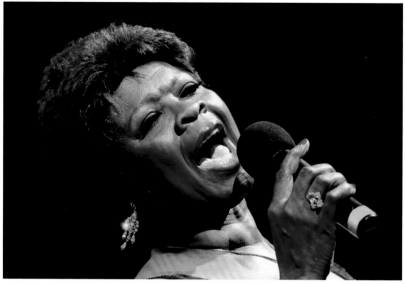

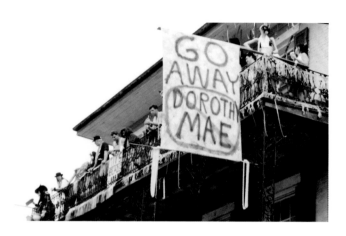

"Go Away Dorothy Mae," referring to activist and Councilwoman Dorothy Mae Taylor's controversial ordinance to ban discrimination in carnival krewes, 1992

Irma Thomas singing "Hip Shakin' Mama," 2011

About a hundred years later, the mayor, the city council, and the city's business community advocated building a highway through the French Quarter, mere yards from the Pontalba Apartments, part of a midcentury effort to brutalize historic urban cores with "progress." Preservationist Mary Morrison created an influential "Greetings from New Orleans" mailer with a rendering of what Jackson Square would look like with the proposed highway bisecting the St. Louis Cathedral and the rooflines of the Pontalbas. Even though it was a dedicated group of activists who eventually defeated the highway, in my mind, more space and weight are given to Morrison's mailer and her perseverance. I liked the idea of a woman reaching across time to protect another woman's vision though the visualization of its devastation, engaging in a successful public fight to demonstrate that vision's importance to the city's legacy and its future.

But New Orleans also harbors legacies that need demolishing. During Mardi Gras in 1992, under that same oak canopy that my sisters and I walked, I experienced an ugly, piercing jolt of history. Usually, having a parade pass within yards of our home was thrilling, the exuberance of the public spectacle enlivening the house with percussive brass and the unified joy of strangers. But that year, it was marred when, across the street, between the floats and marching bands, I saw a couple of young white men holding signs with the face of city councilwoman Dorothy Mae Taylor inside of a bull's eye, encouraging the float riders to hit it with throws. Taylor, a former teacher, civil rights activist who fought for desegregation and prison reform, the first black female Louisiana legislator, and the first female city

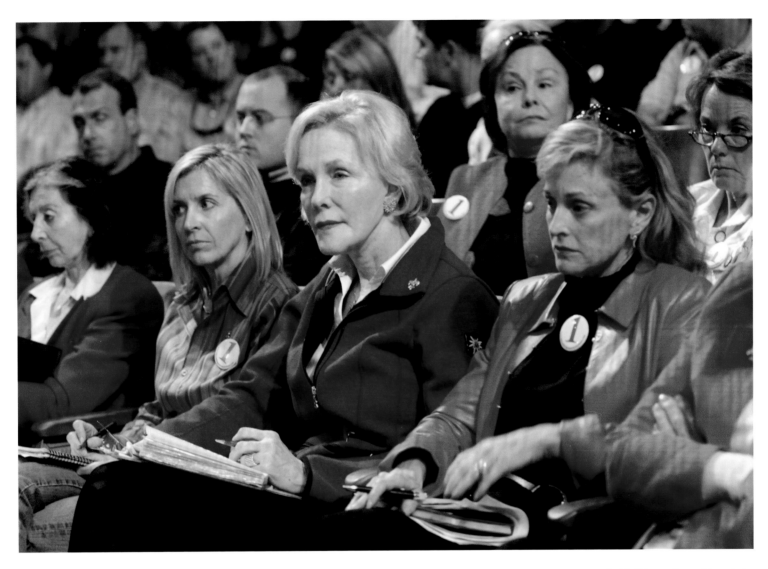

councilwoman, had recently introduced an ordinance forbidding segregated krewes (carnival organizations in New Orleans) to parade on city streets, ripping open a Pandora's box of race, class, and gender. Some all-white, all-male, monied krewes stopped parading altogether rather than desegregate.

I loved Dorothy Mae Taylor—her fire, her focus, the defiance in her severely pulled-back hair and oversized glasses. Having just returned from four years at a northern university, I had finally acquired the necessary distance to see New Orleans more clearly and my love for Dorothy Mae Taylor was part of this new clarity. She embodied for me the force it would take to disentangle ourselves from the sins of the past and move us towards a more just future, the nonstop vigilance and the willingness to piss people off,

Ruthie Frierson (center) founded Citizens for 1 Greater New Orleans to hold lawmakers accountable for the levee protection, which sparked a post-Katrina wave of activism, 2005

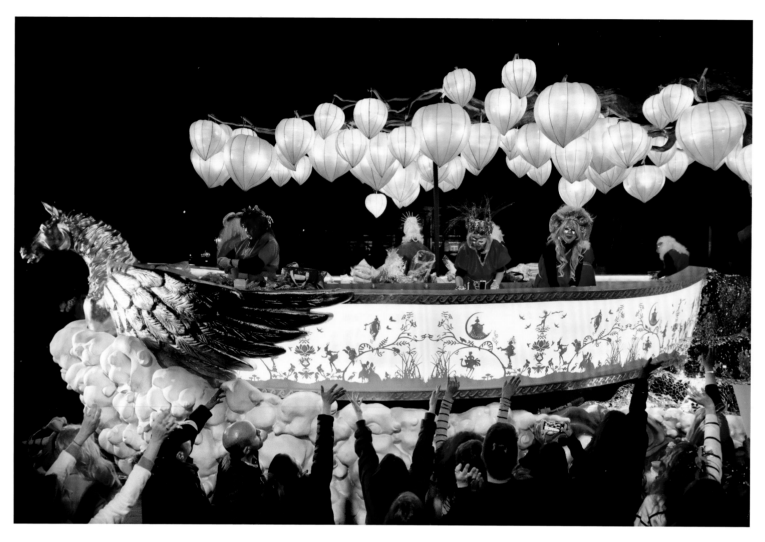

The Sirens float in Muses, co-designed
by Susan Gisleson, 2018

become an actual target of aggression. Women can be relied on to overturn
the status quo because it's never served us.

 While studying up north, I also became conscious of the uniqueness of
growing up in New Orleans with so many cultural heroes who were black
women. Ruby Bridges' solo desegregation of Franz Elementary at the age
of six and Leah Chase's culinary genius and generosity. Our mother once
pointed out the shotgun house Mahalia Jackson shared with thirteen oth-
ers as a child, reminding us that Jackson rejected the blues for the ecstatic
joy of gospel. Baptized in the Mississippi at twelve, Jackson would later be
called "the single most powerful black woman in the United States." As
teens, we sang along with Irma Thomas' demands for pleasure in songs
like "Hip Shakin' Mama": "I put my left leg on his shoulder, the right foot

on the floor . . ." While these women might've influenced how we perceived women and thus ourselves, they had a separate and special status in the feminist pantheon, their *nevertheless* and *in spite ofs* were far higher and steeper than ours, elevating their achievements and fortifying their power beyond our reach. Free woman of color Henriette Delille wasn't allowed to join the Ursulines, so she created her own order to minister to the poor and educate enslaved children, illegal at the time, and is in the queue for canonization by the Vatican.

But race and class boundaries are sometimes crossed to protect the species and respond to threats. Since Succor was not so Prompt after Katrina, women—black, white, Vietnamese, Hispanic, from Uptown to the Lower Ninth Ward—started some of the most important non-profits of the reconstruction. Accustomed to working outside of institutions, many of them put pressure on the government, for aid, for attention, for the truth. Levees.org, Citizens for One New Orleans, Women of the Storm, Katrina Krewe, Ninth Ward Empowerment Network Association. Some used privilege, others deep community roots, all of them organizing and working relentlessly to pull the city back together.

Post-Katrina New Orleans also saw the ascendancy of all-female super krewes, Muses and Nyx, street-level walking krewes like the Pussyfooters and the Bearded Oysters, and a renewed, higher profile appreciation for the downtown Baby Dolls. Embracing female iconography, many thousands of women now roll and enliven the streets, encroaching on the long male-dominated carnival. In a joyful reversal, straight men in polos all along the Avenue now beg for glittery stilettos and purses. Though not her original intent, when Dorothy Mae Taylor re-envisioned Mardi Gras as a more open and inclusive reflection of our city, this was one of the results.

And it's important for women to reclaim the city's public space, real and imaginary. In many minds, Women + Mardi Gras = a stretch of Bourbon Street, bared breasts both indoors and out. Women's bodies have long been tied to the commercialized mythology of the city, its marketing of desire, which becomes flattened out for profit and consumption. From the minute you land at Louis Armstrong International, billboards with glossy, airbrushed women guide you down I-10 to male-owned and run strip clubs on Bourbon Street. But who's feeding the fantasy?

Too often in this town, myth collides tragically with the personal. Our youngest sister, (distractedly trailing on our walks to school) lost herself in the dancing culture so famous and heavily promoted in the city. Lost somewhere between New Orleans the dream and New Orleans the nightmare. Try as I might, even knowing all the factors that might've led to her

The Bearded Oysters, 2013

Baby Doll Denise Trepagnier in Treme, 2012

Strip clubs on Bourbon Street, 2018

suicide, it's hard for me to separate out the commodification of female bodies plied on Bourbon Street from her death. And her twin's death that followed shortly thereafter.

Those sisters, beautiful and kind, are now interred at Lafayette Cemetery No. 1, far too young to be trapped in a picturesque tourist attraction, but forever physically, concretely, at one with the city's appeal, its history. Their eternal rest is a few yards from the Prytania sidewalks, so close to the city's action, so permanently removed from it.

Streets and sidewalks are often where we show our love for the city, its visceral spirit. When my older sister and Ursuline graduate first served on the city council, one of her proudest accomplishments was helping rename a street in Treme to honor Henriette Delille. Another sister designs fantastic,

opulent floats for Muses, including the iconic Sirens float, a celebration of women in mythology fused with the fecund south Louisiana landscape. Another sister is an NOPD cop who works that same parade on the neutral grounds as her sister's float passes, doing her daily work with the less visible, the un-mythologized, the majority of the street-level city.

As I write this, during the year of New Orleans' tricentennial, there's a small movement to bring Micaela Pontalba's remains from France to the St. Louis Cathedral, to be forever flanked by her glorious gifts to the city. I say let her be. Her legacy isn't in what's left of her body anyway—that's been grandly transcended by her vision. The tricentennial will also see our first female mayor, an African American. History has clicked the inevitable into place just in time for the big party, just in time for the future. And while one woman alone cannot deliver the city to a better era, thousands surely can. Nevertheless, in spite of, Amen.

ACKNOWLEDGMENTS

First and foremost, I must thank the women of New Orleans who have allowed me inside their homes and work, and inside their ropes and ballrooms to make these photos to share with the world. Besides the beautiful images they allowed me to capture, they have given me a better understanding of what it means to be a New Orleans woman and what we mean to New Orleans.

To the women who protested in the 2017 in the Women's March, thank you for inspiring this book. To the women and girls who marched again in 2018, thank you for continuing the fight for equality and justice.

I am especially grateful to all of the supremely talented and dedicated essayists who contributed their years of expertise to honor those who came before us as well as acknowledge those carrying the torch to the next generation of New Orleans women.

Special thanks go to Anita Oubre and Janice Kimble for helping with so many of the names. And as Ms. Kimble always says, thanks to all of the women for "showing up and showing out."

Thanks to my husband for letting me be a New Orleans woman who frequently "runs off to the parade," without much notice.

I could spend all day thanking my girlfriends and sisters who have helped me with this endeavor. So, in the deep booming voice of Big Freedia, "You already know!"

Many thanks to Threadhead and the Louisiana Endowment for the Humanities for their grants which made it possible for all of the wonderful essays. Thanks also to the Goldring Family Foundation, who donated to support the publication of this book.

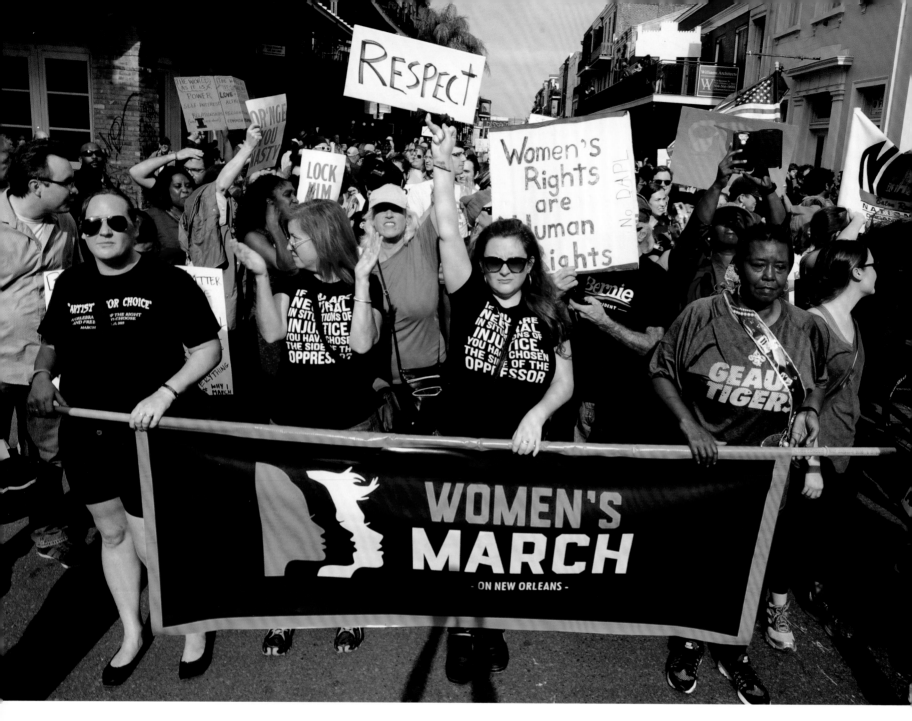

Women's March 2017

Here Come the Girls

CHERYL GERBER

Ever since I was a little girl, I loved observing New Orleans women in action. Whether it was the big-haired woman working the K&B lunch counter who called me "baby" while serving me a glorious root beer float or the beautiful sequined Queens of carnival parades, I relished any opportunity to witness women on the streets of New Orleans, sometimes to the chagrin of my mother. On one occasion, my dad packed all five of us kids into the family station wagon for a thrill ride down Bourbon Street, where the sight of a lady's long legs swinging out of Big Daddy's window is forever etched into my psyche. Even at such a young age, I appreciated the finesse and diversity of New Orleans ladies. As I grow older, that appreciation only deepens.

Yes, I love and adore men. But my camera loves women. For nearly three decades of photographing people, sometimes for clients ranging from *Gambit Weekly* to the *New York Times*, I've had the incredible opportunity of meeting and observing of a huge cross section of women: politicians and public servants, musicians and second-liners, activists and housewives, waitresses and chefs, lawyers and entrepreneurs, Voodoo priestesses and nuns, and socialites and strippers.

While the subject of New Orleans women has always been of great interest to me, having been one my whole life, the idea of doing a book specifically on women didn't occur to me until January 21, 2017. That was the Saturday when nearly five thousand women, with their partners and children, joined the millions who gathered in Washington D.C. and in hundreds of cities around the world to march in solidarity for the protection of women's rights,

safety, women's health and families. It had a profound effect on me. As I peered through my 200 mm lens at the women on the front line, I gazed in wonder at the diversity of women—young and old, black and white, Muslim and Christian, gay and straight. They were mothers, daughters, grandmothers and children. A movement was taking shape.

The idea of *Cherchez la Femme: New Orleans Women* was born. I googled "notable New Orleans women," and a website citing notable New Orleanians popped up. As I scrolled the prestigious list, I noted that 85 percent of the "notable New Orleanians" were men. So I began searching my own archives, and much to my bewilderment, I discovered that my thirty years of photographic archives reflected nearly the same percentage, at least when it came to assignment photography. As I searched my archives for the notable women I had already photographed, I began to reflect on how much they have impacted my own life.

One of the great pleasures in my life was getting to photograph iconic women I've long admired. Take Angela Hill for instance. I was ten years old when she became the first female news anchor on WWL-TV. My dad usually got home from work just in time for the evening news, and I would often plop down next to him, eager to be near him but totally uninterested in the news. That all changed one day in 1975, the day that Angela sat at that desk, forever altering my view. She was beautiful and smart. And rare. Until that day, it never occurred to me that a woman could deliver the news. Sure, I was a huge Mary Tyler Moore fan, but even at ten years old, I knew she was a fantasy. To this day, I believe Angela Hill is the reason I became interested in news. Never could I have imagined that decades later I'd photograph her, much less that she would join our Pleasant Ladies Club, a semi-monthly social luncheon my dear friend Bonnie Warren and I created six years ago.

Every other month, around thirty of us meet at a different restaurant to enjoy some female kinship. We often try to support women-run restaurants like Susan Spicer's Rosedale, Mondo, and flagship Bayona, and Leah Chase's Dooky Chase Restaurant in Treme. On the day we dined at Dooky Chase, then ninety-year-old Leah came out of the kitchen to greet us, and I marveled as I took photos of all of these amazing women in one place. It wasn't the first time, nor the last, that I would photograph Leah.

During the aftermath of Hurricane Katrina, assignments from around the world were pouring in, and the Associated Press called to get a photo of the famous chef, whose restaurant was devastated by the flood. I remember knocking on the FEMA trailer parked outside her flooded-out Treme restaurant Dooky Chase, her husband's namesake, which was not only a great place to eat, but it was also practically an art gallery and an institution

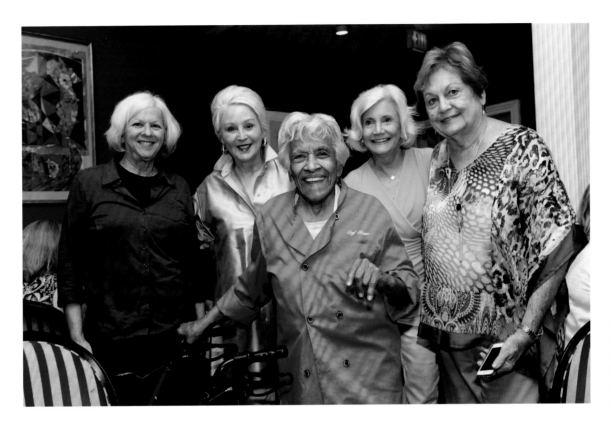

Pleasant Ladies Club members and longtime journalists Sherry Lee Alexander, Angela Hill, Laura Claverie, and Dale Curry, with chef Leah Chase (center) during a 2016 PLC luncheon

of the civil rights movement. When she peeked out of the FEMA trailer still in her pajamas and hair disheveled, I was overcome with emotion.

"Just a second, baby, I'll be right out," she said, which was just enough time to pull myself together. Less than two minutes later, the then eighty-five-year-old reappeared in her starched, bright white chef's jacket with her hair perfectly in shape. We couldn't go into the restaurant because it was destroyed in the flood, so she stood in front of the Dooky Chase sign hanging outside and lit up with a huge smile. I asked her what she was going to do. She said, "We're going to fix this place and make some gumbo. People need a gathering space, and they need to eat." Indeed, people have gathered there. During the 1960s, Dooky Chase became the secret refuge for members of the civil rights movement. Leaders such as Ernest "Dutch" Morial, New Orleans' first black mayor, Martin Luther King Jr., and the Freedom Riders visited the location at different times, often to plan boycotts and other civil rights strategies. Because many restaurants and banks wouldn't serve people of color, Dooky Chase became a secret meeting place for the black communities where they could meet, cash checks, and eat a po'boy. Since reopening in 2007, Chase has fed Presidents Barack Obama and George W. Bush and pop royalty such as Jay-Z and Beyoncé. ■ ■ ■

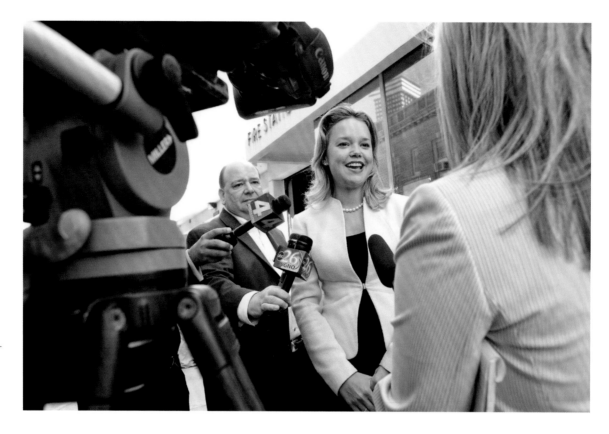

Television news reporter-turned-politician Helena Moreno has the cameras turned on her as she talks to reporters about her political aspirations, 2008

Since Hurricane Katrina and the failed levees ravished the city where I was born, I've noticed an evolution of women activists such as Sandy Rosenthal, a marketing/fitness instructor who took on the Army Corps of Engineers when the levees failed; Anne Milling, who headed Women of the Storm and went to Washington DC to demand hurricane protection and recovery money; Nikita Shavers, who founded Silence Is Violence after her brother was murdered; and Angela Kinlaw, an educator, who co-founded Take 'Em Down NOLA to fight for the removal of Confederate statues. Furthermore, we have seen the rise of women politicians such as TV reporter-turned-politician Helena Moreno and LaToya Cantrell, who rose from a post-Katrina neighborhood organizer to the city's first female mayor in its three-hundred-year history.

I was there on assignment the night that Cantrell won, securing her place in history. The moment was not lost on the hundreds of women who gathered to share in the elation.

She has her work cut out for her.

In New Orleans, the poverty rate is much higher for women than for men, where almost a third of women live under the federal poverty line.

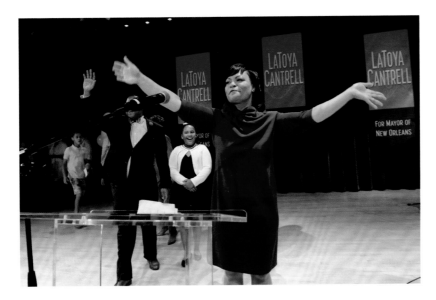

In Louisiana, a woman earns 68 percent as much as a man, and the gap is worse for black and Hispanic women.

And while these dismal statistics persist, so do the women in New Orleans. Pastor Marie Galatas-Ortiz, who ran for mayor in 2006, is one of those women. I have seen her march and heard her preach against racism for decades, and though I never took her passion for granted, I realized I never took her as seriously as I should have. While I was not blind to racism, I was shocked at the number of KKK members and White Nationalists waving flags during the recent protests surrounding the takedown of the Confederate monuments. As the counterprotesters arrived to meet the protesters, the danger and dread were palpable. I trained my camera on Galatas-Ortiz, now in her seventies, holding up her cross and bravely marching past KKK members hurling the n-word toward her as she marched. Undeterred, she persists.

I also photographed activist Nancy Holtgreve as she marched against the Muslim ban and then again as she marched to Representative Steve Scalise's office to register her complaint about repealing the Affordable Care Act, only to be turned away. Moments later, after she left, I witnessed two white men being invited in to register their complaints.

Everyone who knows me, or is a social media friend, knows that I love a good protest. I will always make the effort to get out to a protest, whether I get an assignment or not. But one of those only-in-New Orleans warm nights in early February, I got a call to photograph a protest in the French Quarter. I already had plans for the night, so I shrugged off the call for a few minutes before I listened to the full voice message. Kandace Power Graves,

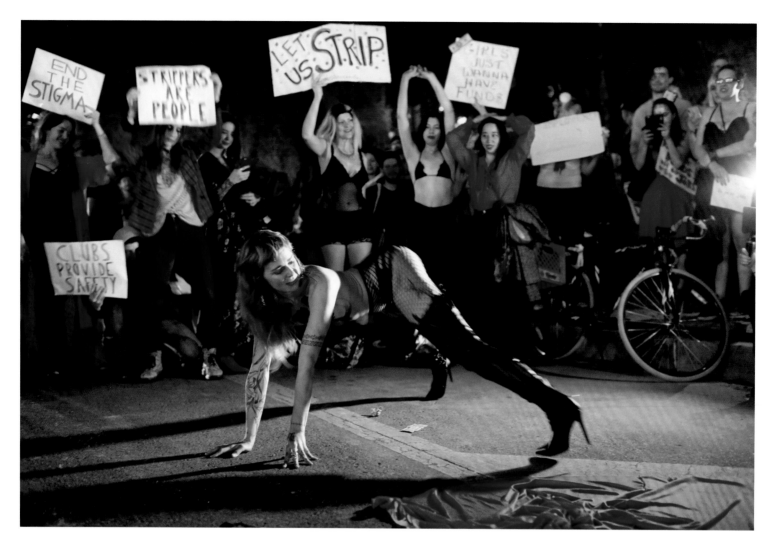

Stripper Elle Camino dances on the streets during the "Stripper Protest," formally known as the Unemployment March, after ATC agents raided several strip clubs, suspending their licenses, 2018

my editor at *Gambit*, wanted to know if I could photograph the "Strippers Protest," formally known as the Unemployment March. Come again? There was no way I would miss that one.

Two weeks before Mardi Gras, Alcohol and Tobacco Control (ATC) agents raided several of the Bourbon Street strip clubs after an undercover sting, suspending their licenses. At the time of the protest, officials declined to discuss the reason for the suspensions. The strippers and the Bourbon Alliance for Responsible Entertaining (BARE) took to the streets in grand New Orleans style. After the protest, Holly "Tamale" Hawthorne, a self-proclaimed "stripper, tamale girl, mom, street performer, burlesque dancer," texted me to see if I wanted to photograph a strippers' pop-up at

Poor Boys on St. Bernard Avenue, since many of the clubs had closed. I wasn't planning on having strippers in the book, but when I saw burlesque artist Xena Zeit-Geist perform that night, or should I say morning, she reminded me how much burlesque artists such as Bella Blue and Trixie Minx have brought back the art while carving out a lucrative niche in the city's cultural landscape.

While officials cited a crackdown on the huge problem of human trafficking, many strippers felt singled out because of a "conservative agenda" to shut them down. Many of the clubs have since reopened, while some turned into dance clubs, and some closed forever.

Despite the cards stacked against them, New Orleans women take to the streets to celebrate life, and sometimes death, elevating our city to a higher ground.

The number of all-women marching krewes such as the Pussyfooters and the NOLA Cherry Bombs has increased exponentially, while all-women super krewes like Muses and Nyx have changed the game during carnival, producing the most popular parades that rival the all-male super krewes Bacchus and Endymion. The recent revival of the African American historic Baby Dolls has now become one of the most coveted sights during the Zulu parade.

For as long as I've been a photographer, I've been drawn to the many strange and imaginative ways that women reveal themselves when out in public, through their fashions, their pets, their body language, the dances, and the hairdos!

Though I've made my living for the past twenty-five years as an assignment and event photographer, it's the street photography that feeds my soul. I first hit the streets in the early nineties, where I started focusing my camera on the beautiful women of New Orleans.

"If you want to photograph people, go to the streets," I was told by my dear mentor Michael P. Smith. And if you want to photograph beautiful women, you look no further than a second line. More and more women are dancing in the streets. The joy and vibrancy of the women of these clubs could never be mistaken for those in any other place in the world.

My primary interest has always been in people and the marks they have left on New Orleans. And right now, women are making their marks.

Through photography, it's my goal to depict the New Orleans women who make life in New Orleans so rich and diverse, with the goal that my photographs create a deeper understanding of who we are and who we are becoming. ▪ ▪ ▪

Stylish Sharon Walker seen frequently at second lines, 2018

Muses, the all-female superkrewe, has become one of the city's most beloved parades, 2018

I would be remiss if I didn't mention some glaring omissions in this book. It has been agonizing, but I had to leave out literary and visual artists, as well as women in media because each category could have been its own book. Quite simply, I had to follow the avenues where my assignments have led me.

The artists, writers, and media who cover and elevate the arts in New Orleans are too many to count, but women such as Diane Mack of *Inside the Arts*, Susan Larson who hosts *The Reading Life*, Gwen Thompkins of *Music Inside Out*, and Peggy Scott Laborde of the long-running *Stepping Out*, Jan Ramsay of *OffBeat Magazine* and Karen Gadbois, founder of *The Lens* have given me deep insights into the lives of many New Orleanians who make being in New Orleans so enriching. Some of the women they have interviewed and highlighted include performance artists Kathy Randels and Becky Allen, longtime cabaret entertainer Chris Owens, artists Lin Emery and Jaqueline Bishop, photographers Chandra McCormick and Judy Cooper, filmmakers Crista Rock and Lily Keber, writers Anne Rice and Sally Asher, and poet Kelly Harris, just to name a few. And "Funtrepreneur" Pat Jolly, in a category of her own because she crosses all of these genres, could easily be her own chapter. I am so grateful to all of these women who have elevated and deepened my understanding of my home and city.

And though I would never pretend that this is the definitive book on the New Orleans woman, because no one work could ever reveal her essence, it is my hope that this book helps us see her grit and grace, her beauty and desires, and, yes, her fashions to give us a collective female portrait of our times.

Cherchez la Femme

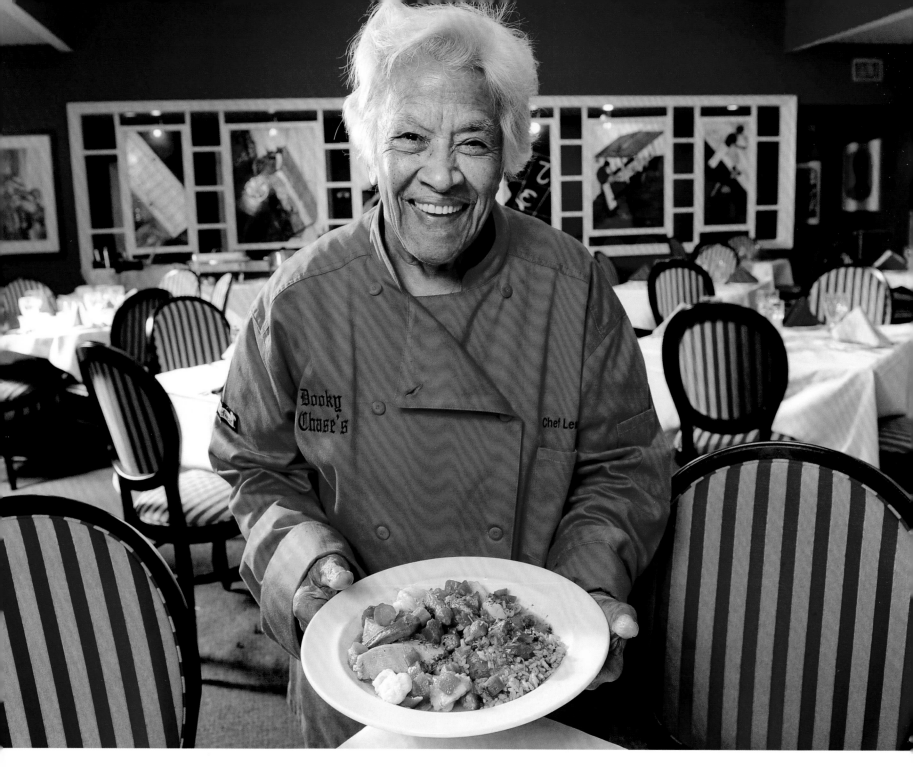

Queen of Creole cuisine,
chef Leah Chase, 2011

Leah Chase

The Queen of Creole Cuisine

HELEN FREUND

Leah Chase often says that the course of American history was changed over a bowl of gumbo. Those who know her story know that Chase is referring to her legendary Orleans Avenue restaurant, Dooky Chase, which served as a meeting point for activists and politicians during the civil rights era—a sanctuary for African Americans during a tumultuous time in the city and a pivotal marker in United States history.

From her kitchen, Chase would emerge with steaming bowls of gumbo, fried chicken, and red beans, acting as a conduit of sustenance and comfort, while at the same time providing a safe haven for the workers, politicians, writers, and activists who dined at her tables.

Even when someone threw a pipe bomb at the building's front door, the restaurant kept on going, and Chase kept on cooking. Food wasn't just a way for Chase to express herself—it was an act of resistance.

But Chase's quiet rebellion began much earlier, when she did what for many at the time was still unthinkable—she entered the restaurant business as a woman. Long before the industry began looking inward at its gender inclusion policies, Chase worked her way into the male-dominated business with a stoic demeanor and can-do attitude that has inspired generations of female restaurant entrepreneurs since. Even today, at ninety-five years old, Chase doesn't mince her words, always peppered with perseverance and a dash of defiant sass: "Every woman needs to get up in the morning, look herself in the mirror, and say, 'I am the prize.'"

Born in 1923, Chase grew up the small shipping town of Madison-ville, Louisiana. The oldest of eleven children, she attended St. Mary's Academy, a Catholic school for black girls, in New Orleans, and by the time she turned eighteen, the city had become home, and she put down permanent roots.

Chase got work as a waitress in a French Quarter restaurant and credits those first few formative years waiting tables and washing dishes as the catalyst for what became a lifelong love affair with the restaurant business. It wasn't always easy. In the early 1940s, jobs in the restaurant industry were typically held by men, while women mostly found work at one of the many sewing factories in town, something Chase said she had little interest in. But wartime changed all of that, and all of a sudden, the city's restaurants found themselves in dire need of labor.

"When I came in this business, it wasn't a popular thing for young black women like me to work in restaurants," Chase recalled. "I only got there because I was a waitress, and I only got to be a waitress because the war started and there were no more [male] waiters. It wasn't easy—we just had to do as we do."

Chase's story is inspiring, but not entirely singular. With the exception of Lena Richard—the trailblazing African American chef, caterer, cook-ing teacher, cookbook author, and cooking show host on New Orleans television—black women did not occupy a large public culinary presence at the time, but they were always involved privately. Women, and black women in particular, occupied a quiet space as domestic servants and in the kitchens of makeshift restaurants and bars.

At the end of the Civil War, newly freed blacks from all over Louisiana came to New Orleans from nearby plantations in search of food, work, and shelter. Domestic work was largely dominated by women of African descent, who later flooded the catering and domestic cook industry and carried with them the deep-rooted knowledge and recipes, which evolved into what we know today as Creole cuisine.

By the middle of the twentieth century, New Orleans had become a food destination for Creole cuisine, and with it came the rise of the so-called celebrity chef. This phenomenon, however, left black cooks out in the cold.

"Some restaurants, you never knew who was in those kitchens," Chase recalled. "You knew the owner, you knew the restaurant's name, but you never knew who was in the back. When people started paying attention to the chefs, well naturally, you're going to take someone with some kind of training, because how else were they going to advertise? That left all the black chefs in the dark."

Chase quietly observed the industry from behind the scenes, and in 1946, she married Edgar "Dooky" Chase Jr., a local trumpet player whose family ran the Dooky Chase restaurant, then a tavern selling lottery tickets and po'boys on Orleans Avenue. Throughout the years, Chase slowly began making her mark on the restaurant, adding menu items and making décor shifts, bringing with her dishes she picked up on during her experience working in the French Quarter in establishments where blacks could work but were still not permitted to eat. In a time when restaurants in the city were still largely segregated, Dooky Chase became one of the few upscale places where African Americans could come to dine and socialize.

"I learned by watching other people. I learned by listening to other people, and I was lucky enough to have people help me," Chase recalls. "For me, this [was] wonderful because I [didn't] have the education that a lot of chefs had. But I learned to really love it. There is something about how a simple thing like a plate of food and kind service can make such a difference in people's lives."

Over the years, Chase has been the recipient of multiple awards and accolades, and she continues to push for progress and equality. While age has slowed her down a bit, she is still a constant presence in the restaurant, stopping by tables to offer warm greetings, a wry smile, and dashes of wisdom and wit.

Chase's work has inspired generations of women chefs and restaurateurs, and she says that there have been many who have inspired her along the way, too. There's Celestine Dunbar, whose long-running restaurant, Dunbar's Creole Cuisine, shuttered since Hurricane Katrina, recently reopened after finding a new home. There's Susan Spicer, whom Chase praises for her work ethic and stamina ("That lady works. She can do anything"). And there's Ella Brennan, the Brennan family matriarch and restaurant empire powerhouse who mentored up-and-coming talents like Emeril Lagasse and Paul Prudhomme while helming a restaurant group in a male-dominated industry long before gender equality in the business became a hot-button topic.

"Ella Brennan was a dynamite woman," Chase says. "She would tell you herself . . . that she had to do it all by herself. She could be a role model for all of us—even though she was not a chef, but she was a restaurateur, and she knew what it took to make that restaurant work."

Chase says she's also hopeful for a new generation of younger up-and-coming female chefs in New Orleans who are opening and running restaurants with a defiant, can-do attitude similar to her own.

"As I grew into it, I looked around at the women in the business, and let me tell you, these women can cook," Chase says. "They don't buckle."

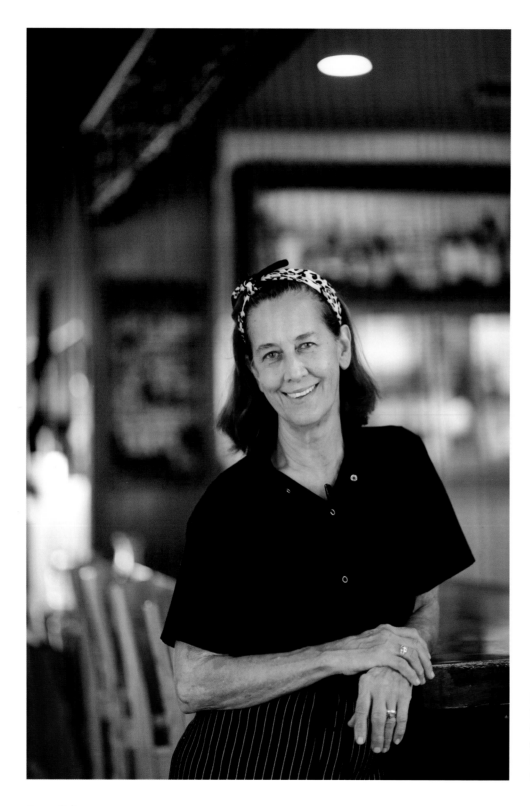

Susan Spicer, the celebrity chef
behind world-renowned French
Quarter restaurant Bayona (which
she owns with Regina Keever) and
Mondo, poses at her newest Lakeview
restaurant, Rosedale, 2018

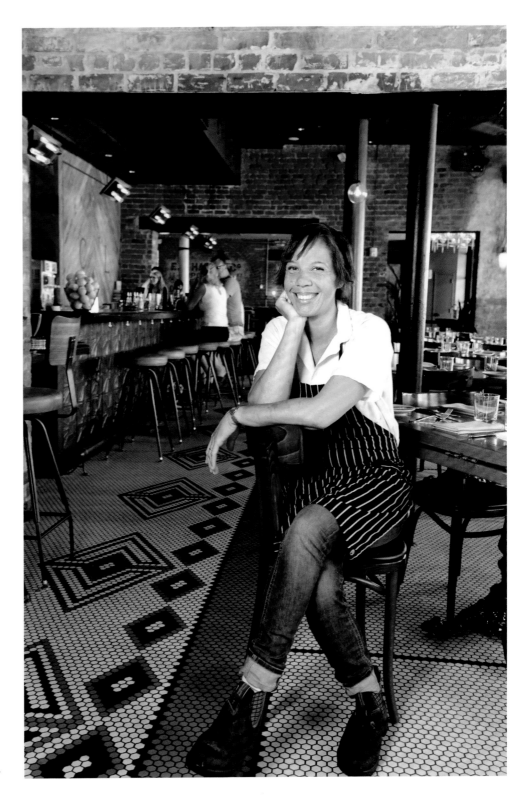

James Beard Award–winning chef
Nina Compton of Compère Lapin
and Bywater American Bistro, 2017

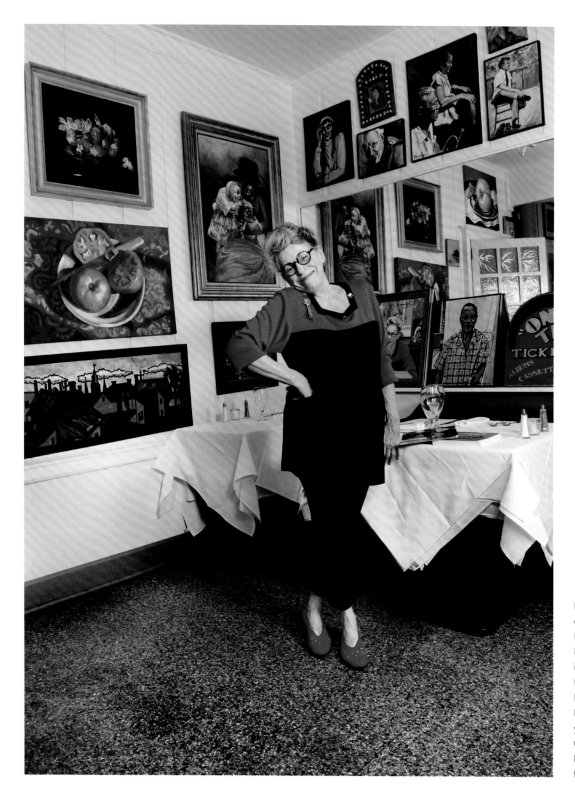

Restaurateur JoAnn Clevenger, deemed "New Orleans' Greatest Hostess," won the Craig Claiborne Lifetime Achievement Award in 2015 and has been a finalist for the prestigious James Beard Foundation's Outstanding Restaurateur for five consecutive years. She is the creator of Fried Green Tomatoes with Shrimp Remoulade at her beloved and art-filled Upperline Restaurant, 2018

Native New Orleanian Poppy Tooker created her niche as a cultural ambassador, culinary activist, radio and television host, speaker, teacher, and author of several books, including her recent *Pascal's Manale Cookbook* and *Drag Queen Brunch*, 2018

Award-winning chef Kristen Essig and
co-owner of Coquette and the new
Garden District restaurant Thalia, 2018

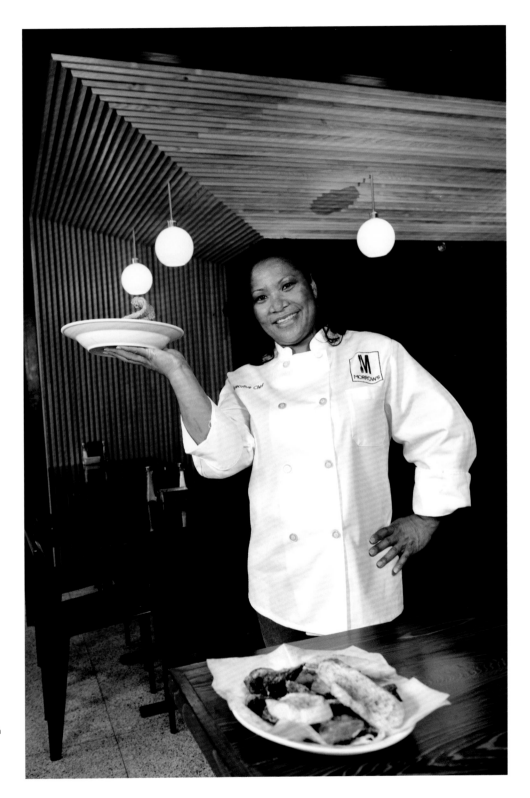

Morrow's executive chef Lenora Chong brings her Korean and Creole-inspired cuisine to the Faubourg Marigny in 2018

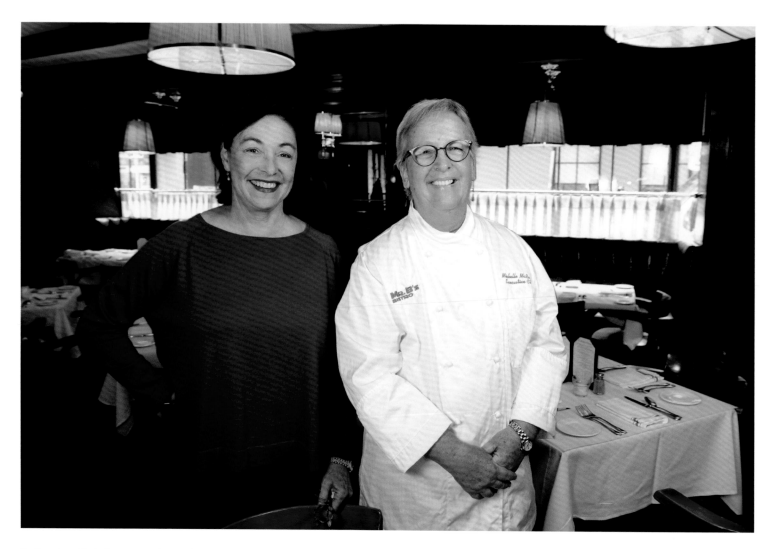

Restaurateur Cindy Brennan and executive
chef Michelle McRaney of Mr. B's in the
French Quarter, 2018

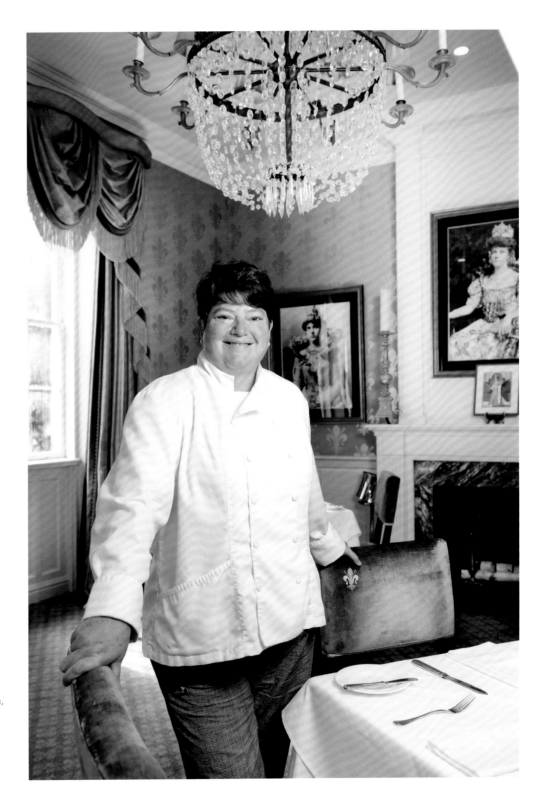

Executive chef Haley Bitterman, the first woman at the helm of any Brennan family restaurant kitchen, presides as corporate chef of Ralph Brennan Restaurant Group, 2017

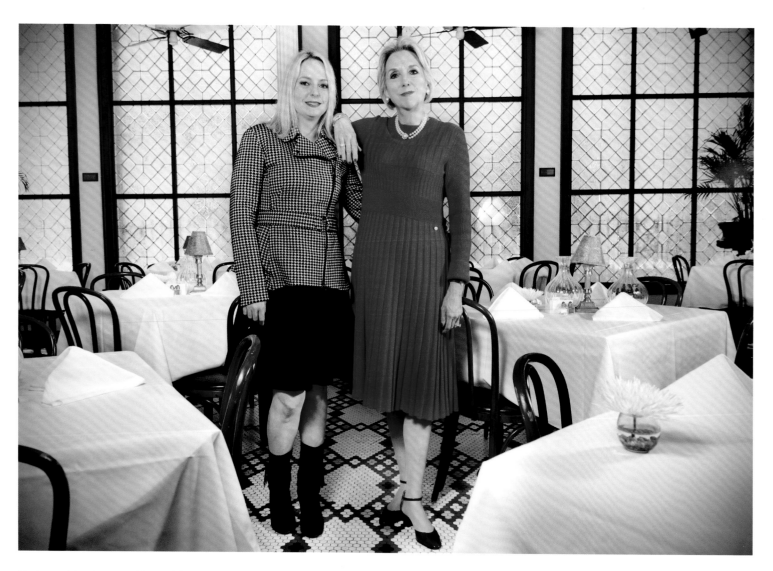

Mother and daughter team Katy and Jane
Casbarian, along with Katy's brother Achie
Casbarian Jr., operate the fabled Arnaud's
restaurant, one of the oldest French Creole
restaurants in the city, 2018

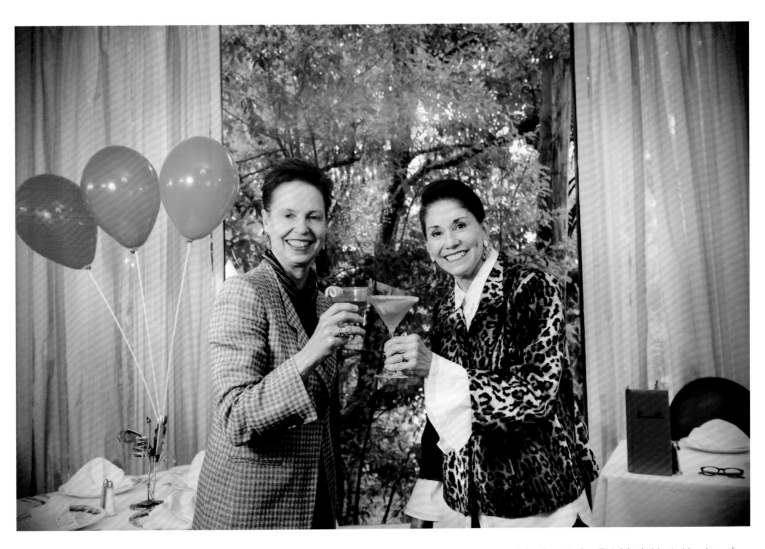

The dynamic duo, Ti Adelaide Martin (daughter of restaurateur and "grand-dame" Ella Brennan) and her cousin Lally Brennan, of Commander's Palace, 2018

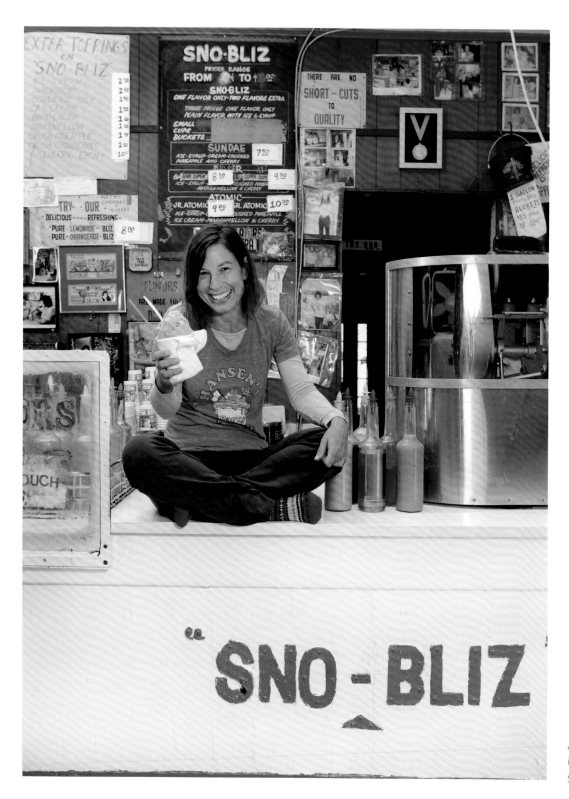

Ashley Hansen runs her grandparents'
iconic Hansen's Sno-Bliz nearly eighty
years after opening, 2018

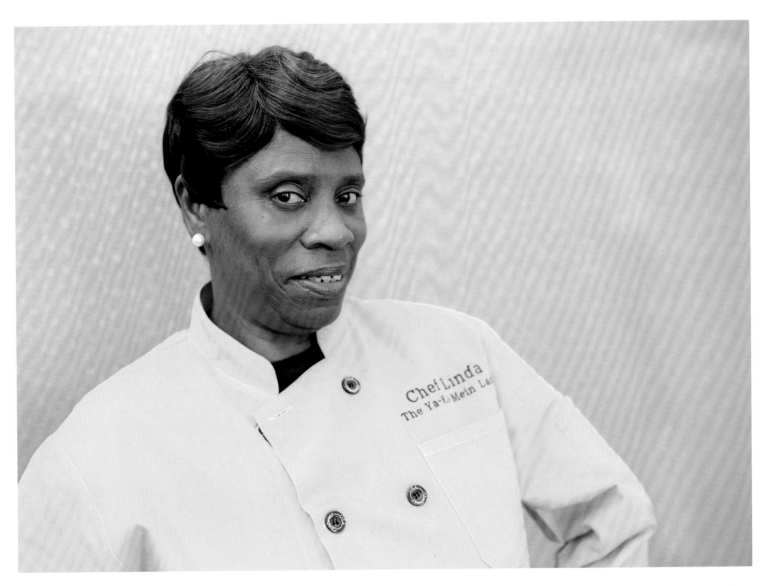

Chef Linda Green, also known as the
ya-ka-mein lady because of her famous
soup that cures hangovers, 2018

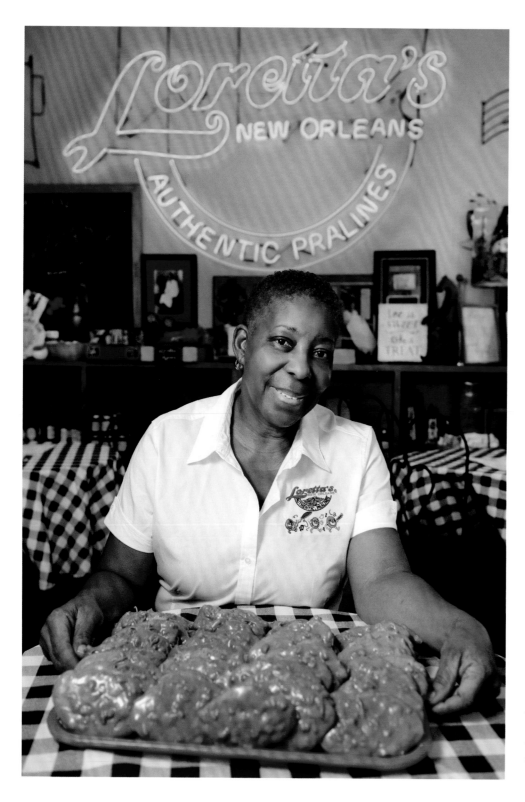

Loretta Harrison, president and CEO of the world-famous Loretta's Authentic Pralines, is the first African American woman to successfully own and operate her own praline company in New Orleans, 2018

"Ms. Okra" Sergio Robinson continues the legacy of her father, Mr. Okra, delivering produce through New Orleans neighborhoods, 2018

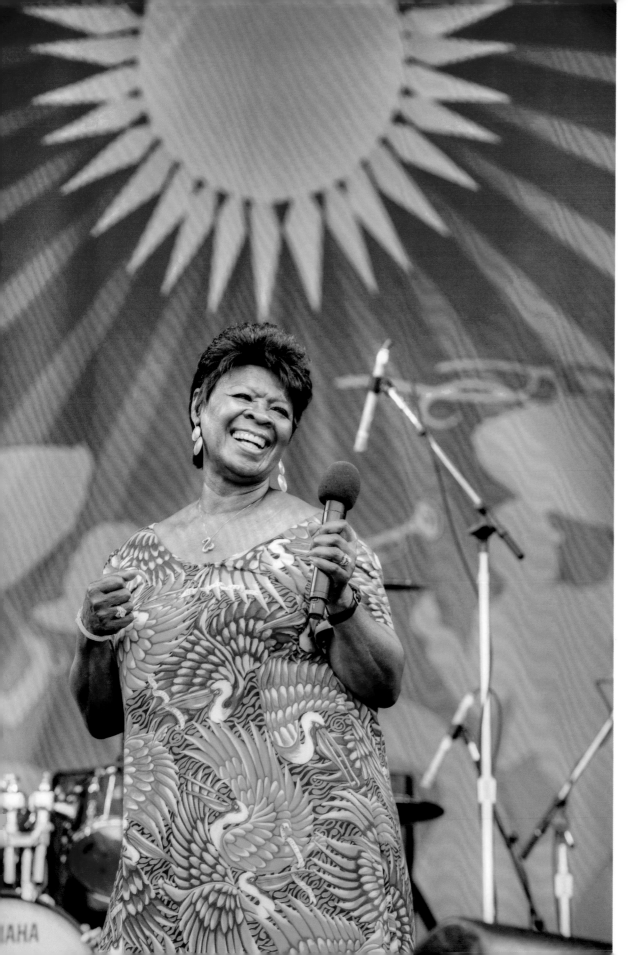

Irma Thomas, R&B singer and queen
of New Orleans soul, at the Jazz and
Heritage Festival, 2014

FROM SWEET EMMA TO CHEEKY BLAKK

Women Shaping New Orleans' Music Scene

ALISON FENSTERSTOCK

In 2004, the New Orleans Jazz National Historical Park commissioned historian Dr. Sherrie Tucker to research and write a study that was startling, in retrospect, in its lack of precedent: a history of jazz in New Orleans that focused on the contributions of women. By the turn of the twenty-first century, New Orleans jazz—the great artistic accomplishment of the twentieth century—had been exhaustively documented, celebrated, and studied, of course, by scholars, collectors, and casual fans alike, from the Crescent City natives who second-lined before they could walk to the passionate tourists who cross oceans just to stand, they imagine, where Buddy Bolden or Louis Armstrong once stood.

Tucker's study illuminated the lives and work of women artists who helped to shape jazz's first one hundred years, including familiar names like Sweet Emma Barrett, born in 1897, whose bell-bedecked garters famously added percussion to her piano, alongside those who are less well known—like Antonia Gonzales, a Storyville madam known to have hired Jelly Roll Morton to play her brothel's parlor, but who also often entertained customers herself, playing her cornet. And the writer acknowledges that early on in her four-hundred-page investigation, answering the question of why, with such a large body of work already existing on such a young art form, such a targeted study was necessary.

"It would be ideal, of course, if all serious historical inquiries automatically considered women as well as men," she wrote drily. "Yet scholars of women's history have found that this has not usually been the case."

When it comes to the well-documented history of jazz in New Orleans, very often, the record keepers and torch carriers were women. The New Orleans Jazz Club, a group of enthusiastic fans and promoters founded in the mid-fifties, collected a priceless hoard of records, sheet music, instruments, photographs, and interviews related to the sound: those holdings became the collection at the New Orleans Jazz Museum. At least three women—Myra Menville, Helen Arlt, and Frances Fernandez—served as its president. Barbara Reid, a young French Quarter bohemian who identified herself as a witch in a 1960s interview with the *Times-Picayune*, spearheaded the earliest iteration of Preservation Hall; Sandra Jaffe, who took over in 1961 with her husband Allan, co-captained the institution for decades afterward. In the mid-nineties, Maroon Queen Cherice Harrison-Nelson of the Guardians of the Flame Mardi Gras Indians and her mother Herreast founded the Mardi Gras Indian Hall of Fame, an institution that honors and advocates for practitioners of the singular culture, helping masking Indians with projects such as retaining copyright to their elaborate feathered and beaded suits and brokering fair-use agreements with the photographers that are routinely dazzled by their display. It was Allison Miner, onetime manager of Professor Longhair, who established the New Orleans Jazz and Heritage Festival's music heritage stage, which presented lengthy interviews with performers, and the festival's archive, which stores them as a resource for scholars and historians.

In 1970—its first year—with Miner's assistance, Jazz Fest presented the New Orleans-born gospel great Mahalia Jackson, an artist whose powerful creative spark and spiritual passion shaped the sound not only of the city but also of her nation. (Indeed, if anyone could give Louis Armstrong, Fats Domino, or Lil Wayne a run for his money as the most influential artist to emerge from the city, it would surely be Jackson.) Her spirit lives again there annually with Irma Thomas' heartfelt annual tribute set, a love letter from one soul-shaking singer to another.

Now in her seventies, Thomas stands as an elder stateswoman of New Orleans music, the finest living representative of the city's golden age of rhythm and blues. She began performing in the late fifties, auditioning for Harold Battiste when the jazz master and future Sonny and Cher musical director was scouting talent for Los Angeles–based Specialty Records. He was impressed, but he thought the teenage soul singer was too young to sign. The New Orleans music scene was flush with talent and opportunity at

the time, with independent labels burgeoning, and after a stint as a waitress at the Pimlico Club, Thomas joined first Ron Records and then Minit. That label, home to R&B greats like Ernie K-Doe, Chris Kenner, and Benny Spellman, was also where Allen Toussaint first honed his skills as a producer, and his creative partnership with Thomas thrived; the pair recorded many of Thomas' most-loved singles there, including "It's Raining," "Ruler of My Heart," and "Cry On."

The nineties in New Orleans mimicked—almost re-enacted—the fifties and sixties R&B explosion with its similar overstuffed independent marketplace of small local labels recording a thriving talent base. Hip-hop had made its way to the bottom of the boot state from its New York birthplace, and while New Orleans generated a fair share of slick lyricists—Mia X, the platinum-selling first lady of Master P's No Limit Records among them—it also birthed the uniquely local, singsong dance-music rap hybrid called "bounce." The new sound—which, especially in its early days, paid liberal tribute to earlier traditions like brass-band rhythms and Mardi Gras Indian melodies—supported a deep bench of female artists. There was Da Sha Ra, one of the earliest artists on the Take Fo label, which would eventually produce Katey Red. There was Cheeky Blakk, the grinning, growling, often-explicit rapper whose wild, high-energy sound recalled tough, sassy blues women like Big Maybelle and Big Mama Thornton. And there was Ms Tee, the soulful R&B singer and rapper who was the first female artist to sign to Cash Money Records. When Lil Wayne held his first Lil Weezyana Fest in Champions Square in 2015, he presented Ms Tee, one of his formative influences, onstage as if he were introducing a queen.

As the new century dawned, and particularly in the shaken-up years following Hurricane Katrina, the scene flourished and diversified as both a new generation came of age and new transplants poured into the city. A newly vital French Quarter busking scene—shades of the sixties, when Jimmy Buffett and Jerry Jeff Walker had played those ancient streets for tips, perhaps—delivered traditionalists like the deep-throated vocalist Meschiya Lake and the soulful folkie Alynda Segarra of Hurray for the Riff Raff. There were also those who took root and bloomed in the supportive downtown scene, like tape-looping cellist Helen Gillet, the endlessly crafty reed player Aurora Nealand, and singer Debbie Davis, whose loungey sets shift, with a wink, from Fats Waller to Tom Lehrer to Led Zeppelin. Some artists with deep local roots matured into their own, like Dave Bartholomew's young cousin Robin Barnes, an ebullient soul jazz singer and writer, and the Pinettes Brass Band, an all-female ensemble first formed at St. Mary's Academy High School. In 2013, when the energy-drink brand Red Bull hosted

a brass-band throwdown called the Street Kings championship under the Claiborne bridge, the Pinettes took top honors—and declared themselves instead the Street Queens.

We investigate and reinvestigate history to better understand our own story, to learn the truth of who we are. And when it comes to the musical culture of New Orleans, already so deeply aware of its connection to the past, such investigation and revelation only serve to mine even more joy, and more pleasure, from a rich and fertile vein. Today, it doesn't take a deep dig like Tucker's to hear that the chorus of New Orleans music rings out with the voices of hundreds of women across the decades and across town: those turn-of-the-century jazz women, the belters of the R&B era, the clever lyricists and dance-floor shakers of nineties hip-hop and bounce, and the post-millennial transplants drawn to the city out of love for its historic sounds or the inspirational and nourishing energy of its tight-knit creative community. Open your ears, and they're there.

Germaine Bazzle

New Orleans' First Lady of Jazz

GERALDINE WYCKOFF

When Germaine Bazzle, New Orleans' "First Lady of Jazz," steps on a stage to sing, she doesn't simply front a band but becomes an instrumental element in its interactions. As a highly educated musician who is a classically trained pianist, an accomplished bass player, and a lifetime music educator, Bazzle boasts a deep understanding of the music's fundamentals of melody, harmony, and rhythm. The members in any given combo, many of whom she's performed with for decades, know and trust her instincts. And, oh yeah, she can swing.

Bazzle's public persona is that of brilliant jazz vocalist—an absolute truism. However, she adamantly denies that she "sacrificed" what could have been a successful career as an internationally renowned recording and performing artist to remain in New Orleans to teach at Xavier College Preparatory High School. Bazzle, who earned a degree in music education at Xavier University, retired from her position heading vocal classes at the high school in 2008.

"Teaching was what I was supposed to do—the [music] gigs are what I could do," Bazzle once explained. "As far as I was concerned, I had the best of both worlds."

Bazzle, eighty-six, grew up in a musical family, where everybody played piano, including her mother, father, aunts, and uncles. Originally from New Orleans Seventh Ward, she holds fond memories of her family's apartment in the Lafitte Projects in the Treme neighborhood, where the piano was center stage. "That was the instrument of the day. You could walk down one block and at least three families in that block had a piano in their home. I wasn't even aware that it was an influence because it was just an everyday kind of thing."

Living in the culturally rich Treme, then referred to as the Sixth Ward, Bazzle was also exposed to the brass band–led second line parades and the ring of tambourines wielded by the Mardi Gras Indians.

While Bazzle continues to be renowned for her elegant dignity and the sense of drama she brings to classic tunes such as "As Time Goes By," the

influences of the city's street beats remain in her essence. She can often be spotted layin' down some mean second line dance moves as she stands at the sidelines as well as on stage.

Bazzle is a serious jazz vocalist whose vast musical knowledge allows her to improvise and perform her very individualistic style of scat with a sense of purpose and freedom. She also knows how to have a good time with a tune and humorously get involved with the story-telling elements of a song's lyrics. An example of that can be heard on her version of "I Just Found Out about Love" on her 2017 album, *Swingin' at Snug*. "And I like it, I like it," she sings with a grin in her voice.

"Basically, music is sound, so when I go on a gig, I just bring another sound to the organization," the always humble Bazzle has offered. "I am aware of the individuality of the performers that I work with. My job, and the individualism that I'm bringing, is that I want to be a part of it."

Though Bazzle has been performing professionally since the 1950s with an array of notable artists, including pianist Ellis Marsalis, the late saxophonist Alvin "Red" Tyler, bassist George French, and numerous others, her limited recording output doesn't really reflect the impact that her enormous talents have had on the New Orleans modern jazz scene and beyond. Again, her passion for teaching surpassed that of any ambition of gaining fame. Importantly, she was also a member the St. Louis Cathedral Choir and the Moses Hogan Chorale, and since its inception, has continued on the faculty of the Louis "Satchmo" Armstrong Summer Jazz Camp.

Bazzle credits her fourth-grade teacher at the Xavier Junior School of Music, Sister Letitia, for what would become one of her signature vocal improvisations. With her voice, she mimics the sound of a trombone, much to the astonishment and delight of audiences. When Sister Letitia would lead the school's orchestra and wanted to demonstrate something to the trumpet or trombone section, she would do it vocally, imitating the instrument. "So I would start harmonizing with the trumpeter by doing what I saw Sister Letitia do," Bazzle explains. "That's how I got started."

Sister Letitia was also prophetic concerning the future of her young student. "One day when I was in her class, she just said to me, 'You're going to be a teacher.' It didn't sound very strange to me because there were teachers in my family. I said, 'Okay,' and didn't think anything of it at all. She saw in me what I am."

Bazzle stands on her own stylistically pulling out many surprises from her fully loaded musical "trick" bag. Always reinventing herself, she'll change her phrasing or a tune's syncopation, making everything new again.

Simply, Germaine Bazzle is a great jazz musician.

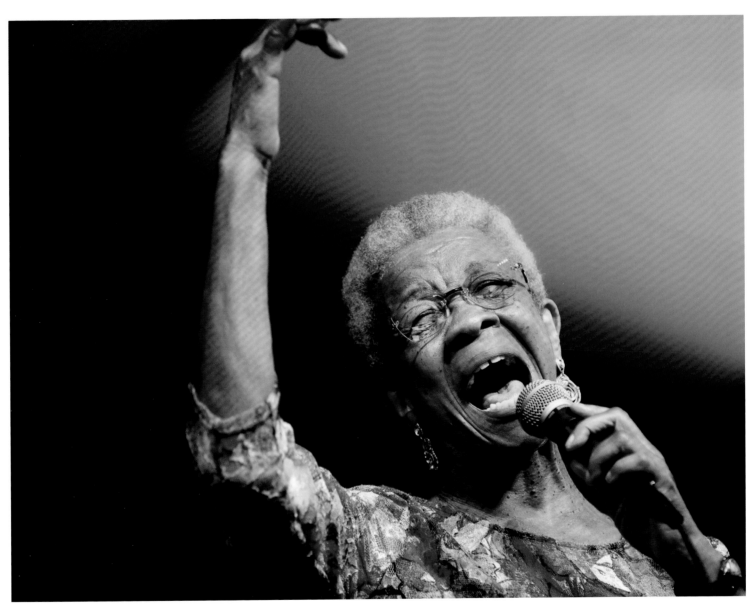

Jazz Vocalist Germaine Bazzle, Jazz Fest, 2017

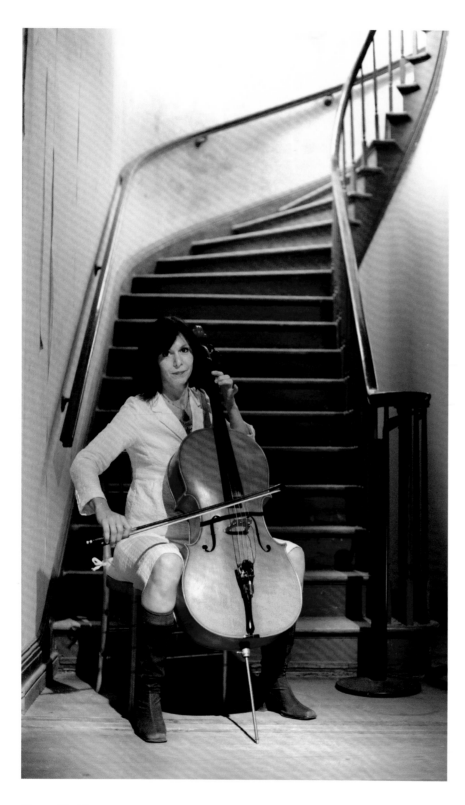

Helen Gillet at the Patrick Taylor
Library at the Ogden Museum, 2011

Jazz Singer Stephanie Jordan,
Ogden Museum, 2008

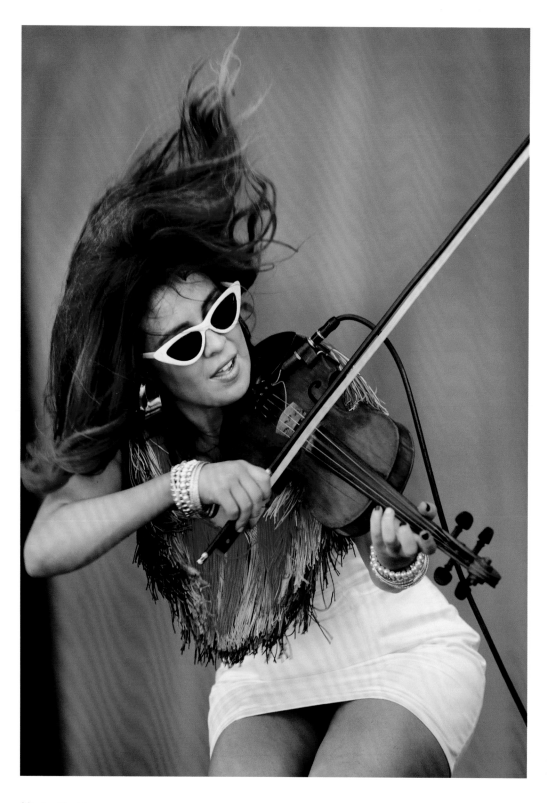

Amanda Shaw performs her
twentieth Jazz Fest in 2018

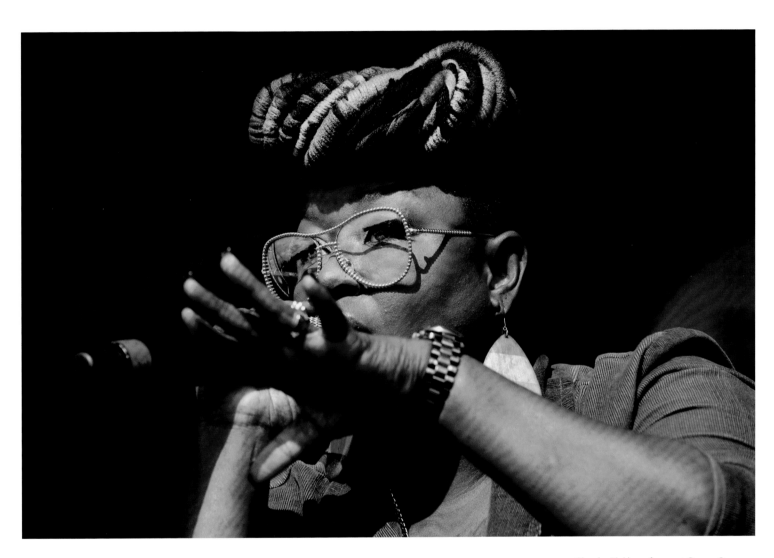

Cheeky Blakk performs at Congo Square
stage at Jazz Fest, 2019

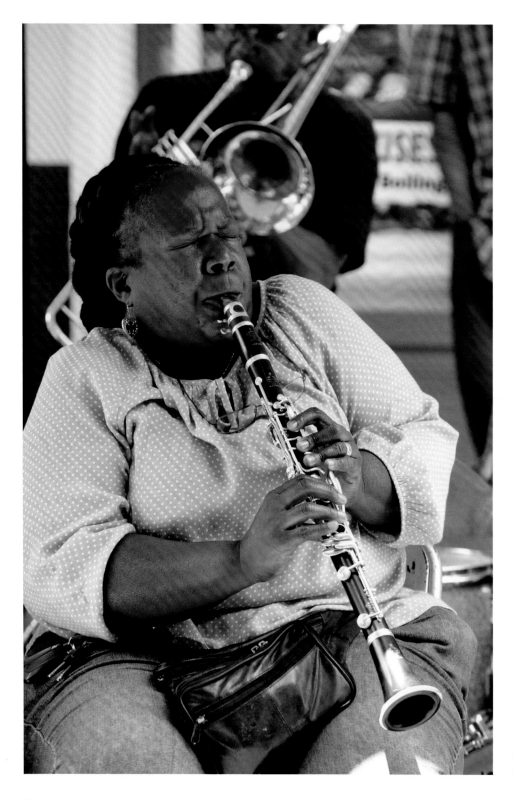

Doreen Ketchens performs
on Royal Street, 2018

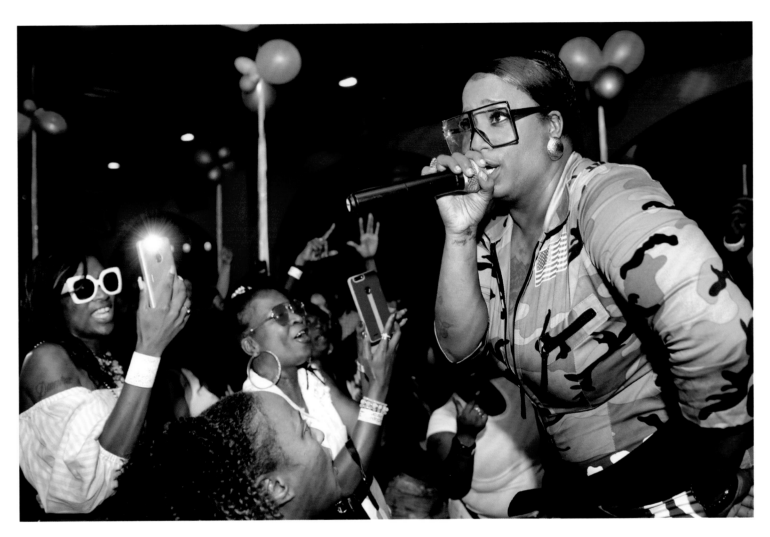

Ms Tee performs at the First Annual
Mama Fest at Lyve Nite Club, 2018

Singer Debbie Davis on
Frenchmen Street, 2018

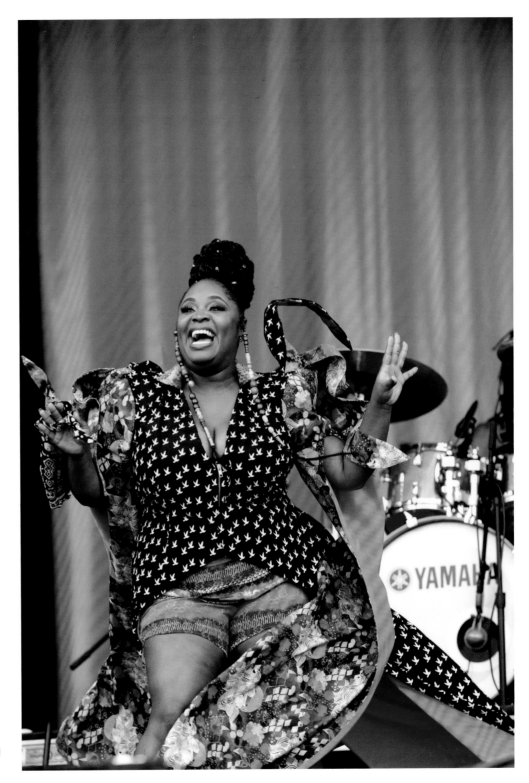

Tarriona "Tank" Ball of Tank and
the Bangas, Jazz Fest, 2018

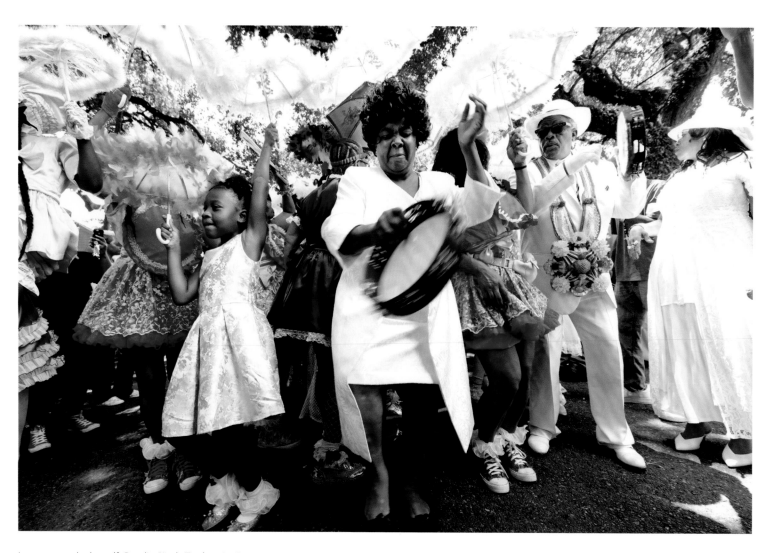

In a category by herself, Rosalie "Lady Tambourine" Washington can be seen at Jazz Fest, Essence Fest, church, and in the movies, but she can also be found on the streets of New Orleans with brass bands, as seen here at Eva Louise Perry's funeral, 2018

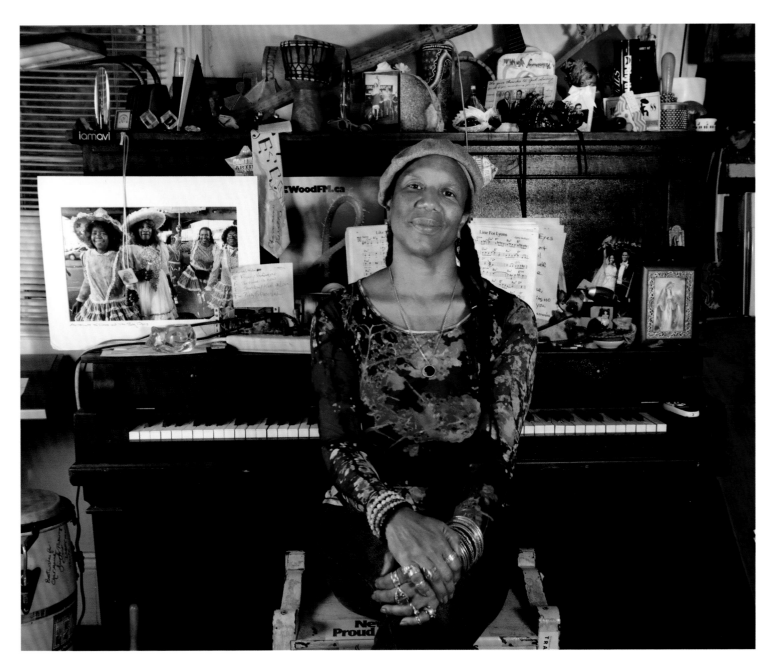

Charmaine Neville at home in Bywater, 2018

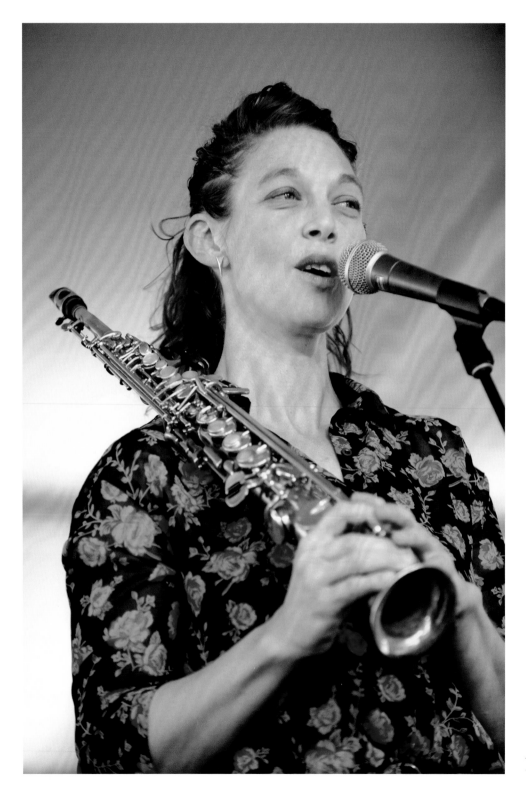

Aurora Nealand sings "Ne Me
Quite Pas" at Jazz Fest, 2018

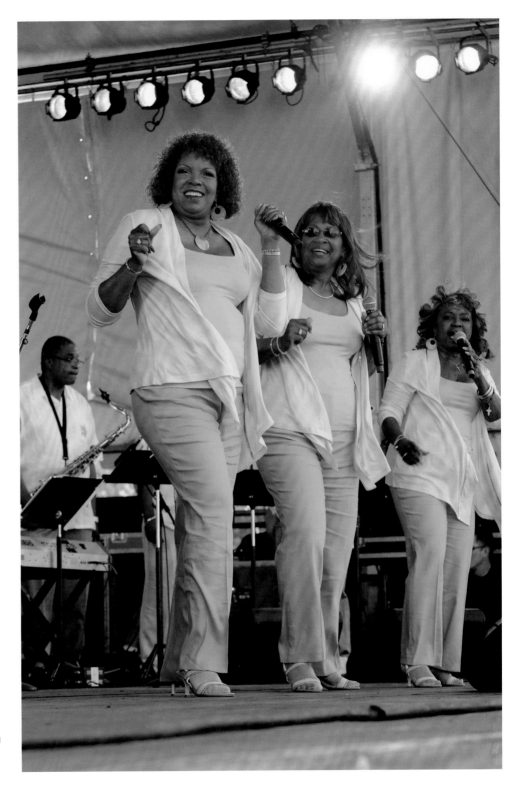

The Dixie Cups, known for their hit song "Iko Iko," perform at the New Orleans Jazz Fest, 2009

The Pfister Sisters, Holley
Bendtsen, Karen Stoehr,
and Yvette Voelker,
celebrate forty years of
performing traditional
jazz in New Orleans, 2019

The Original Pinettes Brass Band, the city's only all-female brass band, at Bullets Sports Bar, 2018

Suzannah Powell, aka Boyfriend, performs her "rap-caberet" at Jazz Fest, 2019

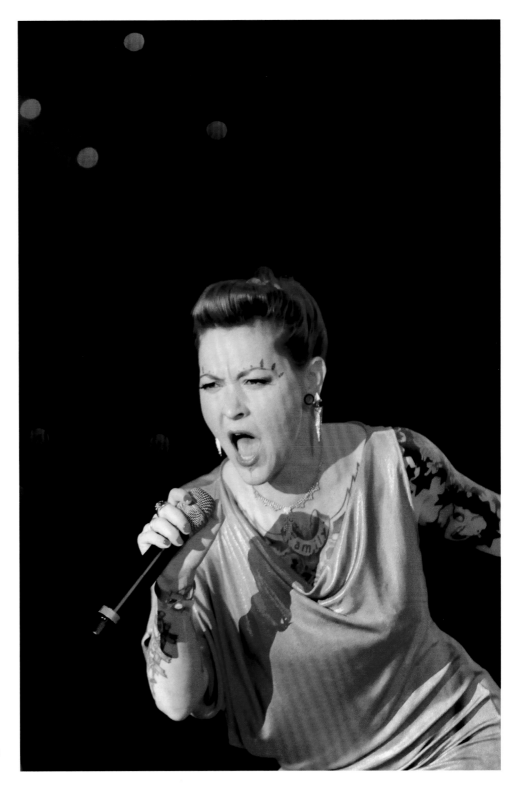

Meschiya Lake performs at
the Big Easy Awards, 2013

Vodou priestess Sallie Ann Glassman
during a hurricane protection ritual, 2005

CAREERS BUILT ON DREAMS

Entrepreneurs, Businesswomen Follow Uniquely New Orleans Paths

KATHY FINN

I t is hardly surprising that Sallie Ann Glassman chose the business of helping others as her life's work. Having spent much of her childhood tending her seriously ill mother, she developed caring instincts at an early age. What is more startling about her career is her chosen profession: Glassman is one of New Orleans' foremost practitioners of Voodoo.

As the owner of a shop called Island of Salvation Botanica in the city's modest Bywater neighborhood, Glassman has for many years dispensed potions, talismans, and advice to help people cope with stress or psychic pain. Her remedies range from "uncrossing" tinctures and negativity-banishing washes to prayer beads and chicken-foot fetishes—all tools of Haitian "Vodou," as the religion is known in its homeland.

Glassman spends each day serving those in need, either from her shop or in their homes, where she customizes remedies to suit the individual. And she says she is happy to have found a calling that is "life-affirming" and fulfilling.

"One of the healthiest things about Vodou is that it seeks balance among the varied spirits who represent forces of nature and psychological principles," says the soft-spoken Glassman.

Though she could have opened her shop in the French Quarter or another spot where tourists likely would have flocked through her door, Glassman, with the help of her husband, chose to support her own neighborhood by

developing a community resource center in the building where her shop is located. She dubbed it the New Orleans Healing Center, and today it offers a range of services, entertainment and a comfortable gathering spot for Bywater residents.

Glassman is among the many women of New Orleans who built careers by following their dreams. Rather than feeling discouraged by the fact that women in Louisiana typically earn considerably less than their male counterparts, these women simply focused on finding fulfillment and helping others in the process. Ironically, their efforts also enabled them to secure a comfortable lifestyle.

Take Trixie Minx, for instance. No, that's not her "real" name, but rather the identity that this former professional ballerina adopted when she decided to pursue a new career—as a stripper. Her name was Alexa Graber in 2001 when she suffered an ankle injury that ended her ballet career. The accident launched her on a search to find new pursuits that might help improve her self-image. Despite having developed extraordinary strength and grace of movement as a ballerina, she had come to realize that she harbored deep insecurities about her body.

A trip to Paris, where she saw the famed dancers of the Moulin Rouge, opened her eyes to the possibilities of a more risqué art form. "To see that performance, beautifully costumed and professionally staged—it entirely changed my view of burlesque," she says.

Back in New Orleans—indisputably a haven for women who like to dance while wearing skimpy attire—Graber began developing new skills and a new identity. She realized that successfully performing burlesque would require a catchy stage name. When a friend came up with the word "minx," it made her laugh, and just like that, she became Trixie Minx. "I think of striptease as comedy-based entertainment," she says. "Maybe I was meant to be a clown, not a dancer."

But her success is no joke. Minx now headlines one of New Orleans' longest-running burlesque shows and spends considerable time staging shows around the country under the banner of Trixie Minx Productions. She says her work has made her feel proud of her body and "true to myself." Equally important, she says, is that she has been able to support other performers by partnering with the New Orleans Musicians' Clinic, which helps artists of all kinds gain access to health care.

Had she taken up residence in any other city, the chances are Minx would never have "found herself" as she has been able to do in New Orleans. And many other local women who have built successful businesses can say the same.

Lauren Haydel is a good example. In 2009, the single mother of three made a bet on her hometown by investing her $2,000 income tax refund into an online T-shirt business that celebrated such beloved symbols of New Orleans as its signature emblem, the fleur-de-lis. Haydel dubbed her business Fleurty Girl and soon found herself expanding into all manner of New Orleans–related merchandise that enabled locals and visitors to tout their love of the Crescent City.

She opened her first retail store in an old shotgun house on Oak Street and made a home for her family in the back of the building. Today, she and her kids reside in more comfortable quarters as she oversees six Fleurty Girl stores that sell hundreds of items designed for people, pets, and homes, all touting New Orleans culture, ranging from Mardi Gras and crawfish boils to a host of local festivals. One of her many T-shirts seems to sum up the philosophy that inspired Haydel's success: "The longer you live in New Orleans, the more unfit you become to live anywhere else."

In a sense, Haydel followed in the footsteps of another local woman imbued with creativity and love of home. Female entrepreneurs were scarce in New Orleans when Mignon Faget launched a ready-to-wear clothing collection in the 1960s. As her fine arts training from Sophie Newcomb College of Tulane University began to assert itself, Faget decided that she should focus on jewelry design.

Today, Faget is, arguably, New Orleans' premier designer of fine jewelry, and many of her works, rendered in precious metals and stones, hearken to New Orleans culture and architecture in the form of fleur-de-lis earrings and pendants; Mardi Gras crowns and king cake dolls; intricate bracelets reminiscent of French Quarter ironworks; and crescent-shaped pieces that echo the city's topography.

Not only have Faget's designs helped carry New Orleans culture throughout the world, but her business success has also enabled her to support her community through her own philanthropic and preservation efforts, which include membership on local museum and art institution boards.

Some of those same boards can claim another of the city's most successful women as a member. Gayle Bird had worked for several decades in real estate and interior design before she met and married New Orleans Saints and New Orleans Pelicans owner Tom Benson in 2004. Fourteen years later, when her husband passed away, Gayle Benson became one of the highest-profile women in professional sports.

In overseeing an estate valued around $2 billion, Benson stepped into her husband's shoes as the leader and public face of both professional teams. She quickly showed that not only would she be an active and engaged owner

of the teams, but she would also be a sensitive steward of her husband's legacy, continuing his charitable giving and committing to fans that their beloved organizations would remain in New Orleans.

"I will own and operate this franchise until my death and do so with the same drive and focus towards success that my husband displayed through his life," she wrote in a letter sent to the National Football League soon after Tom Benson's death. A short time later, after the Pelicans finished a season that took them for the first time well into the championship playoffs, Gayle Benson released another statement promising to "continue to provide the resources necessary to raise a championship banner into the rafters" of the team's home stadium, the Smoothie King Center.

Throughout the history of New Orleans, women have played key roles in helping New Orleans face challenges and move ahead. What many contemporary businesswomen demonstrate is that, in various ways, they are also helping to ensure that the city retains its unique character far into the future.

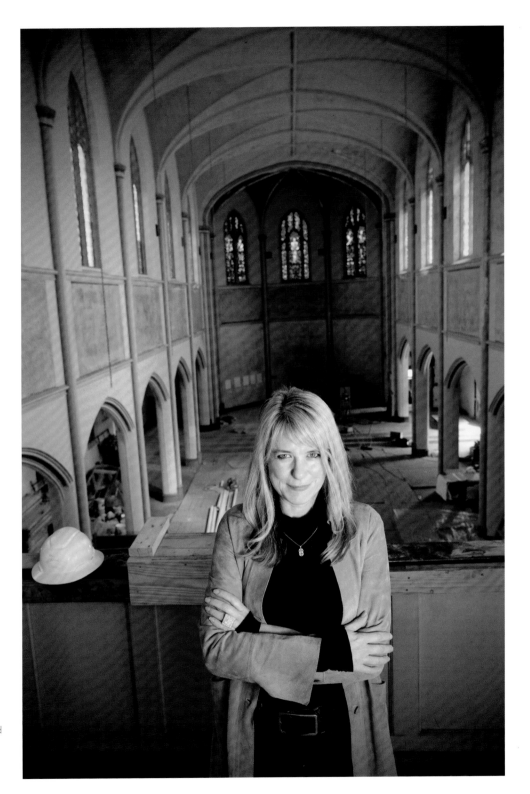

Aimee Hayes turned her passion for acting and directing into her role as producing artistic director for Southern Rep—New Orleans' only year-round professional theater—and led the way to turn a historic church into the theater's new permanent home on Bayou Road, 2018

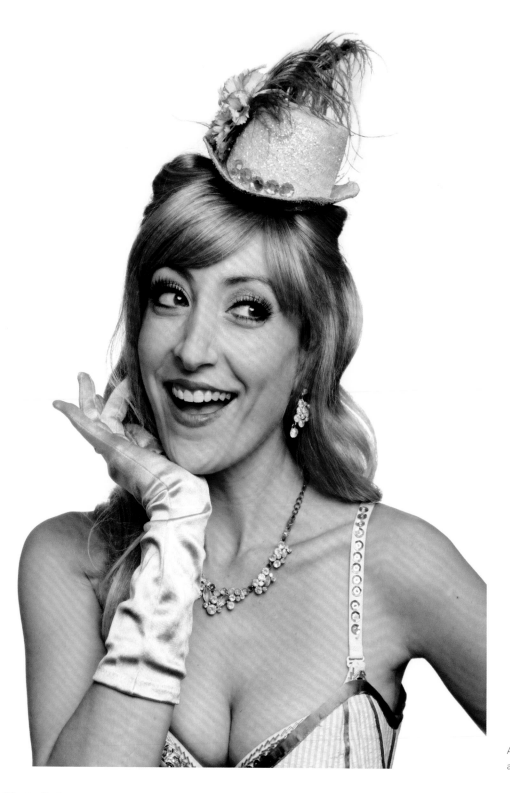

Alexa Graber, better known
as Trixie Minx, 2015

Lauren Haydel, also known
as Fleurty Girl, 2013

Gayle Benson, owner of the
NBA Pelicans and NFL Saints
teams, at her home in 2013

Designer and jeweler Mignon Faget in her uptown office and studio, 2014

Alexa Pulitzer distributes her designs and stationary to more than two thousand retailers worldwide and recently designed the New Orleans Tricentennial logo, 2018

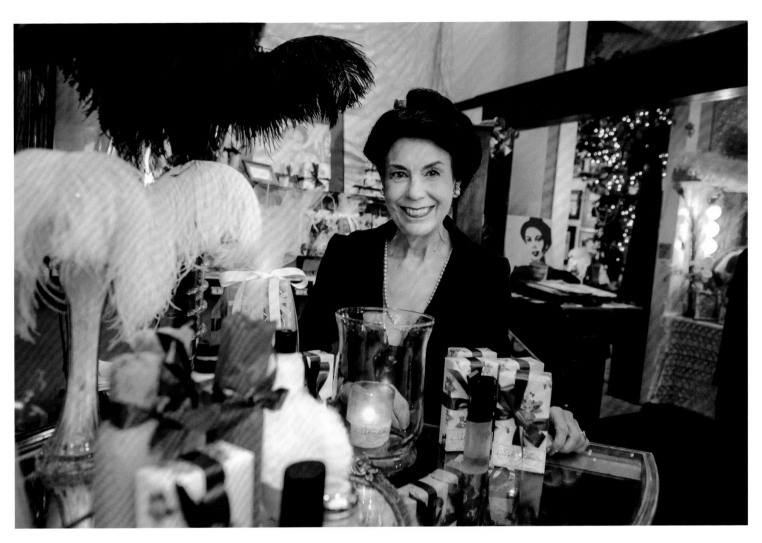

Yvonne LaFleur poses with her signature fragrance in her sprawling namesake boutique in Riverbend, where she has dressed New Orleans women for weddings, carnival balls, and proms for fifty years, 2015

Candice Gwinn, owner and
dress designer of Trashy Diva,
at her uptown location, 2014

Robin Barnes is widely known as the Songbird of New Orleans, but, when not singing, she founded Move Ya Brass, a New Orleans–style dance and music fitness program, which offers classes throughout the city, 2016

Nina Buck opened the Palm Court
Jazz Cafe in 1989 in an old French
Market warehouse, and it has become
somewhat of a traditional jazz center
in New Orleans, celebrating its
thirtieth anniversary, 2011

Claudia Baumgarten, an actress best known for her one-woman show *Wit & Wrath: The Life & Times of Dorothy Parker*, combines her love of preservation, fashion, and theater in her namesake shop Miss Claudia's Vintage Clothing & Costumes, 2016

Bev Church, editor of *St. Charles Avenue* magazine, 2013

SERVING WITH PURPOSE

SUE STRACHAN

Throughout New Orleans' three-hundred-year history, women have played and continue to play an integral part in the city's evolution. Women's roles in society were strictly dictated at the city's beginning, and in some ways still are. But a passion for making the community a better place has always been a guiding force. In many cases, it is women of means, whether it is their family's or husband's money, that allowed them the funds and time to be at the forefront of civic duty.

Micaela, Baroness de Pontalba (1795–1874), could probably be considered the city's first woman philanthropist—and building developer—as she was responsible for the construction of Jackson Square and the Pontalba buildings, creating the iconic visage of New Orleans and, at that time, affordable housing. After a drawn-out lawsuit she got access to her money, which allowed her to create this area of the French Quarter.

There were many other New Orleans women of history who made a difference. One of them was Caroline Merrick (1825–1908), the daughter of a Louisiana planter, who was active in a number of women's clubs and social organizations and served on the board of St. Anna's Asylum, a home for destitute women and children of any religious denomination. She was a women's rights activist and was active in the temperance movement.

Though not born in New Orleans, St. Katharine Drexel (1858–1955), daughter of an investment banker, created a lasting legacy with the $20 million she inherited from her father when she founded the Sisters of the Blessed Sacrament, a ministry focused on educating Native American and African American children. She was also instrumental in founding Xavier College Preparatory High School and Xavier University.

Margaret Haughery (1813–1882), born an orphan and poor in Ireland, turned her life around in New Orleans as an astute businesswoman. Through her fundraising, force of will, and largesse, she opened orphanages throughout the city, and when she passed away, she left her money to those orphanages.

Despite debilitating injuries sustained as a child, Sophie B. Wright (1866–1912) worked as a teacher, establishing free schools and the Hospital for Incurables, for disabled and gravely ill children. She was active in prison reform and the construction of playgrounds. A charter middle and high school, a street, and a park in the Lower Garden District are named for her. She was the first female recipient of the Times-Picayune Loving Cup in 1903, which is given to a person who has worked unselfishly for the community without expectation of public recognition or material reward. She was also a member of the Temperance Union.

Phyllis Taylor was the winner of the Times-Picayune Loving Cup in 2015 and the recipient of United Way's Alexis de Tocqueville Award in 2009. As a champion for education, Mrs. Taylor continues her late husband's legacy to ensure students have the opportunity to receive merit-based, state-paid college tuition scholarships. The scholarship program exists in twenty-two other states and is modeled after the Taylor Opportunity Program for Students (TOPS) in Louisiana. Taylor and the Patrick F. Taylor Foundation have supported the New Orleans Ballet Association, New Orleans Museum of Art, and numerous other arts organizations, nonprofits and schools. The Patrick F. Taylor Foundation also supports our military and law enforcement.

It was her years as a co-anchor on WDSU-TV and learning about the city's charitable scene that inspired Juli Miller Hart to continue to support them after she left. She is the founder of Projects with a Purpose, an organization that researches, scouts, organizes, and staffs customized philanthropic events for corporations and conferences. She has also been involved in committees for numerous benefits.

Ana Gershanik, through her "Nuestro Pueblo" column in NOLA.com | the *Times-Picayune*, keeps the Hispanic and Latino community informed of what is going on in the city. Her involvement in many nonprofits, including the National Council of Jewish Women, the Council on Alcohol and Drug Abuse (CADA), and the New Orleans Hispanic Heritage Foundation, make her a frequent committee chair or attendee at galas.

Beverly Church is an entertaining guru and published author who has also put her talent to work as a benefit co-chair and board member for a number of organizations, including Women of the Storm. She is the editor

of *St. Charles Avenue* magazine, a publication devoted to showcasing New Orleans' nonprofits, and author of *Seasonal Celebrations*.

In 1991, Diane Lyons, a native New Orleanian, started Accent-DMC, an event planning company, using her vast knowledge of local culture, food and music to make each event a world-class New Orleans experience. Seeing a market for bringing women together to empower and encourage them, Diane Lyons founded FestiGals, a weekend-long festival celebrating and inspiring women from all around the country.

Kim Sport is an attorney and a breast cancer survivor. She is a fierce fundraiser and supporter of causes involving breast cancer research. She is a co-founder of Breastoration, part of the Cancer Association of Greater New Orleans, which educates women on the options for breast restoration after a mastectomy and does advocacy work for women's medical rights in relation to cancer treatment. In 2013, Sport began using her legal skills and teamed up with Charmaine Caccioppi, chief operating officer of the United Way of Southeast Louisiana (UWSELA) to lobby for stronger laws against domestic violence, equal pay for women, and an increase in the earned income tax credit. Together, the work of this dynamic duo has been described as a "master class in effective advocacy."

For more than thirty years, Nell Nolan has been chronicling the city's fundraisers, carnival balls, and debutante soirees for the *Times-Picayune*, and now the *New Orleans Advocate*. Through her column, she has set the scene for New Orleans society, but more importantly, she has brought awareness to nonprofits and the good works they do, hopefully getting them new supporters to keep up their work.

Citizens for 1 Greater New Orleans, a nonpartisan, nonsectarian grass-roots organization, was founded by Ruthie Frierson in response to Hurricane Katrina. Frierson and her committee saw a city government with a multitude of challenges ahead and galvanized New Orleanians to set a course for the future of the city. Frierson was awarded the Times-Picayune Loving Cup in 2006.

Anne Milling was a recipient of the Times-Picayune Loving Cup in 1995. When Hurricanes Katrina and Rita hit south Louisiana in 2005, she founded Women of the Storm, a grass-roots organization of Louisiana women who went to Washington DC to educate leaders about the scale of devastation done to the region after the hurricanes. Women of the Storm was also involved in advocacy for coastal restoration after the *Deepwater Horizon* disaster in 2010.

Who doesn't know Margarita Bergen? A bon vivant known for her many ensembles and selfies, she also plays an important role showcasing the arts

community with her monthly Round Table Luncheons and weekly blog "A Toast to New Orleans" which documents the social scene. It isn't a party unless Margarita is there, saying her trademark, "Darling."

Her involvement with the National Council of Jewish Women made Flo Schornstein an icon in the community. She is also the reason the New Orleans looks as green as it does: In 1982 after the city cut the budget to the Park and Parkways Department, which she headed, Schornstein was among a group that started Parkway Partners, an organization that ensures New Orleans' green spaces are maintained and beautified.

These are just a few of the women of history who made New Orleans a better place to live and work. The women in this chapter continue this tradition, and because it is New Orleans, each does it in her unique way.

Juli Miller Hart, founder
of Projects with Purpose,
at the New Orleans
Museum of Art, 2015

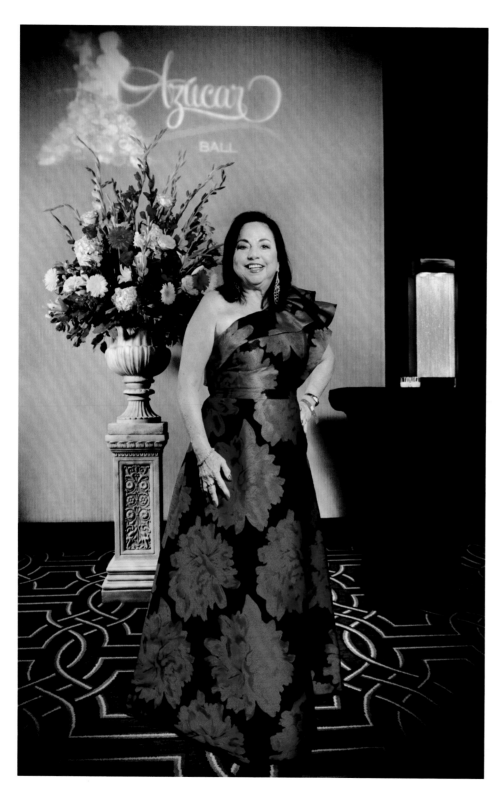

Ana Gershanik, philanthropist and
columnist, at the Azucar Ball, 2018

Philanthropist Phyllis Taylor honored
with the United Way's Alexis de
Tocqueville Award, 2009

Kim Sport and Charmaine Caccioppi at the State Capitol, where they lobby for laws to help women and families, 2018

Diane Lyons, founder of FestiGals, 2015

Nell Nolan, society columnist,
at her home, 2017

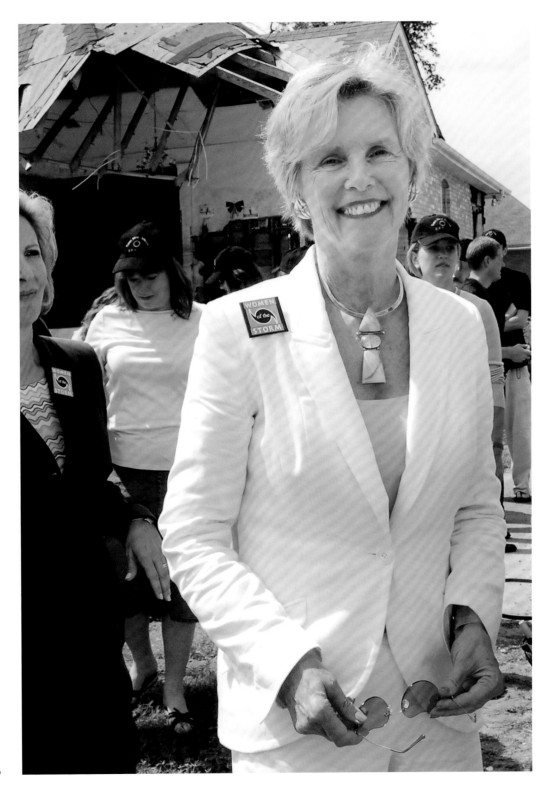

Anne Milling, founder of
Women of the Storm, 2006

Ruthie Frierson, founder of Citizens for 1 Greater New Orleans, at a Garden District fundraiser, 2007

Socialite Margarita Bergen at the
St. Elizabeth's Guild Luncheon, 2017

Flo Schornstein, creator of
Parkway Partners, 2012

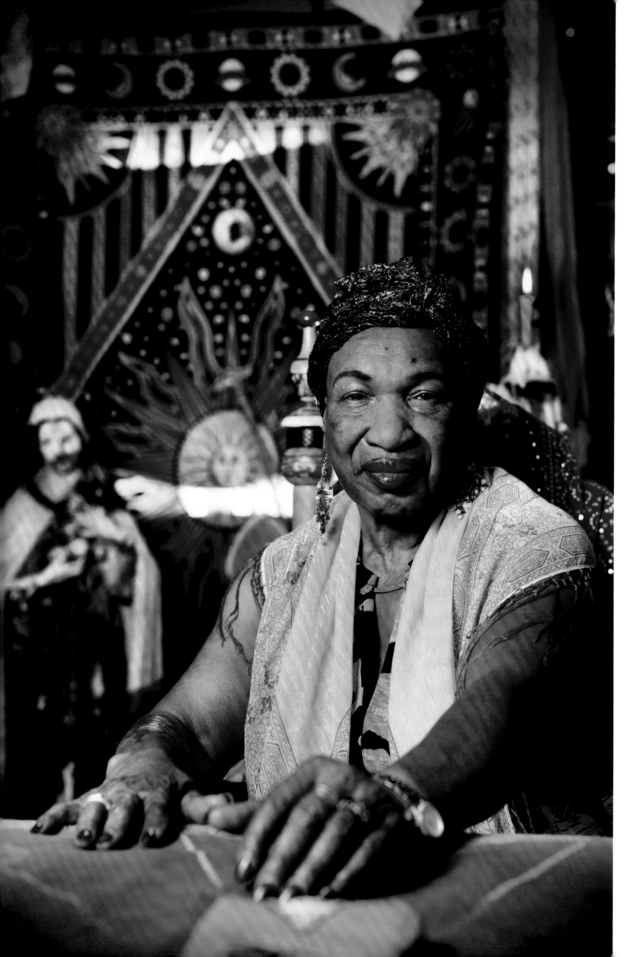

Priestess Miriam Chamani at
her Voodoo Spiritual Temple
on St. Claude Ave, 2018

Saints and Sisters, Psychics and Priestesses

CONSTANCE ADLER

New Orleans may have been founded by men, but when the time came to settle on a name, they looked to a place in France most famous for a young girl, the Maid of Orléans, who saw angels and saints, heard their voices, and followed their instructions to lead France in a pivotal victory over the English. The founders certainly had their own patronage agenda in mind when they named the outpost after the duc d'Orléans. Still, when they brought the name over the sea from the Old World, they also ferried the ghost of Jeanne d'Arc to preside as spiritual mother. If there is any question why New Orleans is such fertile ground for nonordinary reality, then look to Jeanne, who dedicated her life to holding the tension between the visible and the invisible. She claimed her spiritual authority in defiance of the clergy. She declared her visions to be divine truth. She so vexed the male Inquisitors with her sound theological argument that they had to kill her to shut her up. The essential Jeanne is translucent, not of the earth, while her gift for perceiving the uncanny endures. New Orleans snapped into being with the grace of Jeanne's legacy, and the city still calls to her by name.

A statue of Jeanne on horseback, a gift in 1964 from Charles De Gaulle and our sister city in France, stands in the Vieux Carré. This enormous, gilded hunk on Decatur Street portrays Jeanne with a stern, tucked chin, as a stout unimaginative matron. It conveys none of the mysticism that surrounded the adolescent girl. Only the French government could make Jeanne d'Arc look like a bureaucrat. They never treated her right, alive or

dead. Fortunately for Jeanne, she gets the appreciation she deserves now from the Krewe de Jeanne d'Arc. This walking club heaps honor and praise on Jeanne's blessed head with a sumptuous parade through the French Quarter to celebrate her birthday on January 6, the Feast of the Epiphany, and the opening of carnival season. Jeanne resides in her proper home at last.

The descendants of Jeanne appear in many guises in New Orleans. Some wear the high tignon of the once and future Vodou queen Marie Laveau, who, with her soul sister Helen Prejean, stands as an outspoken critic of state-sanctioned execution. Others assume a less public role, such as the Poor Clares who live in the red-bricked convent on Henry Clay Avenue. Mother Magdalen Bentivoglio founded the monastery in 1885 with her sister Constance. They called themselves "the Poor Clares" after Saint Clare of Assisi, who, according to my *Pocket Dictionary of Saints*, "practiced great mortifications and austerities." Clare internalized her vow of poverty with such intensity that she refused to own property, much to the consternation of Pope Gregory IX, who implored her to accept income as a landowner. Clare knew better than the popes, these men of butter (soft, weak, and entitled), and lobbied the Vatican to grant her the privilege of absolute poverty. She also protected the town of Assisi from an attack when she placed the Holy Eucharist on the town's wall and knelt to pray. The invaders retreated. It was the power of Clare's focused intention through the Eucharist that posed an invisible barrier. Years later on her deathbed, too ill to attend mass, Clare was able to "see" the ritual, taking place in the chapel, simultaneously projected onto her chamber wall. Psychics call this talent "remote viewing," and for this miracle Clare became the patron saint of television. She also became the saint of laundry, although my *Pocket Dictionary of Saints* does not explain why she received that honor.

To this day, the nuns who live in the monastery on Henry Clay Avenue do their work in humble terms that Clare would endorse. As a cloistered order, they live in a quiet, inwardly directed community. Secular concerns rarely get past the high brick walls that enclose their home and garden. Their work is to pray. They hold sacred space with their bodies and focus their thoughts. Like Jeanne, they honor the seen and the unseen. You can make prayer requests, and the Poor Clares may direct their intentions toward your benefit. Ask with care because the words have power.

On the other side of town, on Chef Menteur Highway, stands the Motherhouse for the Sisters of the Holy Family, an order of African American nuns that was founded by Henriette Delille in 1842. Now called Venerable, as a prelude to canonization, Henriette was a free woman of color who gave aid and education to enslaved people, in direct opposition to the law. She

also established this community of women religious against Church disapproval. The local archbishop at the time expressed skepticism that women of color could lead a celibate life. That one still rankles 176 years later. The sisters may cherish forgiveness as a holy virtue . . . but forget? Apparently not, since this anecdote persists through generations in Motherhouse lore. Lately, the Vatican has softened its resistance to Henriette's independent thinking. Yesterday's troublemaker is tomorrow's saint. Jeanne knows that better than anyone and stands at the doorway to welcome Henriette. Today, the Sisters of the Holy Family, in the words of their mission statement, work to promote social justice. After they pray in the morning, the nuns open their doors to offer a meal to anyone who shows up hungry. When I consider these sisters' work, I see Jeanne the soldier, hovering overhead and encouraging them to be spiritual warriors—to set right what is wrong. Their first mission is to assert their right to exist.

As a girl who was raised Roman Catholic and then embraced Wicca, I understand prayer and magic to be essentially the same thing: the intentional shaping of consciousness toward a specific goal. In church, we pray to Christ for peace. During a Vodou ceremony facilitated by Sallie Ann Glassman, we seek to stop gunshots on the front doorstep by invoking Ogou. Ritual enacts the thought and carries energy outward to the world. My own bias is that women are uniquely disposed to wield magic because women have a particular genius for navigating the boundary between the visible and the invisible. The knowledge resides in their bodies, where the dark side of the moon becomes manifest each month. Because they were historically denied access to the usual corridors of power, women find their influence in an alternate realm. Only in noncanonical space can women fully grasp their spiritual agency. Again, we see that Jeanne d'Arc exemplifies this ecumenical fluidity. As Saint Jeanne, she is venerated by Catholics for her purity, while the witches also claim Jeanne the seer as their sister in magic.

In turn, New Orleans serves as the cauldron where these archetypal forms simmer together: the saints, the nuns, the witches, the mambo, the priestess of the temple. What rises from the cauldron of their common prayer is a distinctly feminine spirituality—adaptive, nurturing, ferocious. It's a vibrant source that runs through the streets, invisible but real.

Perhaps it was this current that swept me onto the threshold of the Voodoo Spiritual Temple on Rampart Street in 1995. I was visiting New Orleans from my home in New York. Priestess Miriam Chamani invited me to sit with her and tell my story. Back then, I was at loose ends, unsure of my life's direction and hungry for change. Miriam sat as if made of living clay carved from the earth and endowed with electricity. She wafted clouds

of incense from a round metal pan, filling the air between us with smoke, and gazed through the gray tendrils. This priestess appeared to listen with her whole body, not just her ears.

Then she escorted me to an altar dedicated to the loa Papa Legba, whom she introduced as "the road opener," and suggested he might help. I had never heard of Legba, but I gave it my best Catholic girl effort. To kneel in prayer is excruciating. The posture signals a surrender of worldly power and a suspension of skepticism. There is no point in doing it without radical trust. An icon of Legba, a small brown figure, leaning on a staff and smoking a cigar, gazed back at me. He was odd looking to my inexperienced eye, yet I recall reasoning that if I wanted a new life, it would come through an unfamiliar channel.

"Go ahead, ask," Miriam said. I did not say it out loud. Instead, I formed the words in my thoughts. *Show me the way. What is my next step?*

Three days later, I happened upon a perfect house for rent just off Constance Street, in the Irish Channel. The house had my name all over it, literally. The plan came together quickly. I went back north to box up my books and collect my dog, and then I returned to New Orleans. Nearly twenty-five years into this intriguing venture in radical trust, I cannot shake my sense of the uncanny at play. If all things are connected at the subtlest level of experience—and who am I or you to say otherwise—then surely the revolution began with gestures, words, and smoke at the altar. My proper home at last.

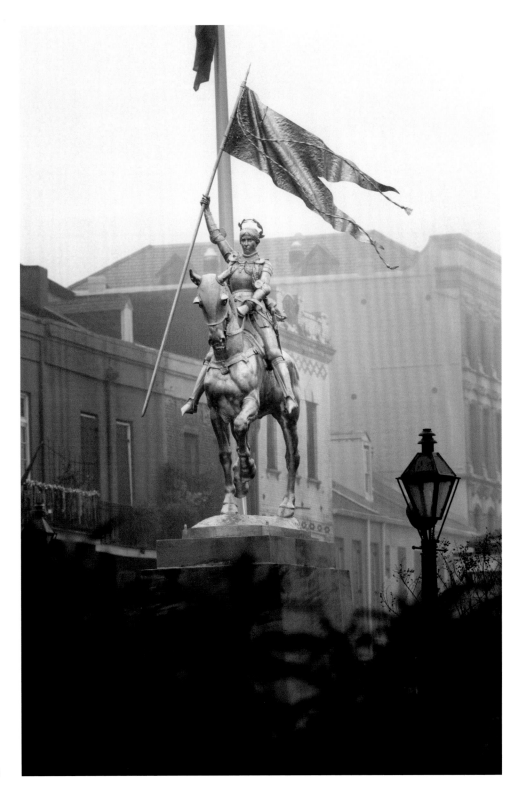

The *Joan of Arc* statue
on Decatur Street, 2018

Sister Leona Bruner's Henriette
Delille pin and crucifix, 2018

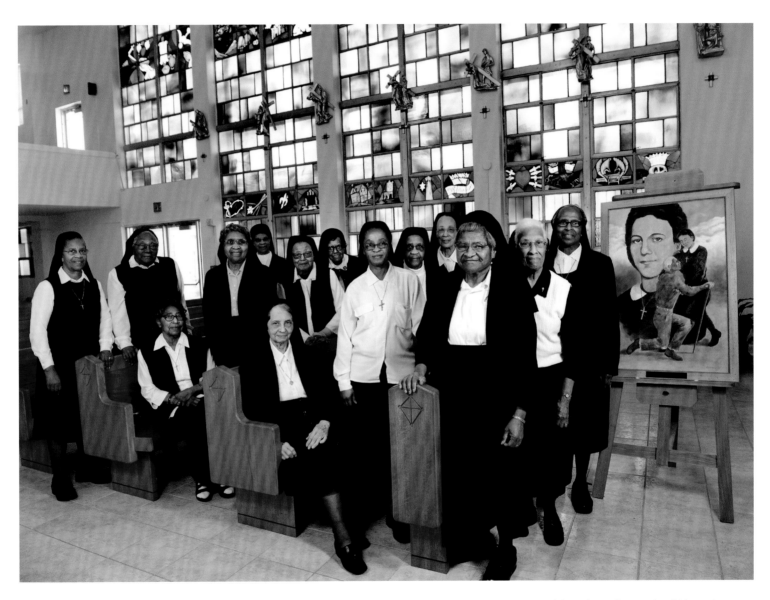

Sisters of the Holy Family, an order of African American nuns that was founded by Henriette Delille in 1842

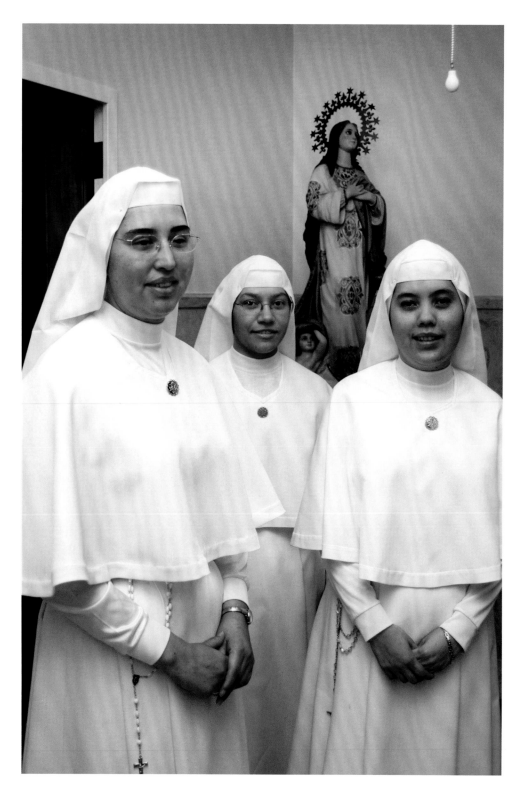

Sisters Silvia Juarez, Alicia Rios, and
Claudia Zamora of the Servants of Mary,
Ministers to the Sick, 2005

Sister Silvia Juarez's rosary, 2005

Sister Margaret Mary Faist of the St. Leo the Great
School hugs student D'Mone Cade, 2015

Mount Carmel student Cristina Hnatyshyn gets a welcome hug from headmaster Sister Camille Campbell on the first day back to school after Katrina, 2006. Cristina tragically died in a car crash shortly after this photo was taken.

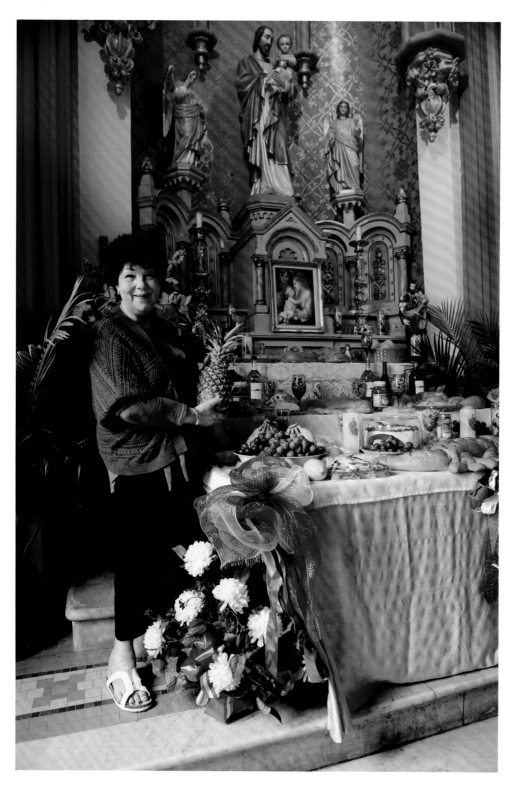

Lillian Moran has been building the
St. Joseph's Day Altars in the Irish
Channel since 1986, many of those
years at St. Mary's Assumption
Church, where she works, 2018

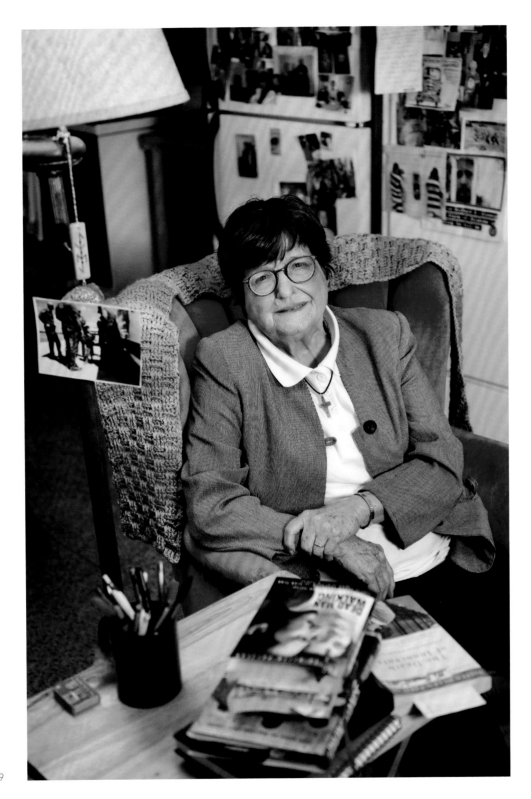

Sister Helen Prejean, a nun known for her work against the death penalty, is the author of *Dead Man Walking*, *The Death of Innocents*, and *River of Fire*, at her home, 2019

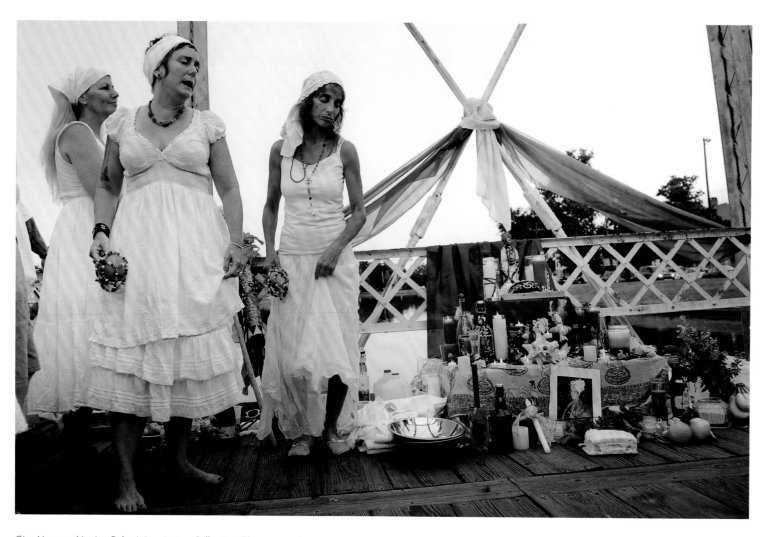

Gina Vega and Lorien Bales join priestess Sallie Ann Glassman on Bayou
St. John for the annual St. John's Eve Voodoo head-washing, 2011

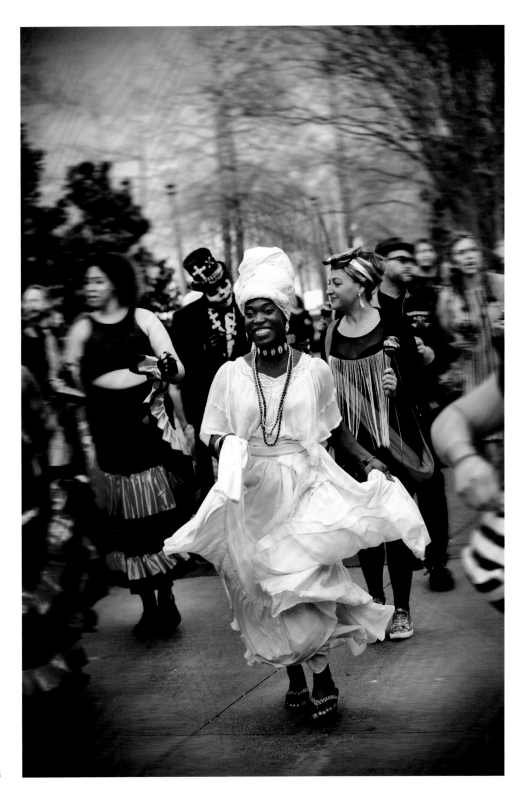

Ifaseyi Bamigbala, a Yoruba priestess, dances during the First Annual Krewe du Kanaval, named for the Haitian word for carnival, and to celebrate Haitian culture in Congo Square, 2018

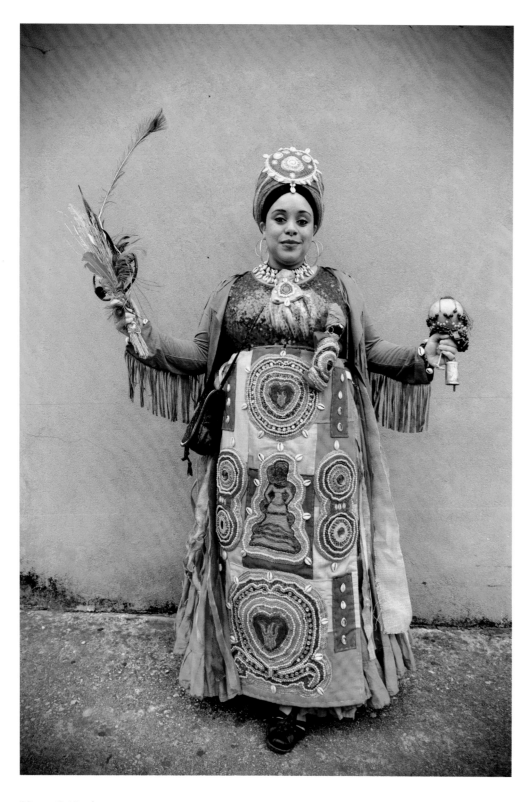

Voodoo queen Kalindah Laveaux,
Super Sunday, Downtown, 2018

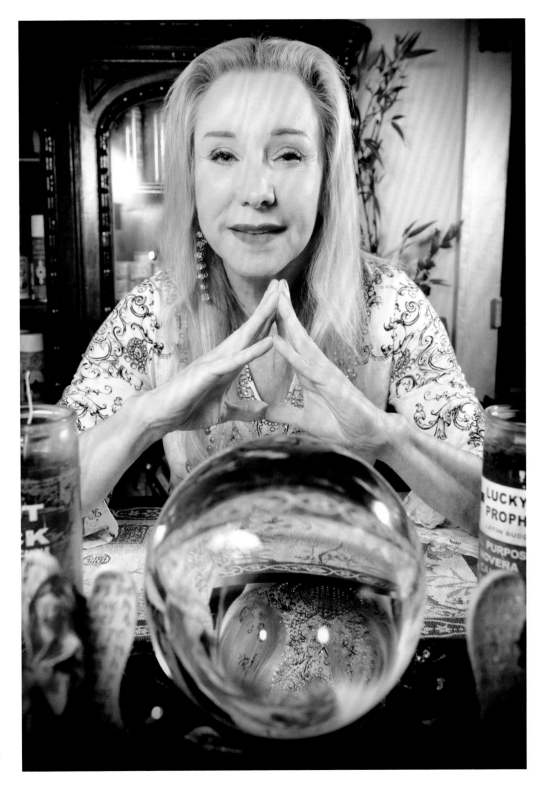

Cari Roy, a third-generation
New Orleans psychic medium,
at her Bywater home, 2018

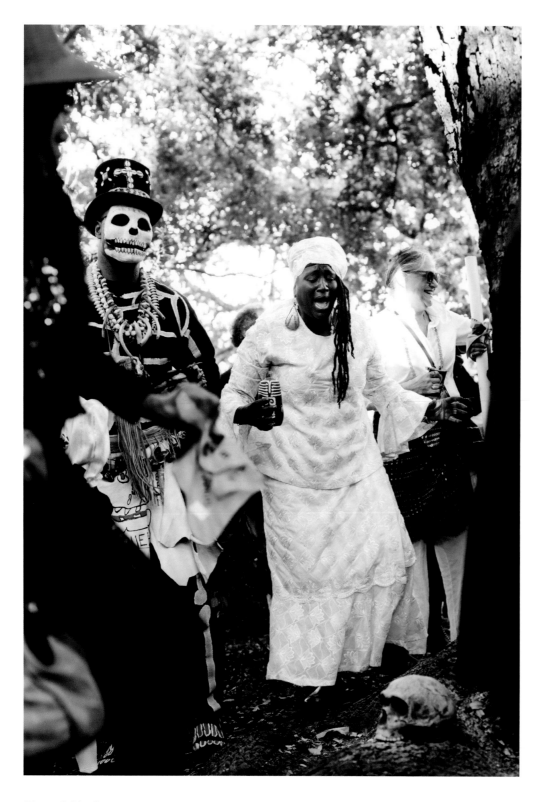

Ausettua Amor Amenkum pouring libations and sending prayers for Royce Osborn's spirit to have a safe passage to the ancestral plane, 2017

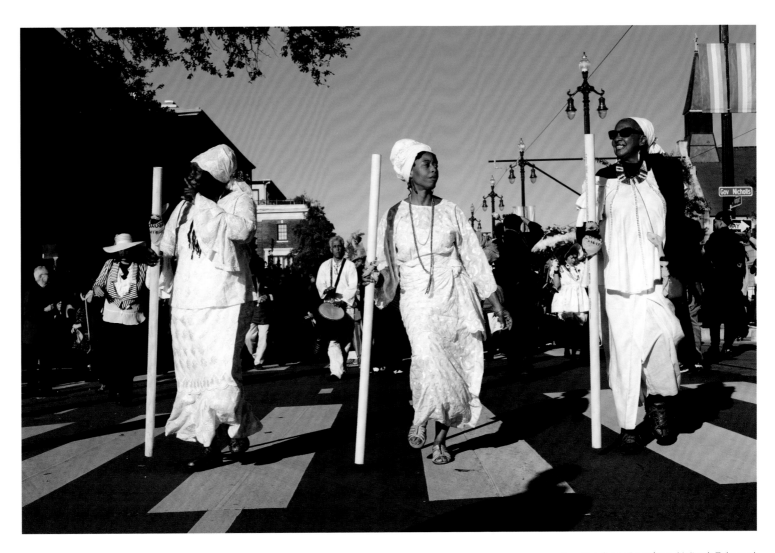

Ausettua Amor Amenkum, Na'imah Zulu, and
Mama Jamilah Yejide Peters-Muhammad lead
a second line to Congo Square during the
memorial for filmmaker Royce Osborn, 2017

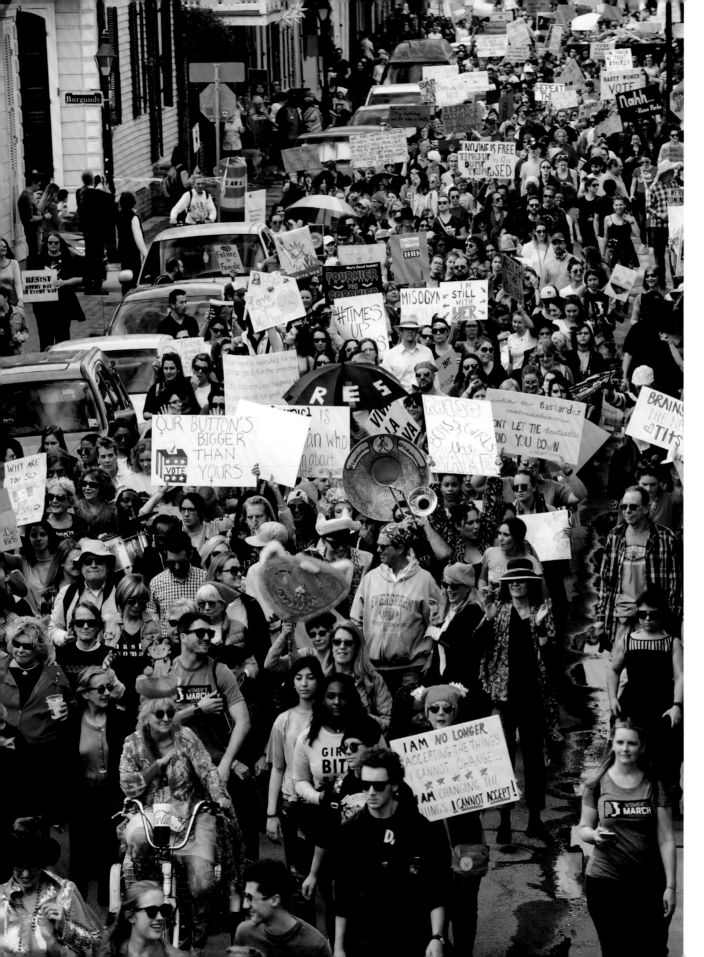

The Women's March, 2018

THE ERA OF WOMEN

A Sea Change

KATY RECKDAHL

Carol Bebelle is a sixty-eight-year old New Orleans activist known nationally for her work at the Ashe Cultural Art Center, which she co-founded with Douglas Redd in 1998. She's humble about her reputation: "I just happen to be in a place where lot of people notice me as an activist. But my sorority is really huge—there are so many other women doing comparable work that we don't see. And the sightline on them is not so clear."

To make her point on a recent morning, Bebelle called off a string of names of women doing invaluable work serving others. "I could do this until the sun went down," she said, describing the thousands of other New Orleans women who spend time in the hallways of local schools and in the city's neighborhoods, looking out for kids who don't get enough attention or the elderly who have no one else.

Bebelle believes that these often-unseen women are at the heart of the current sea change toward what she calls "the Era of Women."

"Women are very much at the core of bringing us together, helping us feel the bonds of connection," Bebelle said. "They're just doing it. And when we see them doing it, we're all reminded, 'I could do something more.'"

STANDING ON SHOULDERS

As a young organizer for the Congress of Day Laborers, part of the Workers' Center for Racial Justice, Chloe Sigal, twenty-four, has learned that

the tradition of resistance in New Orleans is particularly strong. "I feel like we're standing on the shoulders of giants, of black organizers and other people who have always resisted discrimination, criminalization, and dehumanization," she said.

Being a female activist has its barriers, according to Gina Womack, fifty-six, the co-founder and executive director of Families and Friends of Louisiana's Incarcerated Children. "But to be a black female activist is an additional layer. We have to work a thousand times harder. We must dot our I's and cross our T's just that much more. It's exhausting."

Womack has spent many hours in the halls and committee rooms of the Louisiana capitol, trying to get legislators to treat schoolchildren like children, not minimiscreants who get ten-minute daily recesses, a bathroom pass three times a month, and scant access to needed academic supports. "Who I represent is another deafness," Womack said. "It's as though a parent with a child who is struggling is not worth listening to." The inequities that Womack sees today are enduring.

During the civil rights movement of the 1960s, white female college students who volunteered in the South invariably got more notice than the black female organizers from Alabama, Mississippi, and Louisiana, according to seventy-five-year-old Doratha "Dodie" Smith-Simmons. Through her older sister Dorothy, Smith-Simmons became involved at age fifteen with the small but feisty New Orleans chapter of the Congress of Racial Equality (CORE). The backbone of the organization was its women: stalwarts like Betty Daniels Roseman, Sandra Nixon-Thomas, Margaret Leonard, Julia Aaron, and several sets of sisters: Oretha and Doris Jean Castle; Patricia and Carlene Smith; Alice, Jean, and Shirley Thompson; and Smith-Simmons and her sister Dorothy Smith-Venison.

Almost without exception, the CORE women were petite in stature and fearless in spirit. New Orleans CORE members were known for that mindset, said historian Ray Arsenault: "There was a moral assertiveness on their part that was breathtaking, really," he said.

Four decades later, young men and women were prominent in Take 'Em Down NOLA's efforts to get the Lee Circle statue and three other Confederate statues removed in 2017. The younger generation walked alongside seasoned veterans like Malcolm Suber and seventy-eight-year-old Reverend Marie Galatas-Ortiz, who had tried to get rid of the statues for decades.

During one particularly heated protest, Galatas-Ortiz walked straight ahead, holding high the cross she wears around her neck. "After forty-plus years, I wanted those statues down," she said. "But the voice of God told me to bring that cross to get through the Confederate flags and the fighting."

Bringing Home a Fraction of What Men Make

Until forty years ago, men in Louisiana were presumed to be in control of joint household property, under what was charmingly called the "head-and-master" concept. That changed in 1978, as the movement behind the Equal Rights Amendment (ERA), pushed to change blatant gender inequities.

That same year, the *Times-Picayune* publisher Ashton Phelps editorialized at length on the proposed ERA, pronouncing that it "has in fact very little to do with equal rights for women" and that, instead, it would "equalize the rights of men in the sphere in which women presently enjoy preferential treatment."

Karen Newton, president of the local chapter of the National Organization of Women (NOW) responded to the editorial: "Mr. Phelps, we are not who you think we are, and the picture you paint of our 'privileges' is not a real one. . . . We make only 58 percent of what men do, and we who are black make even less. If we have a high school diploma, we can expect to earn the same as a man with an eighth-grade education."

According to the 2017 National Partnership for Women & Families, the situation had barely budged. Louisiana had a gender pay gap larger than anywhere else in the nation. Nationally, women earned eighty cents for every dollar that a white male counterpart made. In Louisiana, white women who worked full time earned sixty-eight cents compared to white men, with black women earning only forty-eight cents, Latina women earning fifty-one cents, and Asian women making fifty-eight cents. Studies have shown that, while men may receive raises after they become fathers, mothers' wages stagnate.

At the 2018 Women's March in New Orleans, Andie Saizan, a thirty-seven-year-old software engineer, said that she had found that she needed to team up with men just to get her ideas heard. Plus, she was paid at least $10,000 less than men hired at her level. "I thought it was just part of being in this field," she said. "But then I thought, 'This is messed up.'"

Walking with Allies

J. Mercedes Cardona, a speaker at the 2018 Women's March, looked out at the crowd and was inspired. "I saw beautiful, empowered women. Strong fighters. Ready-and-willing Louisiana girls. And I saw allies," said Cardona, forty-three, the first transgender person to be hired fulltime by the state of Louisiana. She works for the Department of Health as a health-equity specialist, translating materials into Spanish and helping trans people access

healthcare. In 2010, Cardona concluded she could no longer live as a man. "I had to give up everything to live my truth," she said. "I was a very manly man, very hairy. I was hard until hormones broke me down. And giving up male privilege was so hard. Now I'm a woman who is viewed as unequal with men."

Many of the activists interviewed for this chapter also felt motivated in the company of other politically active women.

"When I'm with a lot of women who believe in the same thing, I always get a feeling like I've just come home," said Sandy Rosenthal, sixty-one. Sandy started Levees.org after Hurricane Katrina to show how failed federal levees, not the hurricane, caused the city's catastrophic flood in 2005.

Though Susanne Dietzel, fifty-seven, first found feminism four decades ago, the need for feminist organizing may be even more dire today. She is the executive director of Eden House, which was founded in 2011 and whose mission is to eradicate human trafficking. In early 2018, Dietzel walked the second annual Women's March with her daughter Uma, who was sixteen. There, Dietzel saw a large contingent of other teens and young women, many of whom wore signature pink "pussy" hats and carried irreverent signs like "Why are you so obsessed with my uterus?"

A few months later, as local students planned their response to the massacre at Marjory Stoneman Douglas High School in Parkland, Florida, young women in New Orleans high schools were a big part of the anti-gun-violence walkouts across town. All of this heartens Dietzel, who believes that "the future is in good hands."

Michelle Cox and her daughters,
Fifi and Anderson, participated in
the Women's March, 2018

Carol Bebelle, co-founder of the Ashé
Cultural Arts Center in Central City, 2015

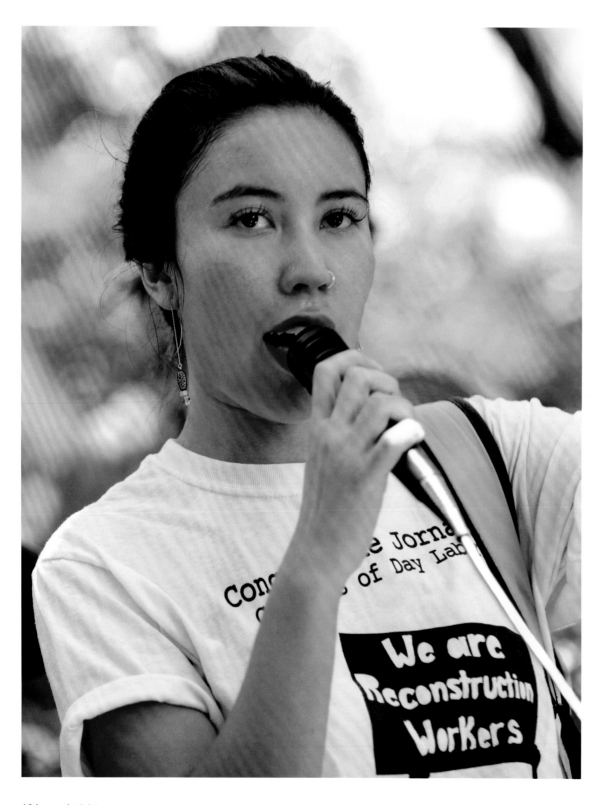

Chloe Sigal, organizer with the
Congress of Day Laborers, speaks
at a rally and march to free families
and abolish ICE, 2018

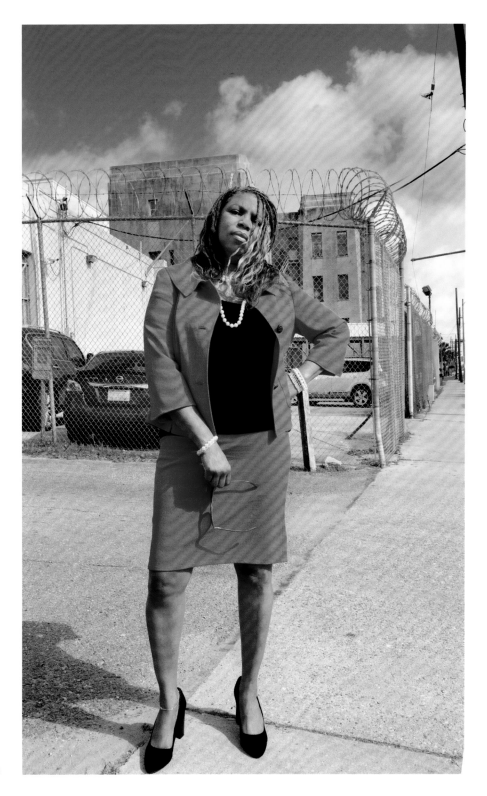

Gina Womack, advocate for incarcerated children, founder of Families and Friends of Louisiana's Incarcerated Children, 2018

Sybil Morial, the wife of the first African American mayor of New Orleans, Ernest N. "Dutch" Morial, spent her career in education and as a community activist, still serving on numerous boards and committees that focus on women's professional advocacy through her memberships with the International Women's Forum Leadership Foundation and the affiliated Louisiana Women's Forum, 2018. She is also the author of her memoir, *Witness to Change: From Jim Crow to Political Empowerment.*

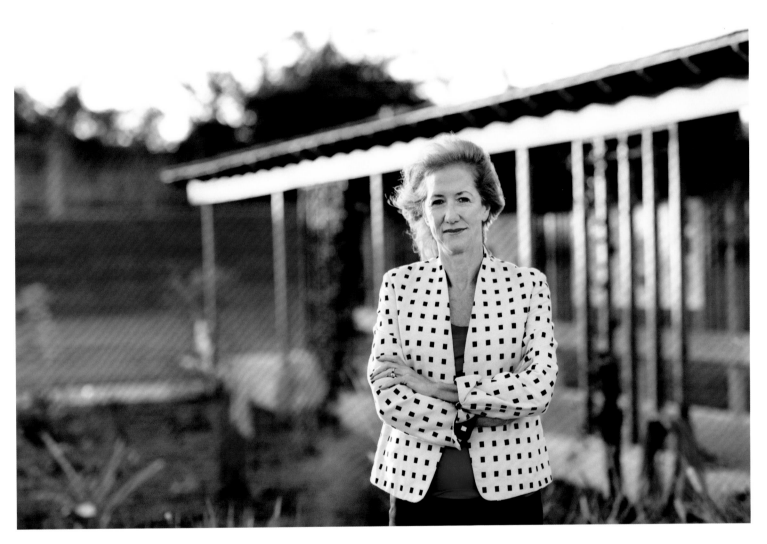

Sandy Rosenthal, civic activist and founder of Levees.Org, an organization created in October 2005 to educate the American public about the cause of the levee failures and catastrophic flooding in New Orleans during Hurricane Katrina, in front of the Katrina memorial at Warrington Drive, 2018

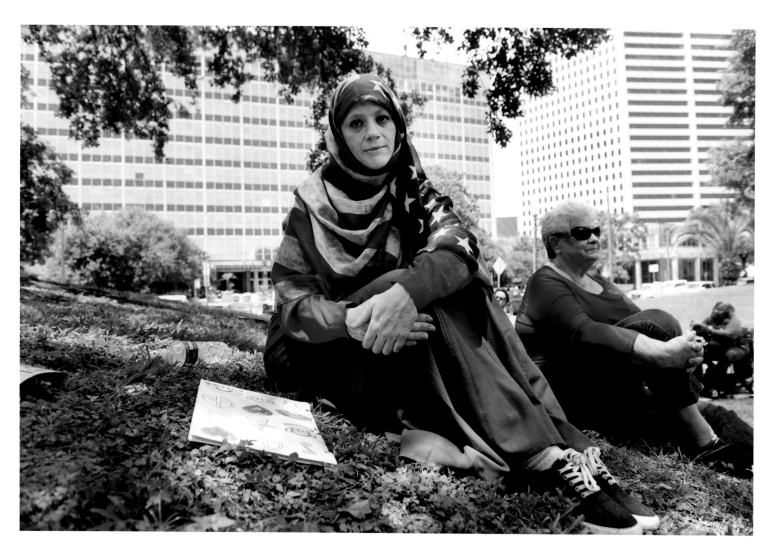

Activist Jenny Yanez, director of *Introduction to Islam/Islam 101 Program* and producer of *NOLA Matters: Islam in the Crescent City* on WHIV FM, at a protest against the Muslim ban, 2017

J. Mercedes Cardona, a speaker at the 2018
Women's March, was the first transgender
person to be hired full time by the state
of Louisiana, where she works for the
Department of Health as a health-equity
specialist and Spanish translator, 2018

Holy Family nuns Sisters Judith Therese
and Marie Elizabeth at March for Our
Lives protest, 2018

Students and faculty from area universities participate in the twenty-fifth annual Crescent City's Take Back the Night candlelight event and march, bringing awareness to sexual assault and domestic abuse at Loyola University, 2016

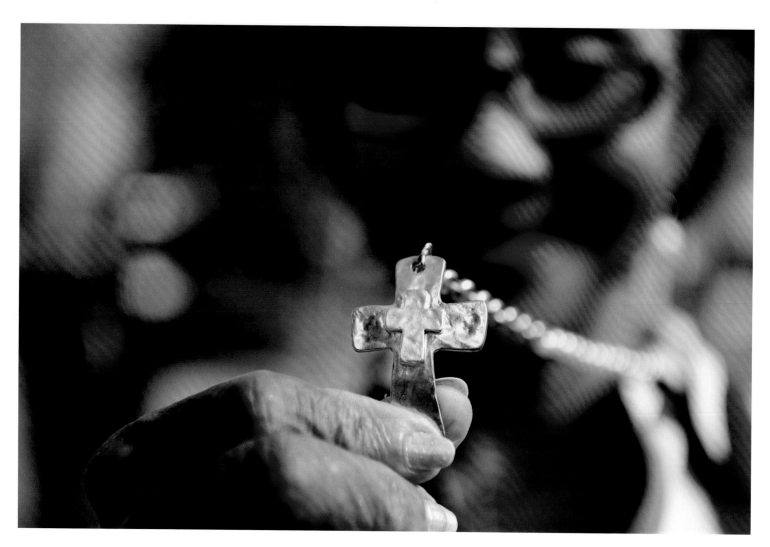

On the day that the Robert E. Lee Confederate Monument
is removed, Reverend Marie Galatas-Ortiz holds up the cross
that she says protected her from the white nationalists she
marched past during an earlier protest, 2017

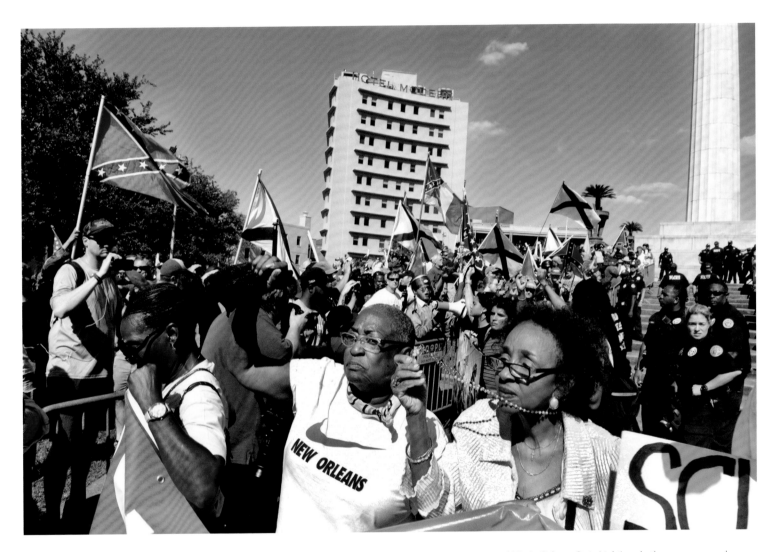

Reverend Marie Galatas-Ortiz (right) and other women march as KKK and white nationalists meet Take 'Em Down protesters at the Robert E. Lee monument, 2017

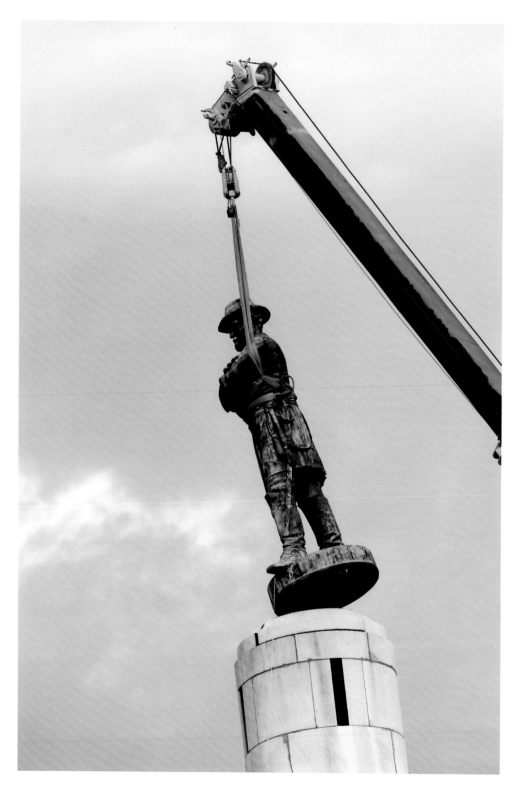

The statue of Confederate general
Robert E. Lee is removed from the tallest
pedestal in New Orleans, May 19, 2017

Angela Kinlaw, educator, activist, and co-founder of Take 'Em Down NOLA and the People's Assembly of New Orleans, watches as the Robert E. Lee monument is removed, 2017

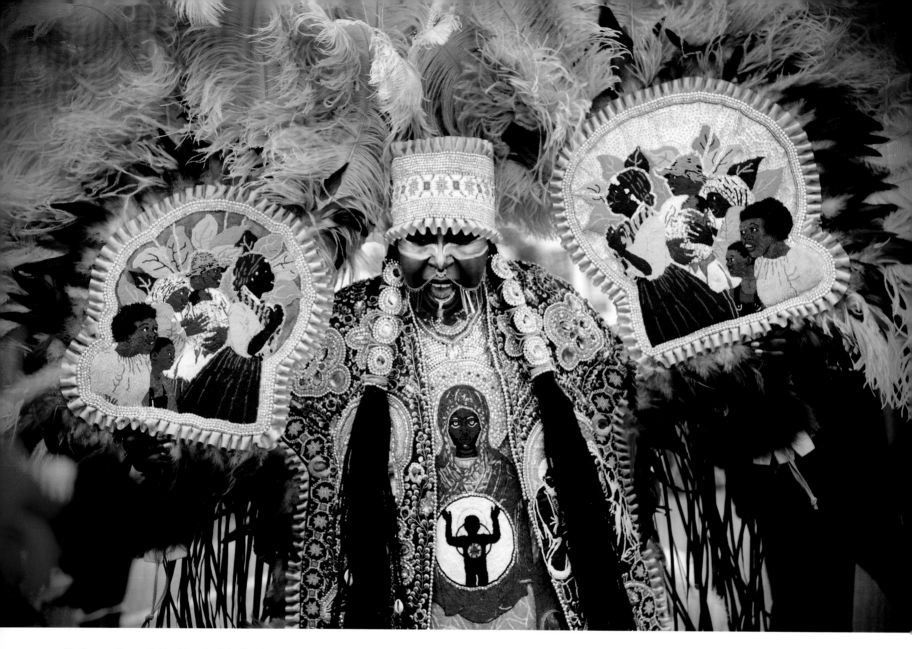

Big Queen Abenaa Rukiya Montsh of the Creole
Wild West, Super Sunday, Downtown, 2018

Unmasked

CHERICE HARRISON-NELSON

My daddy lived his life unapologetically, joyously, and rebelliously out of the proverbial box of conformity. I am his daughter! When I was younger, I tried to rationalize; his way was not particularly civil or the norm. Civil disobedience, in my opinion, can take many forms. I am the rebellious civil disobedient Maroon Queen Reesie. For me, to be a contemporary maroon means not bowing down, being a free spirit, expressing myself on my terms without regard for social norms (neochains); it means being self-actualized and, most important, comfortable with me in this stretched-out skin.

I don't know why I am compelled to record a Cherice Chronical today. Maybe it's the lightning thunderous rainy weather (Oya speaking to me), the half shrimp po'boy with champagne (don't knock it until you try it) or being forced to go through a mental rehearsing of my solo show, *If You Don't Like What the Big Queen Says* . . . without my director extraordinaire sun to direct me. The play is really a series of monologues punctuated by traditional Mardi Gras/Black Masking Indian chants. My Sunday morning performance will focus on New Orleans post August 29, 2005, so I'm planning to include the monologue about my childhood neighborhood. Anyway, as I mentally went through the themes for the show, I pondered how to discuss my suit, which, by the way, is my favorite one to date. I'm very pleased with everything about it, and know I'm pretty, pretty in it—just saying.

I always tell interested, well, and maybe not so interested folks, "I DON'T MASK!" I unmask; it is the art of the strip. I was stripped of my identity through miseducation, geographic location of my birth, interactions with media, Western standards of beauty, and ways of not being my authentic

self. My true identity was cloaked in falsehoods and outright lies. However, the glorious Creator, who I'm certain is a woman with a sense of humor, gave me parents, womentors, an opportunity to study in Ghana and Senegal on a Fulbright Scholarship and this emancipating tradition of, again for me, unmasking.

When I create the self-expressive ceremonial attire referred to as a suit, I have engaged in a radical form of stripping and bearing myself in all of my splendid nakedness for the entire world to behold. It is the rebelling of Western standards of beauty, ladylike decorum of being meek, and the representation of the epitome of African Womaness. Yes, I wrote it, African Womaness, the rebellious act of being free and a reconfigured African in American. My existence is the empirical evidence that I found a way to remember who I am and whose I am. The evidence of my ancestry was not beat or bred out of my ancestors. Although I am an American African, my preferred descriptor, I am a child of Africa from the crown of my head to my pedicure-needy feet, to the very marrow in my bones. Life as me has not been a crystal stair (reference to the Langston Hughes poem "Crystal Stair" intended). As I prepare for my presentation Sunday, I am elated to share the narrative of my suit. First, because I know my dad is saying, "Yeah, ya right! Put something on their minds. You can't go out just to be pretty, just striving to be pretty. No good, no good. You are MY pretty, pretty, nicey nice queen, Guardians of the Flame, ain't no shame," while he tilted his head in that confident Big Chief Donald way.

A little about the suit: a full description is forthcoming in a booklet that will detail the meaning of everything on my 2018 "City of NOLA Tricentennial suit—We Are Still Here." First of all, my dress is a traditional West African design with a shoulder stole. The fabric, a formal Nigerian lace in our color, purple, picked by youth member Scottlyn. Every year, a child picks the color, and each individual can pick a "cut" color. I picked lilac. Why? 'Cause I like monochromatic colors, sometimes. Additionally, every year, my suit has a nod to one of the Orishas. This year, it is to Oya, a warrior. She is the Orisha of thunder, wind, lightning, change/transformation, and the marketplace (thus, my purple purse with cowrie shells). She has other symbols and characteristics (you can read a little about her at http://santeriachurch.org/the-orishas/oya/).

One side of the shoulder stole memorializes the tricentennial, and the other side honors Oya and the Motherland. The suit includes a red, black, and green fleur-de-Afro sewn by my mom and me with a green Peters Projection map center, a butterfly created by the late ninety-four-year-old elder Flag Boy Ike, mermaid charms from Little Princess "You Are My

Sunshine" Ariya, and amulets that represent Oya. My crown has decorated shells and amethyst crystals, while my shoes have a hurricane symbol with Oya's number "9" embedded.

As though all of that does not make me pretty, pretty, my favorite patch is the "Me Too" one. It is an extension of my *It's a Crying Shame* series. My Me Too patch is the continent of Africa, and it reps the many ways the continent has been and continues to be assaulted/raped. My dad said art needs to be responsive, reflective, and reactive. I know I hit the mark with this one. I ain't bragging, but I'm damn proud of the patch. My best yet, but just wait until you see my 2019 suit. Mom hands on deck, and I can't wait to step out the door carnival day, March 5, 2019. Ariya picked the color, and it's supposed to be a secret. Anyway, she picked the bright, shiny silver. I know, there are no bright, shiny plumes. I did my *orisha* research and discovered Obatala. He's the *orisha* of justice, his color is white, and he can have an androgynous presence. My suit will be white with silver, and the main patch will be based on my dad's "Trial of Tears." That patch, done as a surreal creation, depicts the scales of justice historically not being very just for people of African descent. My patch will be a surreal depiction of the scales of justice with a nod to contemporary issues that plague the lives of my people. I absolutely love being at the intersection of art, advocacy, and activism, it is my sweet spot!

Writer's Note: As most of you know, my chronicles are more like free-flowing rants (term I adopted from my womentor Eve Ensler). They are in the moment and unedited. I decided long ago to share them in this form. Every one I edited, I did not share. I want to share this one, so here it is, straight from the queen's soul to you.

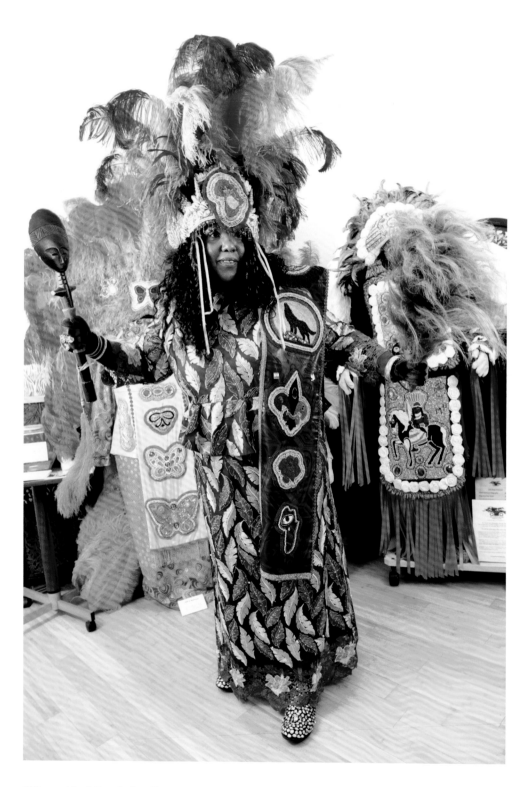

Maroon Queen Reesie, Cherice Harrison-Nelson, member of Guardians of the Flame and founder of the Mardi Gras Indian Hall of Fame, Ninth Ward, 2018

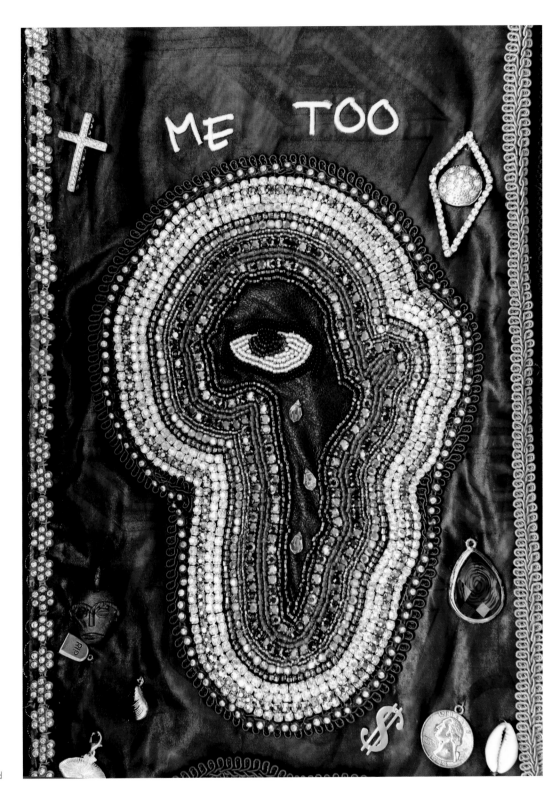

Harrison-Nelson's Me Too
beaded patch of the Motherland

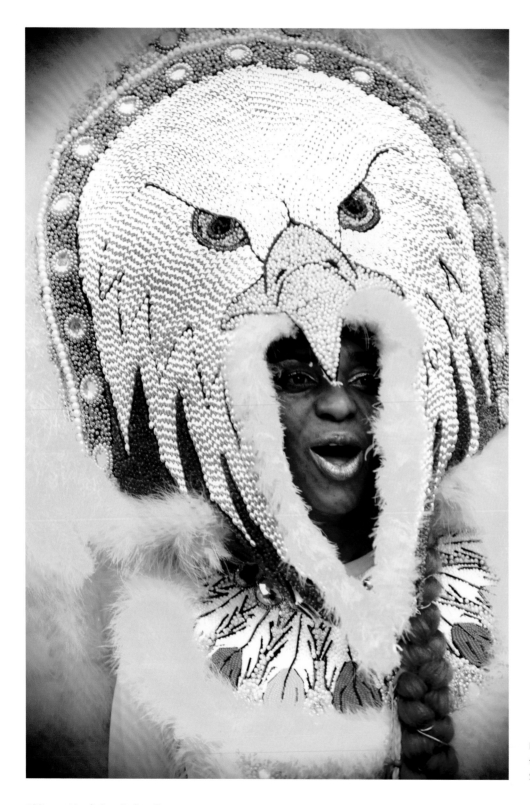

Flag Queen Kelly Pearson of the Creole Osceolas, Super Sunday, Downtown, 2018

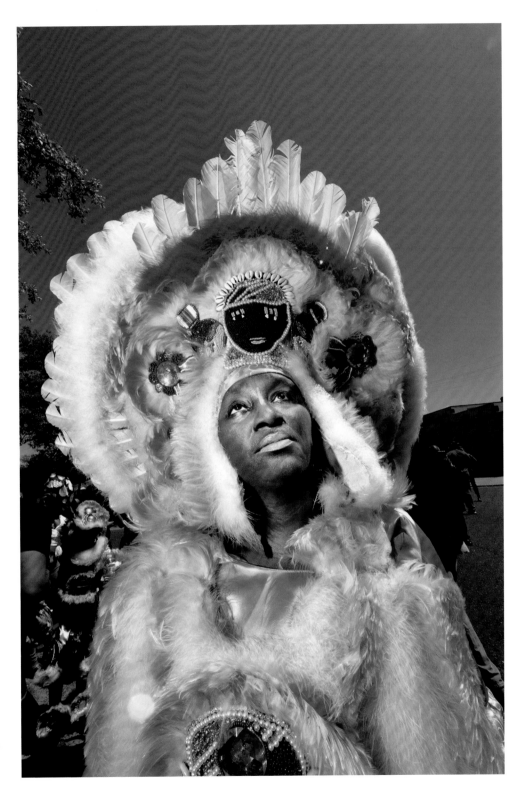

Big Queen Ausettua Amor Amenkum
of the Washitaw Nation, Super
Sunday, Central City, 2018

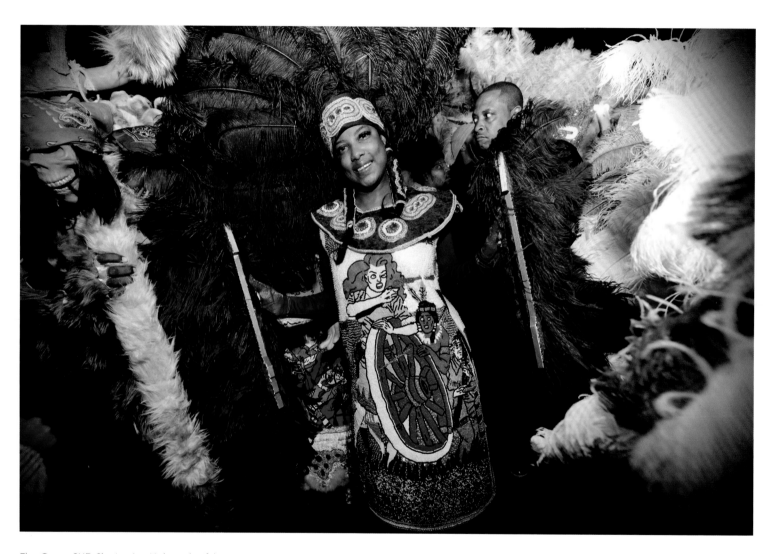

Flag Queen SHE, Sherina Ann Yarbrough, of the
Golden Eagles, St. Joseph's Night, Central City, 2019

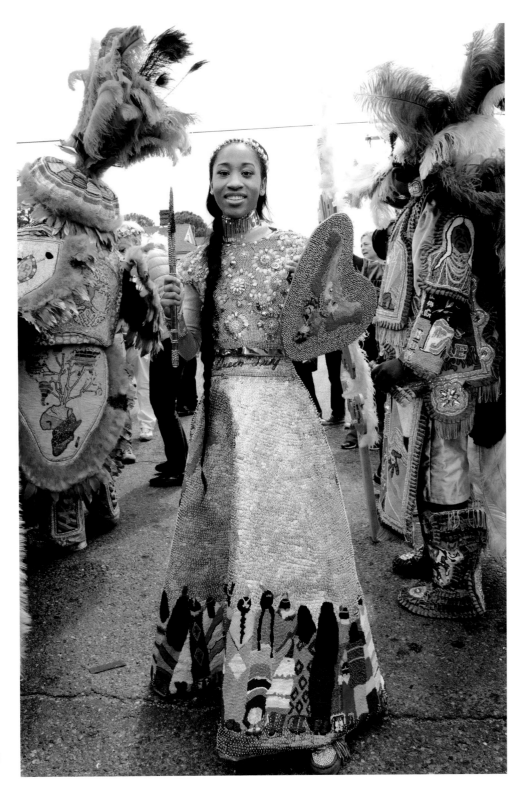

Queen Tahj Williams of the Golden Eagles, Super Sunday, Central City, 2019

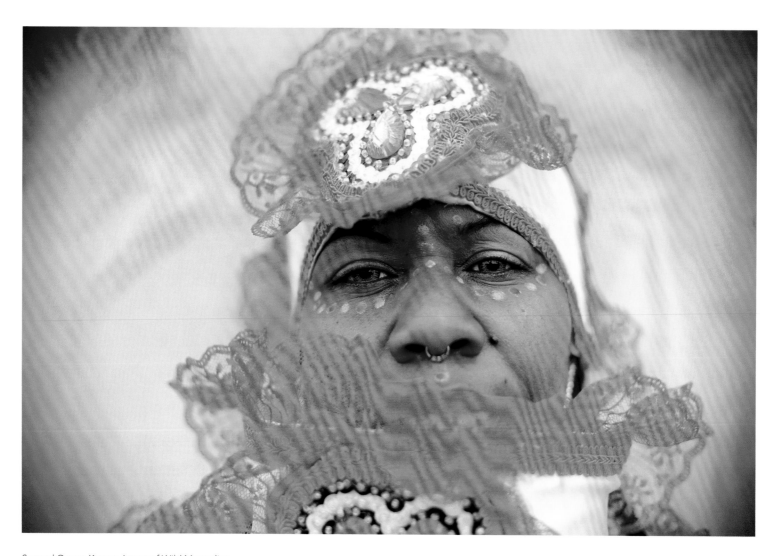

Second Queen Karena James of Wild Magnolias,
Super Sunday, Downtown, 2018

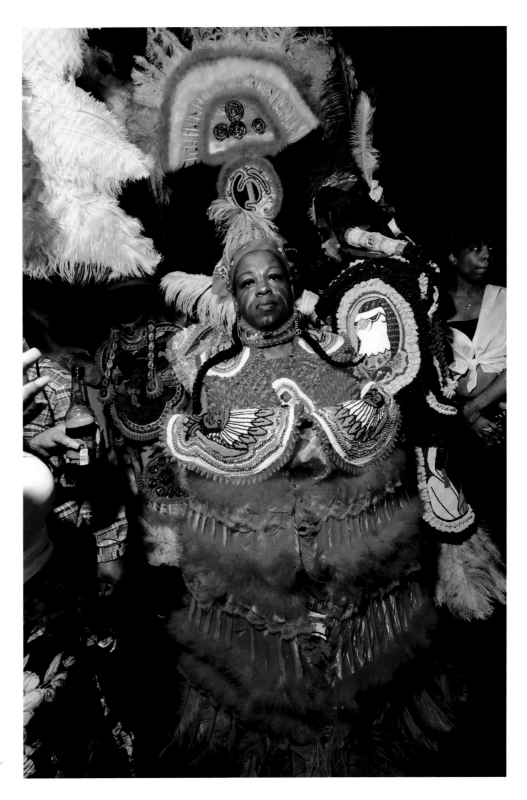

Scout Queen Lashime Brown of
Golden Blades, St. Joseph's Night,
Central City, 2018

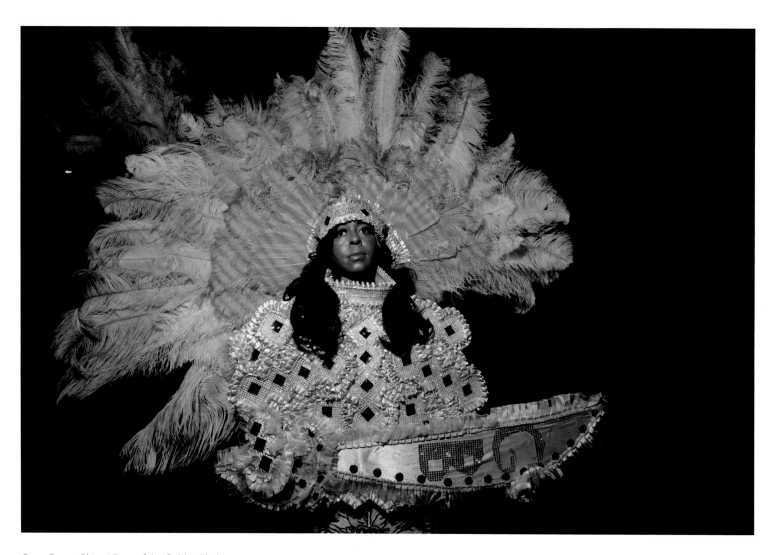

Gang Queen Chianti Berry of the Golden Blades,
St. Joseph's Night, Central City, 2018

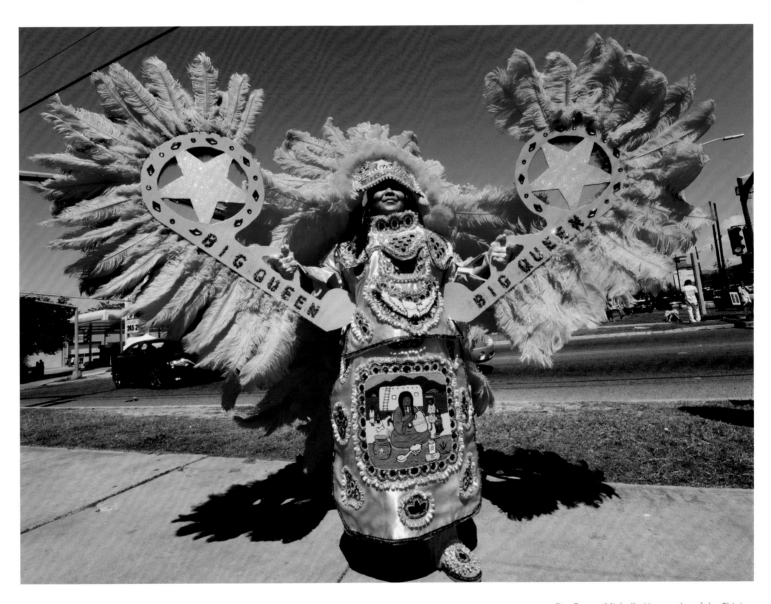

Big Queen Michelle Hammothe of the Shining
Star Hunters, Super Sunday, Uptown, 2018

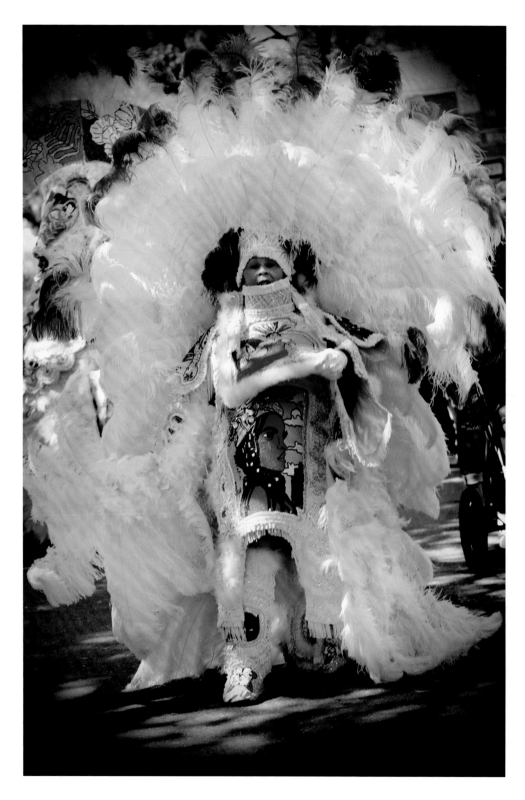

Big Queen "Rita," Laurita Barras
Dollis of the Wild Magnolias,
Super Sunday, Uptown, 2018

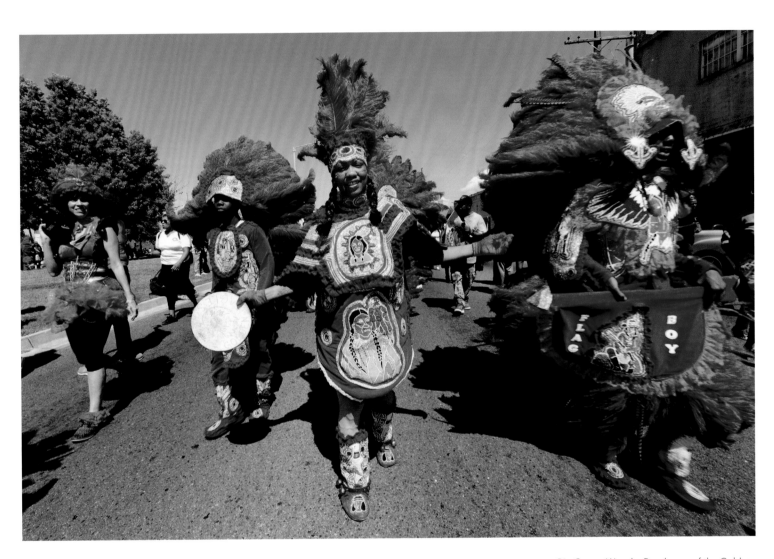

Big Queen Wynoka Boudreaux of the Golden
Eagles, Super Sunday, Uptown, 2018

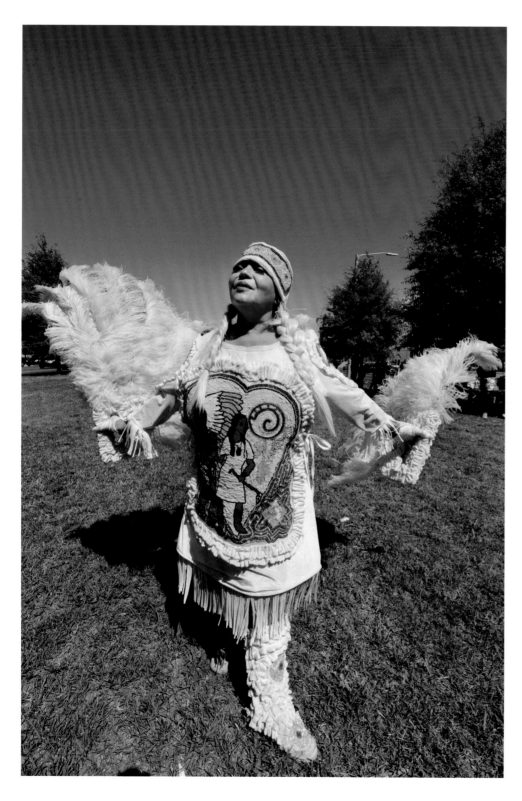

Big Queen Laurie Kaufman of
Red Cheyenne, Super Sunday,
Central City, 2018

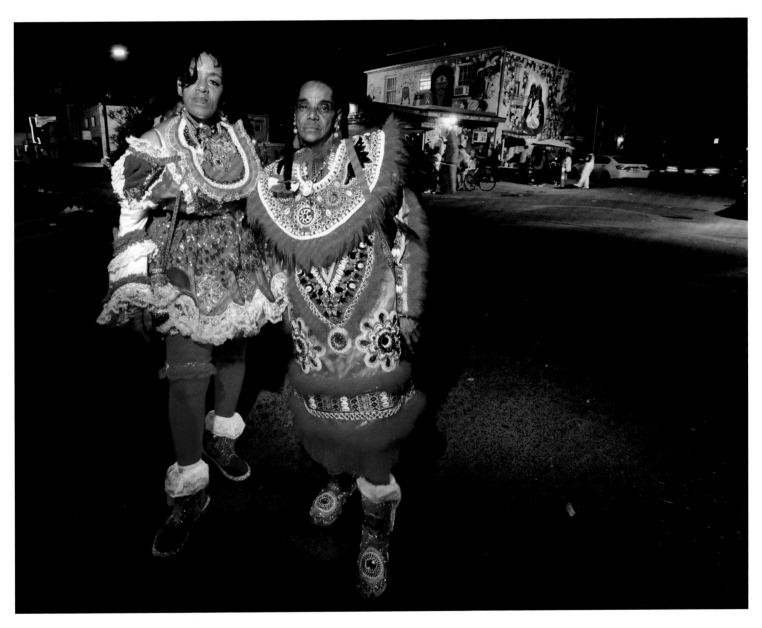

Baby Doll Cinnamon Black, Resa Bazile, and Big Queen
Cutie Kim Boutte, of the Fi-Yi-Yi and the Mandingo
Warriors on St. Joseph's Night Seventh Ward, 2018

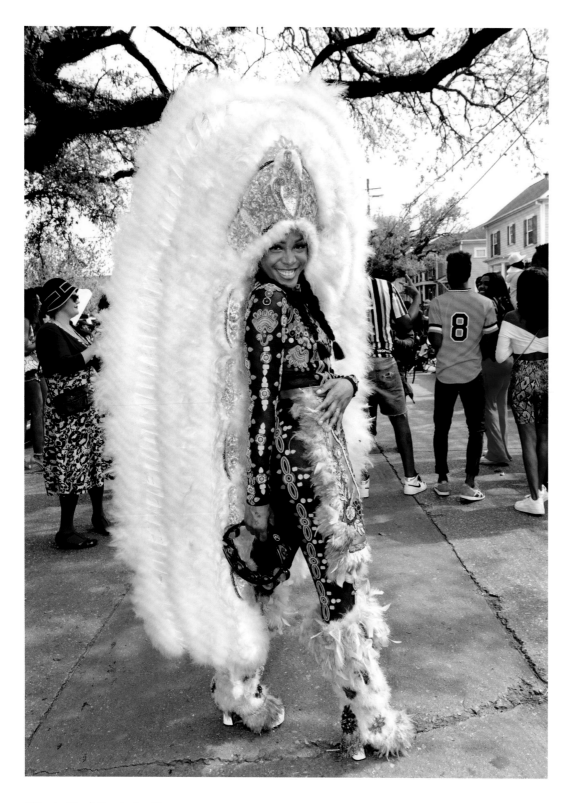

Dawn Richard, an international pop singer and actress, comes home to New Orleans to mask as Queen of the Washitaw Nation, Super Sunday, Central City, 2019

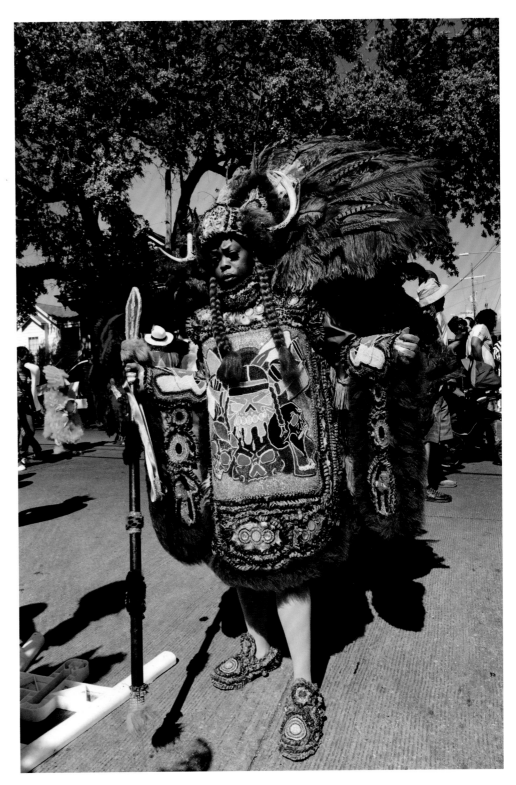

Wild Queen Katrina Carter of the
Creole Wild West, Super Sunday,
Central City, 2018

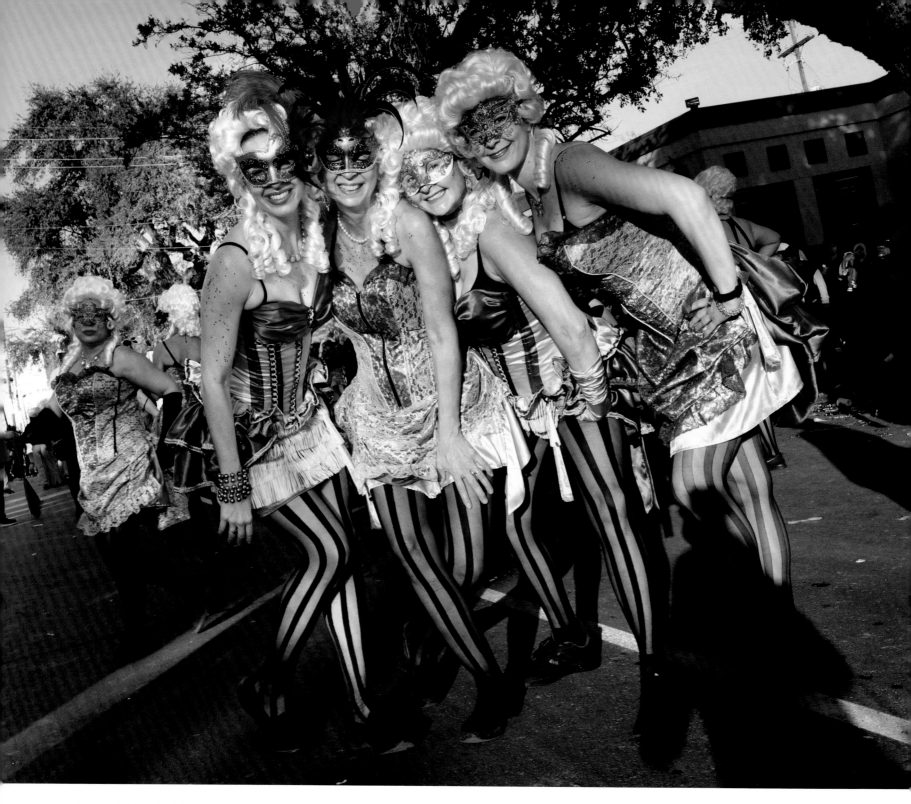

Oui Dats de la Nouvelle-Orleans Mardi Gras Krewe, 2018

GODDESSES, PUSSYFOOTERS, AND BABY DOLLS

Women and Carnival in New Orleans

KAREN TRAHAN LEATHEM

For the past two decades, women have been at the forefront of a sea change in New Orleans carnival. Women, of course, have always been a part of this city's Mardi Gras and the carnival season leading up to it. They have reigned as queens, designed and created costumes both humble and spectacular, and masqueraded on the streets. But in this century, women have been the architects of a new carnival experience. A quick survey of the women's krewes formed since 2000—Muses, Nyx, Femme Fatale, and Pandora—and the growth of older krewes, such as Iris, reveal a new, women-centered carnival. The explosion of marching groups, beginning with the Pussyfooters in 2002, points to another innovation that has become entrenched in carnival—we can no longer imagine a parade without phalanxes of women showing off their choreographed moves. Simultaneously, Baby Dolls, who had virtually disappeared, revived a storied tradition and are now found on Mardi Gras on the side streets in the same neighborhoods as Mardi Gras Indians and Skeletons.

Looking over today's carnival, one might not suspect that men's krewes dominated the past. Until the mid-nineteenth century, New Orleans carnival was primarily informal, with private parties, public masquerade balls, and spontaneous, loosely planned processions. In a vivid description of Mardi Gras in 1835, visitor James Creecy marveled over "men and boys, women and

girls, bond and free, white and black, yellow and brown, . . . in grotesque, quizzical, diabolical, horrible, humorous, strange, masks and disguises." He saw "mermaids, satyrs, beggars, monks, and robbers, parade and march on foot, on horseback, in wagons, carts, coaches, cars . . . in rich confusion, up and down the streets."

Starting with Comus in 1857, but even more so in the 1870s and 1880s after the advent of the Twelfth Night Revelers, Rex, Momus, and Proteus, all-male krewes turned the celebration away from extemporaneous entertainment and toward controlled theatrics. This new direction relegated women to the sidelines. Only male krewe members participated in the parades and the tableau presentations at the balls. They were the only ball attendees who appeared masked and in costume. They also controlled access to the dance floor, establishing a system of "calling out" women for dances; the "call outs" became formal invitations, issued before the ball. Simultaneously, krewes promoted the ideal of the elegantly attired carnival queen; female carnival royalty, queens and maids, were young debutantes, their names printed in newspapers, thus underscoring the social prominence of their families. Meanwhile, the kings were older men. Except for Rex, whose identity was revealed, krewe kings remained secret.

As these new paradigms took hold among the elite, women began to chafe against these restrictions. As early as the 1880s, they began hosting leap-year parties. By custom, leap-year privileges allowed women to assume typical male roles in courtship. In New Orleans, that meant that masked women invited unmasked men to their parties, "reversing the order of things," as one newspaper suggested.

Following this leap-year tradition, in 1896 socially prominent women formed Les Mysterieuses, the first large-scale women's krewe. The krewe reversed the practice of men's clubs: disguised, secretive women in masks invited men attired in formal dress, and the identity of the queen was not revealed, but the king's name was publicized. Les Mysterieuses was short-lived, vanishing after its second ball in 1900 (another leap year), but it opened the door for later women's krewes, including the Mittens in 1901 and Iris in 1917.

Despite widespread financial hardship during the Great Depression, women founded several krewes. Among those were Iridis, Hypatians, Aparomest, Elenians, and Noblads. It was not until 1941, however, that a women's krewe dared to parade on the streets of New Orleans. That year, the Krewe of Venus debuted with a dozen floats illustrating the theme of "Goddesses." Its captain, Aminthe Nungesser, who had founded the Krewe of Iris more than two decades earlier, announced that "it was time for the

women to have the fun of parading, too." While most spectators welcomed Venus, some reacted violently, throwing rotten tomatoes and eggs at the floats. Nonetheless, krewe members were thrilled about their groundbreaking procession, and Venus, undeterred, paraded until 1992. Over the next twenty years, five more krewes followed in Venus' footsteps, including Iris, which first paraded in 1959. The biggest increase in women's parading krewes came between the early 1960s and the late 1980s, with seventeen founded in the metropolitan area. Among the longest-lived of those were Shangri-La, Rhea, Cleopatra, and Isis; the latter two still parade today.

The Krewe of Muses, rolling for the first time in 2001, ushered in a new era of women's krewes. More than six hundred riders, led by captain Staci Rosenberg, introduced the organization's trademark elements: a diverse membership, a satirical theme, and a signature cup featuring a student design. Muses quickly gained a reputation for one of the most stylish parades of the season—one with innovative throws, witty themes that both celebrate and spoof feminine ideals, and creative marching groups such as the Pussyfooters and the Rolling Elvi. The krewe also devotes itself to community philanthropy.

Since Muses, other new all-female krewes have likewise helped breathe new life into New Orleans carnival. First parading in 2012, Nyx has already become the largest krewe, male or female, in New Orleans, with more than three thousand members. Like Muses, whose members present hand-decorated shoes to parade spectators, Nyx awards uniquely festooned purses. The Krewe of Pandora, which began parading in Metairie in 2016, hands out ornate boxes inspired by its namesake in Greek mythology. The Mystic Krewe of Femme Fatale, a predominantly African American krewe that debuted in 2015, is known for its chic mirrored compact throw.

While women's krewes perhaps garner the most attention, the relatively new marching troupes have created a new category of carnival participation. Before the Pussyfooters debuted in the 2002 parade season, parade dance troupes were composed of school-age girls associated with either school bands or dance schools. Camille Baldassar, the founder of the Pussyfooters, remembers that she "just loved the marching bands and the dance teams." "I want to do that," she thought, "I want to dance in the parades." It is this spirit of being a part of carnival that motivates the ever-growing number of dancers who animate the long processions of floats and marching bands. As another Pussyfooter, Kacey Hill, reflected, "Once upon a time, participating in Mardi Gras meant standing on the side of the road and hoping you'd catch something, but Mardi Gras belongs to everyone, and everyone should be able to participate."

Once the orange-and-pink-attired Pussyfooters got the ball rolling, carnival dancing troupes multiplied. The next groups to strut their stuff were the Camel Toe Lady Steppers (2003) and the Bearded Oysters (2004). The embrace of all things carnival post–Hurricane Katrina led to the biggest marching-group growth spurt between 2009 and 2011, with the formation of the Muff-a-Lottas, the Star-Steppin' Cosonaughties, the Organ Grinders, and the Sirens of New Orleans. As we end the decade of the 2010s, it's become nearly impossible to track all of the women's groups, which now include the Amelia EarHawts Cabin Krewe and the Companionettes. The movement has also seen all-male and coed spin-offs, including the 610 Stompers and the Disco Amigos.

Many of these women's carnival troupes place their identities as empowered women front and center. The Bearded Oysters, for example, proclaim their devotion to "sisterhood, fun, art and personal growth" on their web page. Inspired by Amelia Earhart, the famous pilot who visited New Orleans just before her plane disappeared, the Amelia EarHawts (modified for a classic New Orleans accent) carry a banner that asks, "Can You Handle the Turbulence?" The risqué names of some groups boldly reclaim derogatory terms aimed at women or else assert their sexuality.

The largely African American Baby Doll groups, some of whom march in parades, also affirm themselves as women with the right to "walk raddy" on the streets. Like the predominantly white dance troupes, Baby Dolls have organized more than a dozen groups over the last decade and a half. Unlike the parade groups, they claim a longer lineage, tracing their origins back to the 1910s, when a group of African American working-class women dared to take to the streets in baby-doll costumes. Defying the social norms of the day, they danced, sang, and sometimes acted as men did, smoking cigars and flashing money. Later, women and men of Treme and other neighborhoods adapted the practice begun by these tough and playful women, some of them reputed to be prostitutes. The custom waxed and waned, evolving over time but always reflecting the original revelers' spirit, claiming space that the dominant white society was reluctant to grant.

Today, a new generation of Baby Dolls has resurrected the enduring traditions of street masking, chanting, and dancing. Kim Vaz-Deville, whose research and publications not only documented the tradition but became a part of it, writes of the Baby Dolls' "celebration and promotion of the fierce independence of New Orleans' Creole women."[1] Among the Baby Doll groups are the Black Storyville Baby Dolls, the Antoinette K-Doe Baby Dolls, the Nawlins Dawlins Baby Dolls, and the New Orleans Creole Belle

Baby Dolls. Like the dance troupes, their growth has been so rapid that it's difficult to draw up a precise list.

Carnival in New Orleans is about many things. It's about mystery, disguise, performance, hilarity, friendship, family, sisterhood, and brotherhood. It's about art, history, dance, and creating a space apart from everyday life. Sometimes it's about unity, other times, divisions and inequality. But one thing that it's about in the twenty-first century: women. New Orleans carnival is radically different today compared to 1980 and 1990 and even 2000, in large part due to the women who have staked out their ground in this vast ritual.

Note

1. Kim Marie Vaz, *The "Baby Dolls": Breaking the Race and Gender Barriers of the New Orleans Mardi Gras Tradition* (Baton Rouge: Louisiana State University Press, 2013), 6.

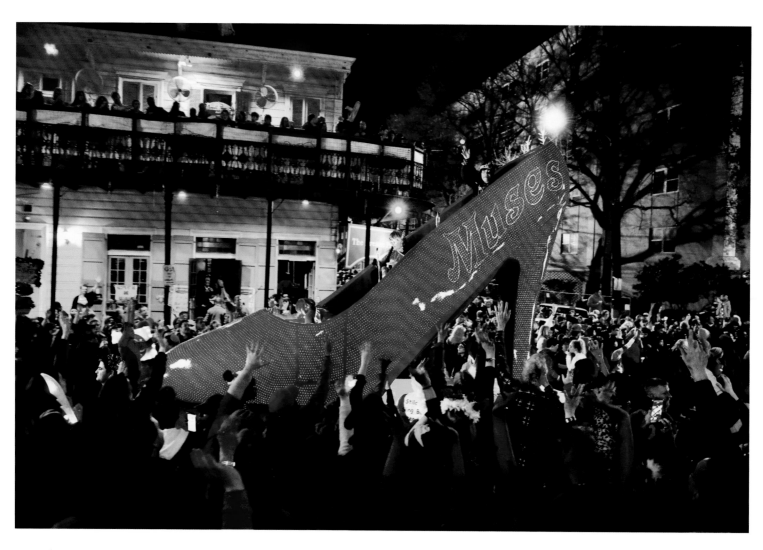

Mayor-elect LaToya Cantrell rides in Muses'
signature shoe float, 2018

Muses rider Mindy Brickman, 2017

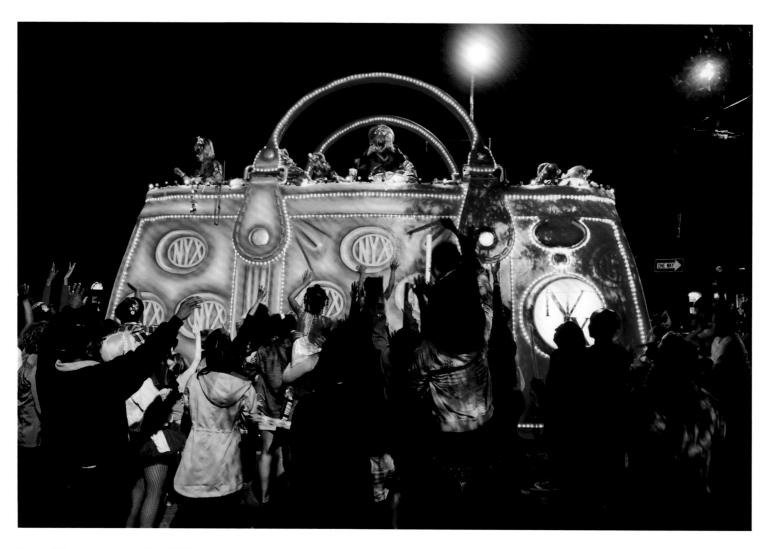

Krewe of Nyx signature purse float, 2017

Nyx rider, 2017

Endymion Queen Victoria Hanzo, 2013

Queen of Iris parade, Renee
Bauchat Kutcher, 2013

The Merry Antoinettes gather for champagne
before marching with the Krewe du Vieux, 2018

Crescent City Dames, known for their hand-beaded corsets in the French Quarter, 2018

The Leijorettes, a marching group in
the Krewe of Chewbacchus, honoring
Princess Leia Organa of Alderaan, 2018

The Amelia EarHawts Cabin Krewe at the
Krewe of Jingle parade, Downtown, 2017

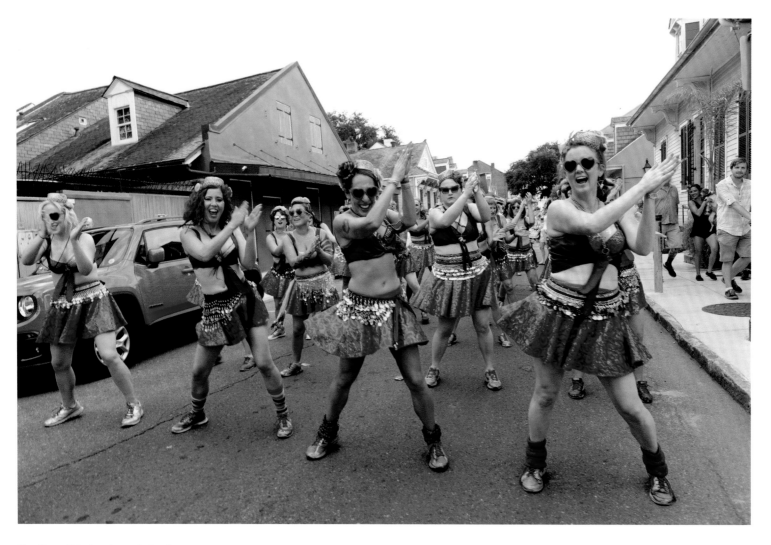

The Organ Grinders dance during the
Southern Decadence parade, 2017

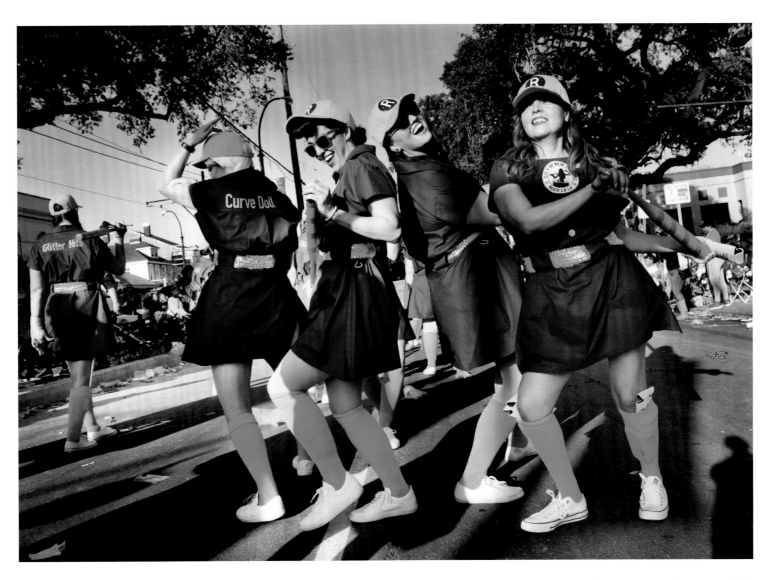

A League of Roux's Own parades, Uptown, 2018

The Bearded Oysters parade, Uptown, 2013

Gia Monteleone of the Camel Toe Lady Steppers,
Uptown, 2018

The Lady Godiva Riding Group,
during the Krewe of Muses
parade, 2014

Martha Pinney rides as Joan of Arc in
the Joan of Arc parade, 2018

Holly "Tamale" Hawthorne during
Krewe du Vieux, 2013

Nakosha Smith, also known as Coco, rides with the Caramel Curves, the all-female African American Motorcycle Club, 2018

The Streetcar Strutters, 2018

The Sirens strut through the French Quarter during the FestiGals parade, 2018

Cindy Williams dances with
the Pussyfooters, 2018

Marissa Leal dances with the NOLA Nyxettes during the Iris parade, 2018

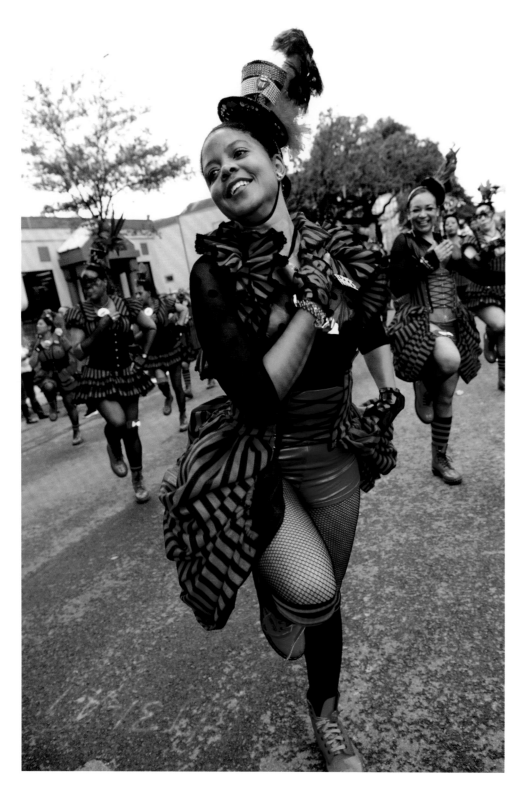

Femme Fatale's Cherchez La Femme
lead dancer Erica Spruille, 2018

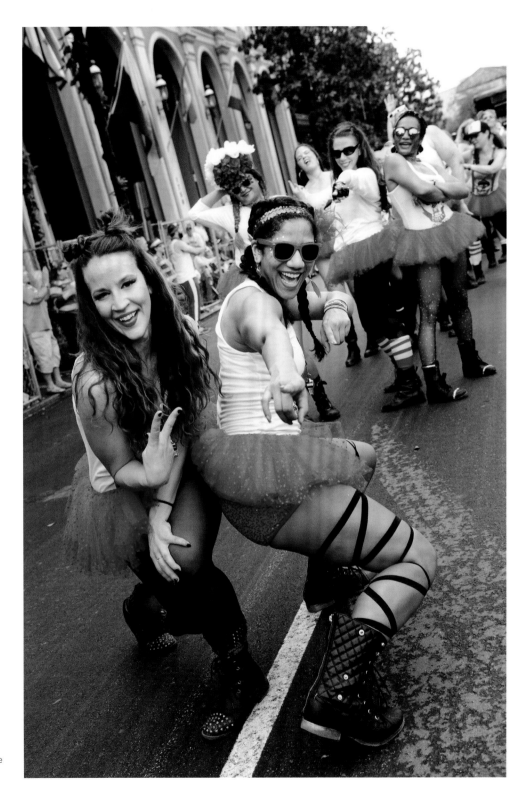

NOLA Cherry Bombs Emily Mabile
and Brianna Nowlin, 2018

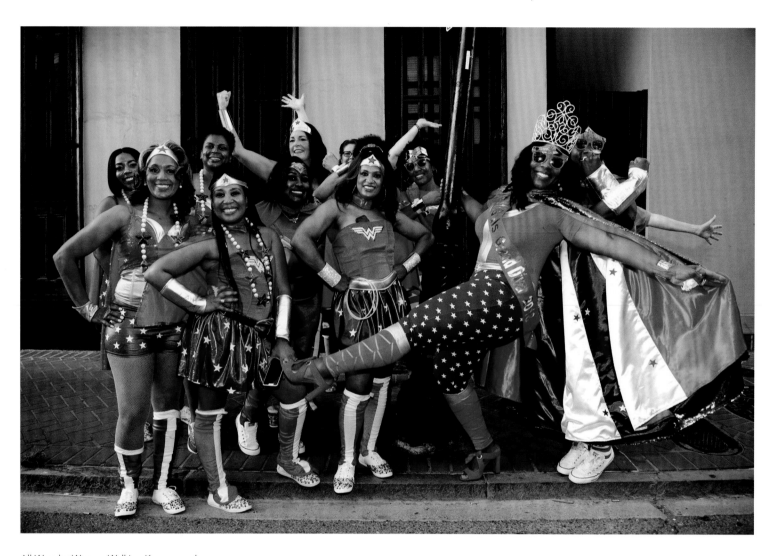

All Wonder Woman Walking Krewe marches
with the Krewe of Chewbacchus, posing here
for FestiGals parade, 2018

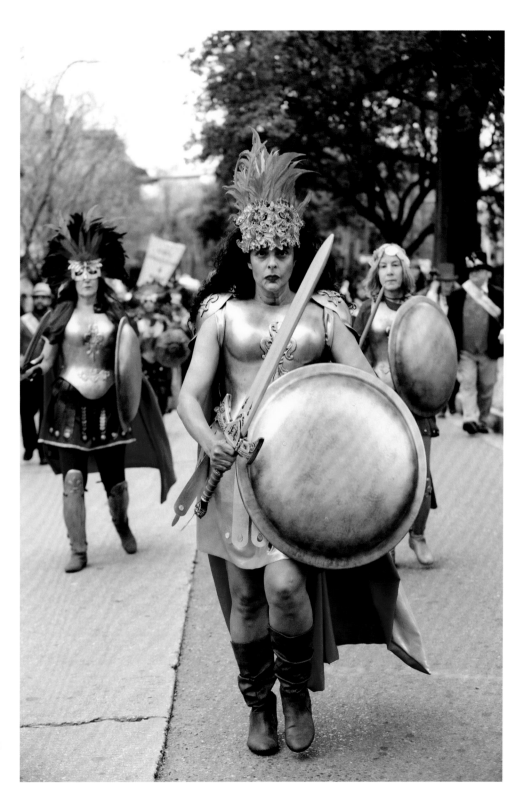

Dianne Honoré, founder of
the Amazons, who honor
cancer survivors, 2018

The Mystic Krewe of People for the inclusion of Unicorns,
Elves, and Whinebots in Chewbacchus (PUEWC), 2018

The Muff-a-Lottas march in the Krewe of Jingle parade, 2011

Baby Doll D'Myrie Smith is the center of attention during a
memorial second line for Aretha Franklin, 2018

A Renaissance of Community-Based Baby Doll Mardi Gras Masking

KIM VAZ-DEVILLE

> Our celebratory culture and accepting nature conceal a city with a troubled soul. Behind the mask of serenity resides a divided city—not just by race, but also social economic demographics which liberates some and traps others in the iron cage of inequity.[1]

Baby Dolls emerged as a fun, fanciful, and critical Mardi Gras performance tradition. The practice celebrated black women's bodies even as it ridiculed the very restrictive norms of femininity that society said they were incapable of attaining. Similar to their masking peers, the black "Indians" and the Skull and Bone gangs, small groups of men who sewed by hand their elaborate attire, maintained suited positions charged with certain responsibilities for the welfare of the group and were the main stars of black Carnival. Along with an all-male parading krewe, the Zulu Social Aid and Pleasure Club, the Baby Dolls were locked out of Mardi Gras. They were not invited to white, elite carnival clubs and were not welcome on Canal Street to watch the spectacular parades. Black men and women made a place primarily for black women or the expression of black femininity at a time when they were visible to whites, only when in a position of servitude.

By the 1930s, women dancing bawdily in short skirts and adopting male signifiers of power such as the smoking of cigars while attired as innocent young girls became anticipated characters each Mardi Gras. By midcentury,

the tradition was on the wane. Early maskers had grown old, and the young did not continue this type of revelry. The local civil rights movement leaders largely frowned on the antics of this style of working-class agency.[2] The destruction of the central staging ground for neighborly fun and communion on Claiborne Avenue scattered former residents to distant parts of the city.[3] Only here or there might one be fortunate enough to encounter someone masking as a Baby Doll deep in the recesses of black neighborhoods until it became a memory of a distant past.

As the world progressed to a new millennium, what was once old became new again. According to Resa "Cinnamon Black" Bazile, in my interview with her on July 17, 2017:

> While visiting with the neighbor elders, Antoinette K-Doe, Lois Andrews, and Merline Kimble at the Mother-in-Law Lounge, the subject came up, and we were all excited. Ms. K-Doe spoke up and said, "If we bring them back, and they come out of my club, they will be the Ernie K-Doe Dolls." This caused uproar from the other women. They felt violated by Antoinette's demand. "K-Doe was not a jazz musician," said one, and the other said, "My grandmother was a Doll during her early years. She was a Gold Digger. She's still one, so that is what I am. That's what I am going to be."
>
> Later that evening we resumed the matter to bring back the Dolls to the street and exchanging ideas about costumes. We decided to ask "Uncle" Lionel's sister, Miriam Batiste Reed, to show us what the dress and bloomers should look like. Antoinette's club was in the Seventh Ward, and we were from the Sixth Ward. We overlooked the tradition of staying within our wards for the moment. That same night, we went to see Merline's grandmother, *Louise* Recasner Phillips, who was about ninety years old. She immediately named her dolls Gold Diggers. We enjoyed hearing her stories of what it was like in her time of masking. I wanted to be a Gold Digger because they knew how to dance; but the K-Does had the business network. I was with both groups and decided to go renegade. Eventually, the groups began to develop different tastes in costumes. I began to put my own special additions. I wanted style.

At first, there were only the Ernie K-Doe Dolls, co-founded by Antoinette K-Doe and named in honor of her late husband R & B singer Ernie, Geannie Thomas, Eva Perry, and their friends and associates such as Gaynielle Neville, Charmaine Neville, Ann Bruce, Prudence Grissom, Sally Young,

Susan Mahaffey, Felice Mitchell Guimont, and Vicki Mayer. There were the Gold Digger Baby Dolls founded by Merline Kimble and Lois Nelson Andrews. Bazile masked with both and founded her own groups. The most lasting one has been the Treme Million Dollar Baby Dolls. Tensions between groups mounted, haunted as they were by the past association of the practice with sex workers, the desire of one group to express more sensuality than the other, and the question of racial integration: Was there a place for white women in this resurgence? For K-Doe and Bazile, early on, inclusion was welcome, for different reasons. K-Doe expressed a mandate for racial inclusion, referencing her late husband's song "White Boy, Black Boy." She made the Baby Dolls part of the activities that generated patronage at the Mother-in-Law Lounge. For Bazile, the reputation of the Baby Dolls and their risqué theatrical performances on the streets on Mardi Gras, made it hard for her to recruit black women, so she welcomed white women into her fold. The Gold Digger Baby Dolls began and remain a tight-knit group of relatives and friends and have not integrated.

Unrelated to the developments in the Sixth and Seventh Wards, Pierre Monk Boudreaux, big chief of the Golden Eagle Mardi Gras Indian gang, wanted to create the cast of costumed characters that had traditionally been associated with black Mardi Gras: moss men, skeletons, and baby dolls. He invited his supporters, largely white, to assume these roles for his recreation of the "101 Runners." A founding Golden Eagle Baby Doll, Michelle Longino, sought blessings and guidance from Antoinette K-Doe, which were generously given and received and shared among the group's members: Kari Lee, Marli Jade Mason, Christy Carney, Erika Molleck Goldring, JennIfyah Johnson, Deborah Vidacovich, Jessie Wightkin Gelini, and Tiffany Lee Williams.

Immediately following Hurricane Katrina, musician and jazz historian Eddie "Duke" Edwards was a mentor to Millisia White, and he suggested to her that she could distinguish her dance company, the New Orleans Society of Dance, with what White termed a signature act called the "Baby Doll Ladies." As the leader of a dance organization, White recruits dancers and holds auditions. Like the earlier Baby Dolls, she sought mentoring from Miriam Batiste Reed and her late brother, Lionel Batiste. White takes great pains to separate her organization from the informal friendship-based groups that are emerging across the city. White and I served as guest curators on the Louisiana State Museum's 2013 exhibit *They Call Me Baby Doll, a Mardi Gras Tradition*, which featured costumes, historic photos, and memorabilia and was based on my book, *The Baby Dolls: Breaking the Race and Gender Barriers of the New Orleans Mardi Gras Tradition*. The national

attention that followed the exhibit brought the Baby Doll tradition back to local public consciousness, and, suddenly, an old custom was being reimagined by scores of women who wanted to experience the pleasure of being seen on their own terms.

Realizing that there are few artistic representations of this little-known yet significant New Orleans tradition, painter Ron Bechet and I placed a call for art for a show, *Contemporary Artists Respond to the New Orleans Baby Dolls*, that was inspired by the Baby Doll masking tradition. Artists in the show created works that made reference to a largely visually undocumented practice dating back around 1912. The show engaged in the important work of educating, preserving, and ensuring the contemporary relevance of this aspect of New Orleans' cultural heritage. The image of a painting of Merline Kimble by Meryt Whittle Harding became the featured art on the commemorative poster for the fall 2015 season of Jazz in the Park, produced by People United for Armstrong Park and located in the Sixth Ward at Louis Armstrong Park. Harding's art was printed on twenty-two New Orleans Regional Transit Authority buses and three billboards. Throughout the fall fest, New Orleans' Baby Dolls celebrated Kimble; her family, who had been in the Sixth Ward for many generations; and the iconic place of the Baby Dolls as culture bearers. The season opened on September 3 with a performance by Charmaine Neville (who masked as a Baby Doll with Antoinette K-Doe), and she lovingly recognized Kimble and all the Baby Dolls with a dedicated song and invitation to share the stage with her. The series closed on October 29 with a second line led by the Young and Talented Brass Band, Sudan Social Aid and Pleasure Club, and all the Baby Dolls who stood in sisterhood with Kimble. The following Mardi Gras, three new Baby Doll groups made their debut: the Black Storyville Baby Dolls, the New Orleans Creole Belle Baby Dolls, and the Wild Tchoupitoulas Baby Dolls. They joined the existing groups: the Gold Diggers, the Treme Million Dollar Baby Dolls, the Ernie-K-Doe Baby Dolls, the Golden Eagle Baby Dolls, the 504 Eloquent Baby Dolls, and the Satin Baby Dolls. Following these new groups came Carol "Baby Doll Kit" Harris' Nawlins Dawlins and Anita Oubre's Mahogany Blue Baby Dolls.

Visibility was raised by the 2013 publication of *The "Baby Dolls": Breaking the Race and Gender Barriers of the New Orleans Mardi Gras Tradition* by the Louisiana State University Press and the 2013 Louisiana State Museum exhibit *They Call Me Baby Doll: A Mardi Gras Tradition*. The importance of adult literacy gained center-stage with the Baby Dolls as they supported each event. Political scientist Monte Piliawsky famously pegged the failings

of the city to provide tangible and lasting gains for creating equity in social relations and economic parity along racial lines on the municipality's "Mardi Gras syndrome."[4] The syndrome arises as an elite few keep control of the wealth and opportunities of the city, sharing it among their friends and associates. They pacify the masses with their tolerance of and tangible contributions to the ritual deviance and controlled chaos of carnival. The conditions that first produced and then hailed the Baby Doll practice back into being must be understood through a "sustained analysis of the imbrication of histories of the plantation, of labor exploitation, of racial oppression and injustice, as the foundation for the contemporary political order."[5] As of 2017, according to Equity New Orleans, a citywide initiative of the office of the mayor, 67 percent of New Orleanians are people of color and constitute a disproportionate number of the poor. Forty-seven percent of the jobs in the city are low paying. Unemployment among African Americas is 14 percent, compared to 5 percent for whites. Twenty-seven percent of African Americans reside in neighborhoods that are high-poverty areas, compared to 8 percent for whites.[6] A recent report from the Institute for Women's Policy Research has confirmed that African American women in Louisiana fare worse in core areas of income, employment, and health care than in any other part of the country except for Mississippi. A majority of black women in Louisiana work in the service industry, and a staggering 31 percent live below the poverty line.[7]

Life under these conditions continues to render the Baby Doll masking tradition an effective avenue of release and of counternarrative. This modern resurgence of an old tradition holds complex meanings for the women currently masking. For Resa "Cinnamon Black" Bazile, who has been masking the longest of current revelers, the pleasure of having all eyes on her is heightened by the amount of sacrifice that goes into preparing to appear on the street in ornate, handmade attire. Rosalind Theodore has transitioned into the tradition from her deep roots in the city's second-line club culture, as well as the jazz and rhythm and blues musical heritage of her family. Janice Kimble, sister to Merline, has formed a group called the Treme Baby Dolls. She and Rosalind dance to enjoy themselves as a break from the tedium of everyday life and also to train the children in the family. They refuse to let the tradition die out. New Dolls such as Dianne "Sugar Baroness" Honoré and Joell "Jo Baby" Lee are paying homage to the hardscrabble life of the women who labored in the "black Storyville," red-light district, masked in short skirts, and were called "baby doll" after the trend of Vaudeville entertainment in which women impersonated little girls for

the titillation of male customers. For others still, the meaning is personal. The custom allows Shannon "Queen Chocolate" Paxton to be the baby doll she always wanted and for her group member Leslie "Baby Doll Lollipop" Dedmond to put a smile on the face of others. Kadrell Batiste's intention to use the tradition to find her own way is crystalized in the name of her group, Renegade Rebel Baby Dolls. Mercedes Stevenson, also known as "Queen Mercy" or "Queen Mert," was born in New Orleans in 1925. She was a queen with the Mardi Gras/Black Masking Indian gang founded by the legendary George Landry called the Wild Tchoupitoulas. The gang's name was taken from the street that ran through their uptown neighborhood. Before masking Indian, she masked for a couple of years with her friends as a Baby Doll. In later life, Stevenson began to mask again as a Baby Doll and offered wisdom to the new generation of Baby Dolls while continuing to support and sustain the Mardi Gras/Black Masking Indian tradition. Carol "Baby Doll Kit" Harris delivered the tribute of the Baby Dolls at Queen Mert's funeral, recalling how she inspired Carol with her words of support and encouragement, reassuring Carol that through her investment in the practice, she "brings the beauty to dolling . . . and represents the beautiful black women of New Orleans."

Traditionally, Baby Dolls masked on Mardi Gras and on the night of St. Joseph's feast, which is an annual observance on March 19. Today, they mask for funerals of cultural bearers (such as Mardi Gras/Black Masking Indians, Skull and Bone Gang members, jazz musicians, and social and pleasure club members). During carnival, some groups participate in Mardi Gras parades and on Mardi Gras, they can be found in the neighborhoods, on preannounced routes, at 45 Tchoup, at Backstreet Cultural Museum, at the Mother-in-Law Lounge, and under the Claiborne Avenue bridge. March through May is a time for masking opportunities at the New Orleans Jazz and Heritage Festival and the "Super Sundays" that occur at parks around the city. In August, there is the annual Satchmo Salute, a second line parade that begins after a jazz mass at St. Augustine Catholic Church during the Satchmo Summer Fest sponsored by the French Quarter Festivals, Incorporated.

The ritual of soulful replenishment is not mere escapism; it is coupled with a growing political analysis and critical commentary available through the women's social media platforms on issues related to gentrification of their neighborhoods, cultural appropriation of the black masking arts, municipal politics, sexual abuse of women, and informed activism regarding stopping the rampant violence against the city's children. The Baby Dolls

invite others into the dance of life. At any given revelry opportunity, a Baby Doll can spot a woman sitting on the sideline. With her Baby Doll sisters, they call her into their circle, place a mask on her face and the handle of an open umbrella in her palm, lead her to the floor, and applaud her impromptu performance. Laughter pervades, the spirit is renewed, and the return to life is emboldened.

NOTES

1. Silas Lee, *A Haunted City? The Social and Economic Status of African Americans and Whites in New Orleans: A Comparison of the 1983 and 2003 Census Data.* May 8, 2003. Available online at http://www.silaslee.com/SOCIAL-ECONOMIC%20STATUS%20REPORT--A%20 HAUNTED%20CITY--FINAL%20Draft.pdf.

2. C. Trillin. "The Zulus," *New Yorker*, June 20, 1964, 41; and C. Trillin, "Mardi Gras," *New Yorker*, March 9, 1968, 138–44.

3. Lolis Elie, Planners push to tear out elevated I-10 over Claiborne, *Times-Picayune*, July 11, 2009, http://blog.nola.com/news_impact/print.html?entry=/2009/07/photos_for_iten.html.

4. Monte Piliawsky, "The Impact of Black Mayors on the Black Community: The Case of New Orleans' Ernest Morial," *Review of Black Political Economy* 13 (1985): 5–23.

5. Laurent Dubois, director of Forum for Scholars and Publics at Duke University, commenting on the December 13, 2017, Alabama senate race, https://twitter.com/Soccerpolitics/ status/940948800176304128.

6. EquityNewOrleans, *The Road to Equitable Government*, 2017, http://www.equityneworleans .org/.

7. Kat Stromquist, "Report: Louisiana One of Nation's Worst States for Black Women," *Gambit*, June 15, 2017, https://www.bestofneworleans.com/thelatest/archives/2017/06/15/ report-louisiana-one-of-nations-worst-states-for-black-women.

Anita Oubre, Resa "Cinnamon Black" Bazile,
and Alana Harris parade as traditional Baby Dolls
through Treme on Mardi Gras, 2018

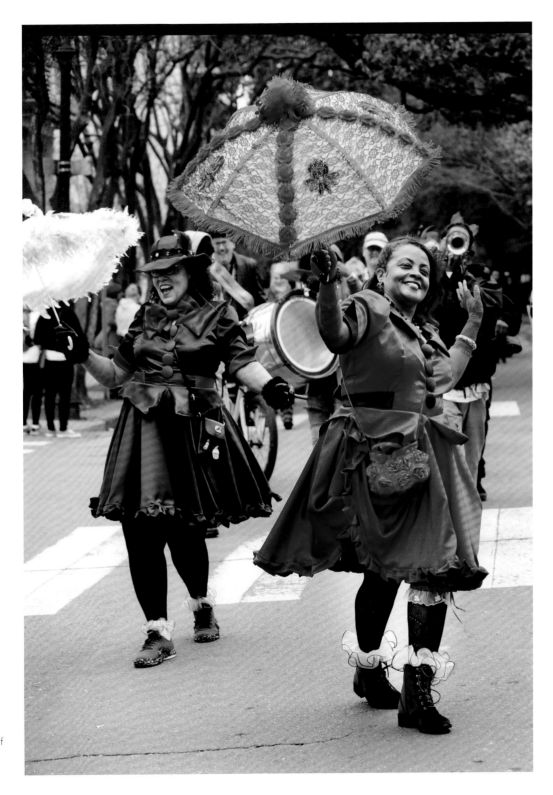

Melanie "Baby Doll Frannie Chanel" Walker and Karen "Baby Doll Rose" Williams dance ahead of the Krewe of Amazons during its inaugural Lundi Gras parade, New Orleans, 2018

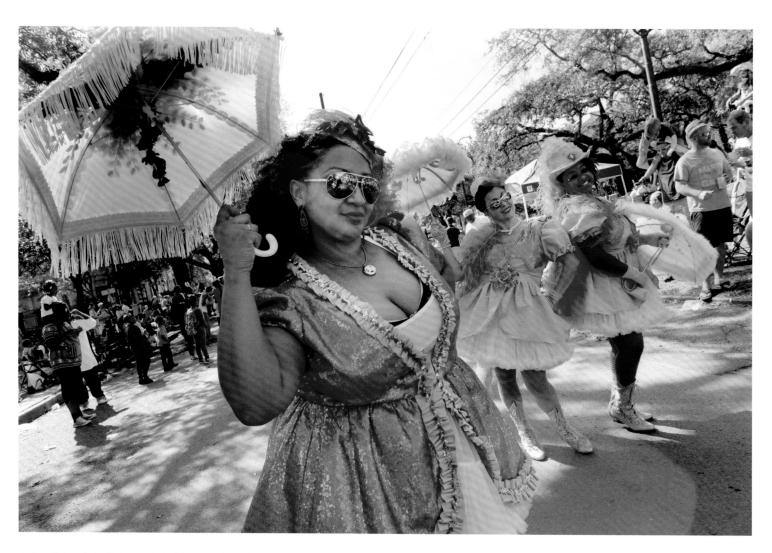

Arsène DeLay, Anita Oubre, and Joell Lee parade as the
Black Storyville Baby Dolls during an uptown parade, 2017

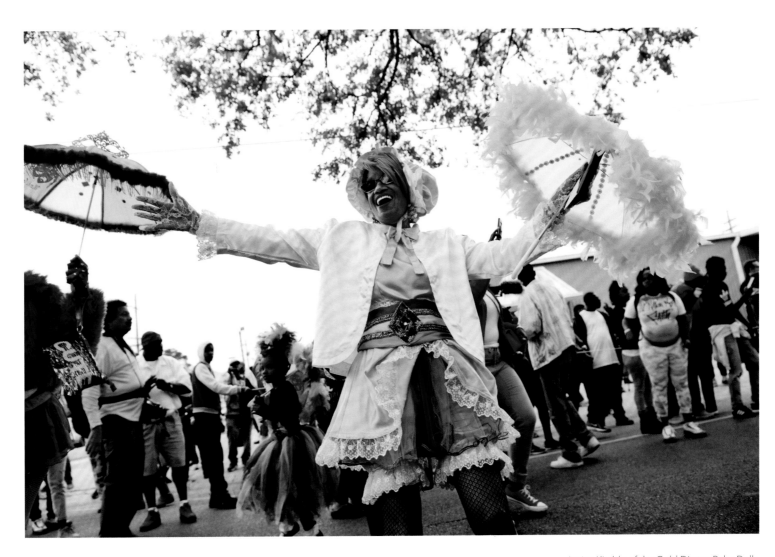

Janice Kimble of the Gold Digger Baby Dolls
dances during Super Sunday, 2018

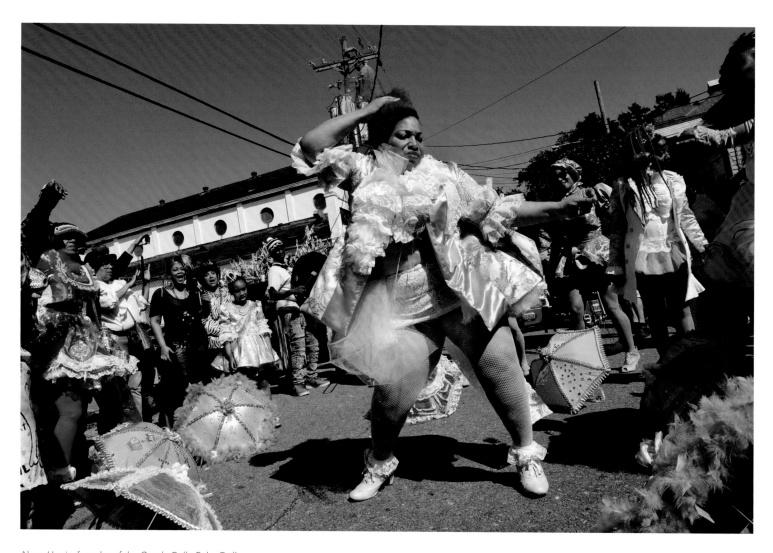

Alana Harris, founder of the Creole Belle Baby Dolls,
dances in Treme on Mardi Gras, 2018

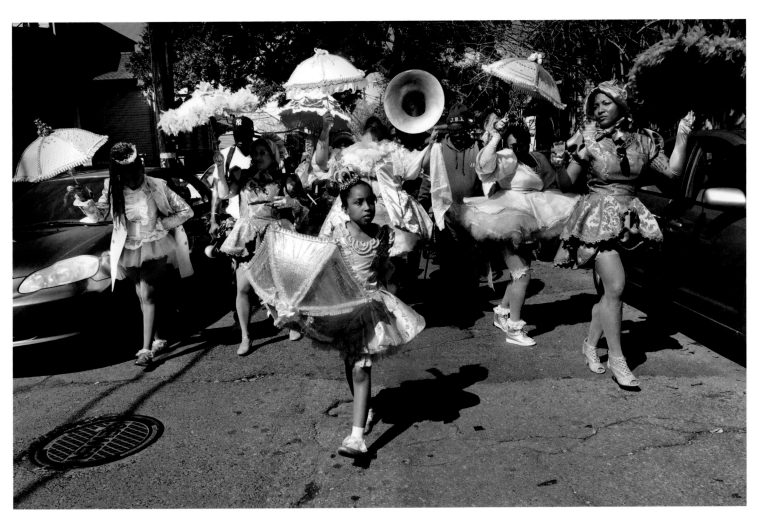

Pinky Harris of the Creole Belle Baby Dolls leads
the parade through Treme on Mardi Gras, 2018

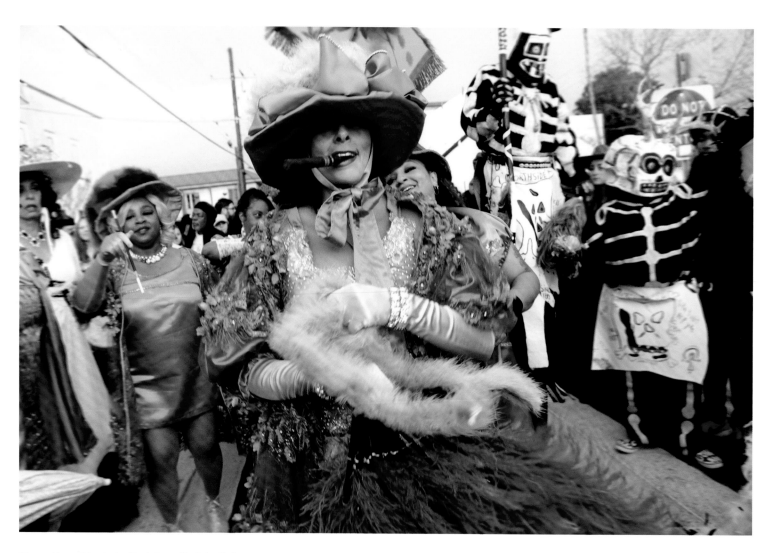

Dianne Honoré leads the Black Storyville Baby Dolls
in the Seventh Ward on Mardi Gras, 2018

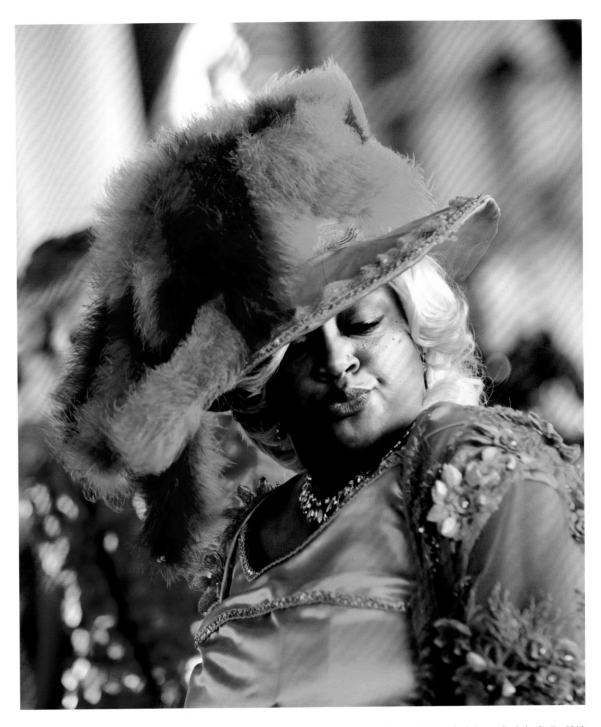

Joell Lee with the Black Storyville Baby Dolls, 2018

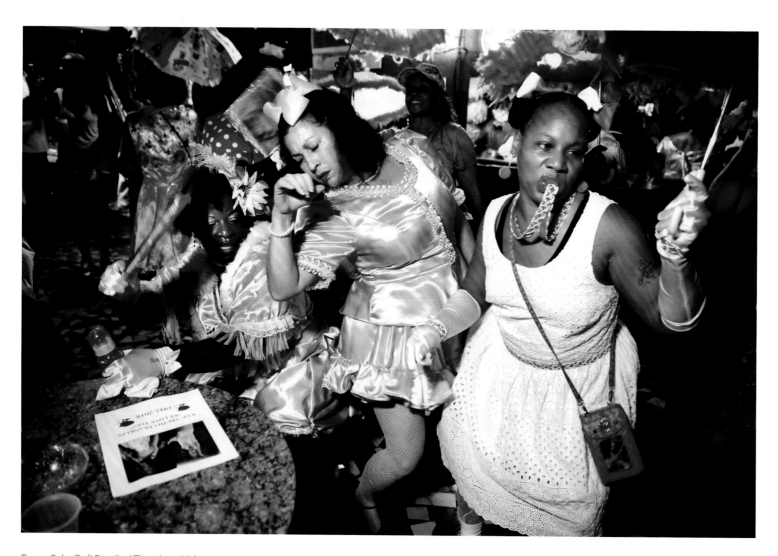

Treme Baby Doll Rosalind Theodore, Mahogany
Blue Baby Doll Anita Oubre, and Karena "Baby Doll
Unique" James honor Queen of Soul Aretha Franklin
during a memorial second line in Treme, 2018

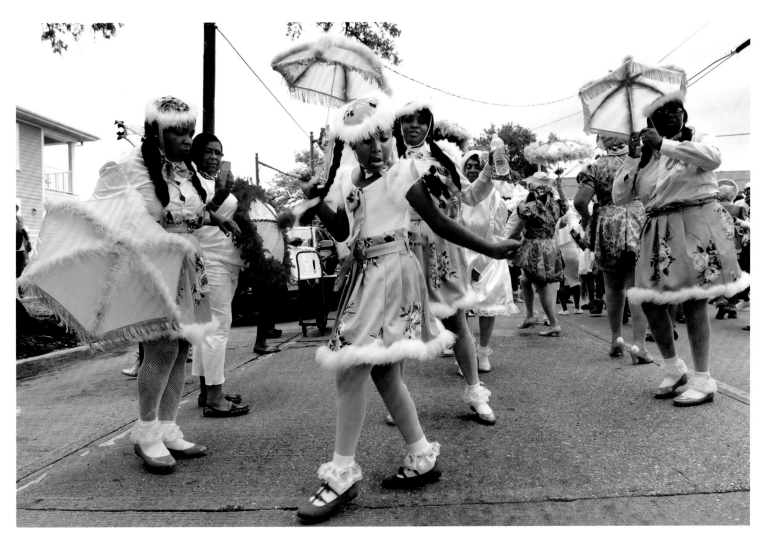

London Curtis, seven years old, and the Montana Baby Dolls (followed by her grandmother Dewanda Montana, who designs the outfits), join friends and family to say goodbye as they lay Tee Eva Perry to rest with a funeral and second line in Central City, 2018

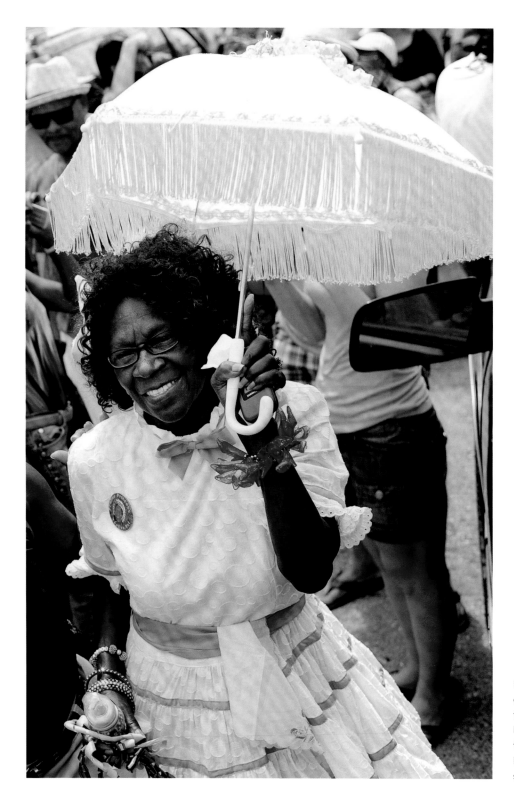

Eva Louise Perry, known as Tee Eva, co-founder with Antoinette K-Doe of the Ernie K-Doe Baby Dolls, second lines at musician Uncle Lionel Batiste's funeral in 2012. Tee Eva, an active Baby Doll, entrepreneur, and back-up singer was laid to rest in 2018.

Carol "Baby Doll Kit" Harris pays homage during musician Dr. John's (born Malcom Rabennack) funeral, 2019

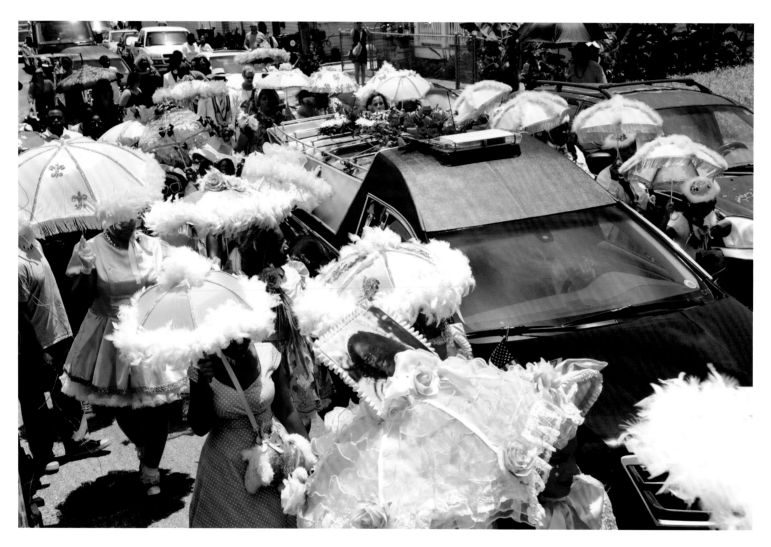

Friends, family, and Baby Dolls say goodbye as they lay
Tee Eva Perry to rest with a funeral and second line in
Central City, 2018

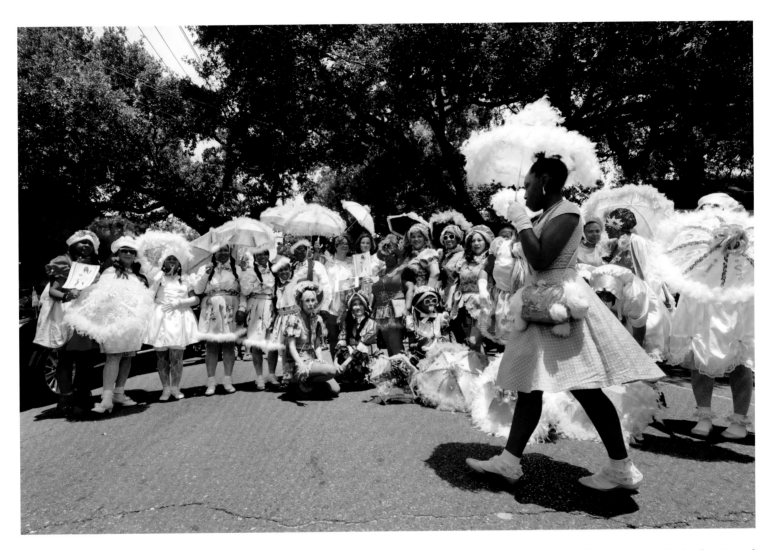

Reminiscent of the iconic Norman Rockwell painting of Ruby Bridges, who integrated New Orleans' schools, Baby Dolls gather for a group photo at the funeral of Tee Eva Perry, 2018

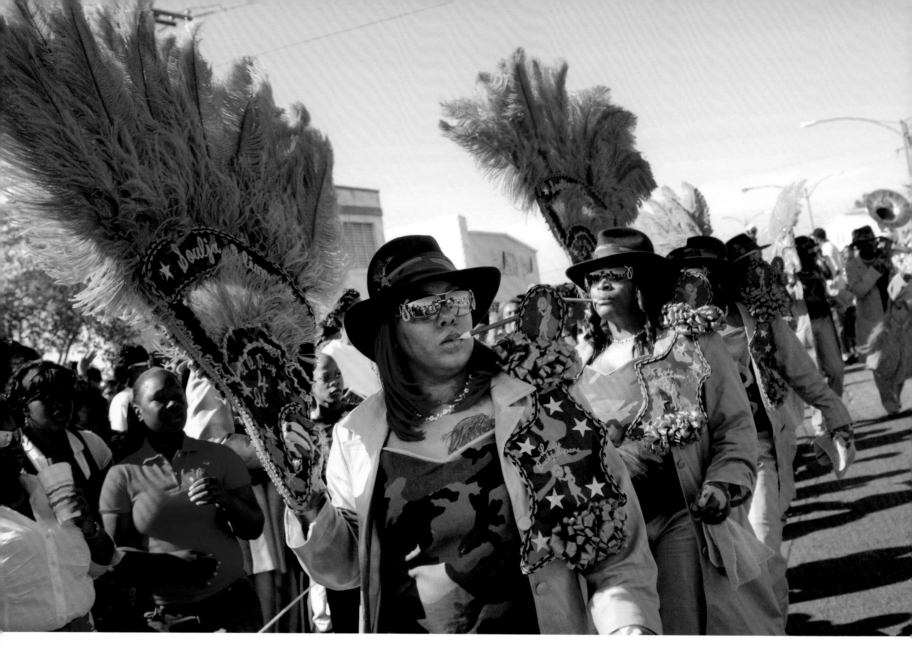

The Original New Orleans Lady Buckjumpers
pay homage to the National Guard following
Hurricane Katrina, 2006

African American Femininity on Display in the Streets of New Orleans

Social Aid and Pleasure Club Ladies Keep a Centuries-Long Culture Alive

KAREN CELESTAN

I t is a fall Sunday afternoon, and a cadre of about fifteen African American women are dipping and weaving down a New Orleans street in front of a full brass band. The female members of a social aid and pleasure club (SAPC) in colorful regalia are thrilled to host their annual parade after months of planning. Handcrafted fans are snapping the air in sync with the band's driving rhythm. The ladies are creating spontaneous moves that are driven by the music and exhortations of the crowd yet maintaining the order of moving forward. Everything comes together to create a Crescent City–specific ritual known as the second line.

The dance and pageantry of second-line parades are derived from the customs, rhythms, and body movements of African people from various tribes, all brought to America by mercenaries through the Trans-Atlantic slave trade and sold at markets on the riverfront in New Orleans. Some Africans were snatched from the Senegambia region and the Bight of Benin on the continent's west coast. Others were brought to America from Sierra Leone (the Kissy), the Windward Coast (the Canga), the Gold Coast, and Mozambique. Tribes from which the enslaved were drawn included the

Bambara, Mandinga (also known as Mandinka), Wolof, Fulbe, Nard, Mina, Fin, Yoruba (Nago), Chamba, Adó, Kongo Angola, Caraba, Ibo, and Moko.

For centuries, American people of African descent were allowed only limited forms of personal expression, giving existential importance to the "dance-of-the-tribes" ritual and the ability to feel sound and vibrations emanating from the *djembe* (drum). The kinetic procession viewed on weekend streets in the Crescent City is nothing less than liquid muscle memory, showcasing and elevating the humanity of SAPC members and their devoted throng of second-liners.

African descendants in New Orleans have maintained a strong sense of self and reverence for their culture. It is a heart and spirit release from oppression, a basic freedom within the organized chaos of a parade. It is fresh joyfulness, majestic, paying tribute to their ancestors. A true social aid and pleasure club is organized and may shroud itself in secrecy for protection and to avoid being co-opted, but its parade is open enough to welcome all into what performance art is. It is precise, yet intuitive. It is the African diaspora on display.

A club spends eleven months engaged in planning—setting by-laws, seating club officers, paying dues to cover expenses, deciding on a theme, ensuring that the necessary and overpriced permits and police details are in order, organizing their suits and accessories, praying that the weather will cooperate—so 'hitting the street' is another component of the euphoria when all goes well. It is camaraderie in the public sphere.

An additional layer of the culture is the long-standing history of exploitation in America of black feminine bodies—as sexual plows for masters; as broodmares to ensure that the line of enslaved remained strong to pick cotton, cut sugar cane, or 'keep' houses; as entertainers for plantation owners and their families—most of which continues in various forms today. Enslavement in New Orleans has only evolved to meet society's time period, as all but the most connected or educated African American females are herded into demeaning, low-paying jobs. They support the city's tourism economy through service positions—cashiers, food and laundry workers, hotel housekeepers, janitors, servers, and so on—to help keep their families fed and housed while fending off all manner of harassment with little to no protection or recourse.

Their moment in the sun is perfect, unfettered release that comes through the annual parade for their beloved social aid and pleasure club. Feminine beings immerse themselves into the vibrancy of a perfect color scheme, knowing that their beauty and fullness of self will be recognized

during the club's afternoon parade. The spirit-joy will be shared and reflected back to themselves as the music enters the bloodstream and sinews of their bodies, moving each joint to the sound of the drum. Every feminine footfall is definitive, pounding the earth that often seeks to swallow them. Every twirl and swing to the New Orleans brass band polyrhythms is a cry to heaven, an offering to the ancestors' call for expression that was denied. Saving grace.

It is movement without fear or judgment—succor and protection as they are encased by the band and second-liners who fill city sidewalks—familiar and caring spirits conjoined in the music and individual performances that make up the whole. Lady SAPCers demonstrate their complete power in those moments. Their bodies are the embodiment of Harriet Tubman, Sojourner Truth, Ida B. Wells, Rosa Parks, Mahalia Jackson, Maya Angelou, Angela Davis, Shirley Chisholm, Queen Latifah, MC Lyte, Ava Duvernay, Oprah Winfrey, and Michelle Obama—the life song of justice denied and respect reclaimed in one annual showcase. Black Girl Magic, control, defiance, ego and beauty, all delivered in an afternoon.

Who cares if at the end of the day there are ruined hairdos, chipped nails, wobbly shoes, ripped hems, broken accessories, and sweat? The club showed up and showed out—yeah, you right! Distinctive outfits will be discussed for weeks, maybe months, until their next parade—a community buzz not unlike a custom church-lady hat or designer gown for a carnival ball. The communal light is bright and blinding. It is the direct line back to Africa and tribal pageantry, the comfort of an internal compass that connects each member to the homeland, even if she does not know where it is or from which tribe she is descended.

The call and response of the feminine spirit at their SAPC parade is an Aretha Franklin record on the stereo in 1970s Treme, pushing out a free-form, yet orchestrated squall into the neighborhood for all the sisters to hear and absorb. Pure, honest, and real. The women sing out as they dance and strut, heralding their fertility, strength, and survival. The motion is so powerful that all in the vicinity of the second line feel its guile and mystery. The ancestors approve, and the club's faithfulness is rewarded as the spirit life force beams through the clouds and sun.

It is time for your creativity, femininity and perseverance to be respected and saluted. It is time for your cultural dedication to be honored for its centuries-long allegiance to tradition. It is time that your public art is revered and no longer treated as a modern embodiment of so-called lax morals and lasciviousness. It is time for you to be held in high esteem as the daughters, sisters, aunts, nanans, wives, mothers, and grandmothers that contribute

to the growth and health of New Orleans, as you have since you arrived by force to the riverfront of our Crescent City.

Keep singing and swinging, Lady SAPCers! Hold your heads high as you glide down streets paid for by your hard-earned tax dollars. Your elegance and distinct presence are unapologetic. Your African American tribal ritual invigorates and strengthens your community. You are the spirit of a city that it is true and unique due to your presence. We cannot wait to see what your imagination and the touch of your foremothers will bring next fall and in the years to come. It is the promise of rejuvenation and renewal. When the drum sounds, you bring forth the truth that is New Orleans. Your creative crusade is the *uhura ngoma* (Swahili)—Freedom's Dance.

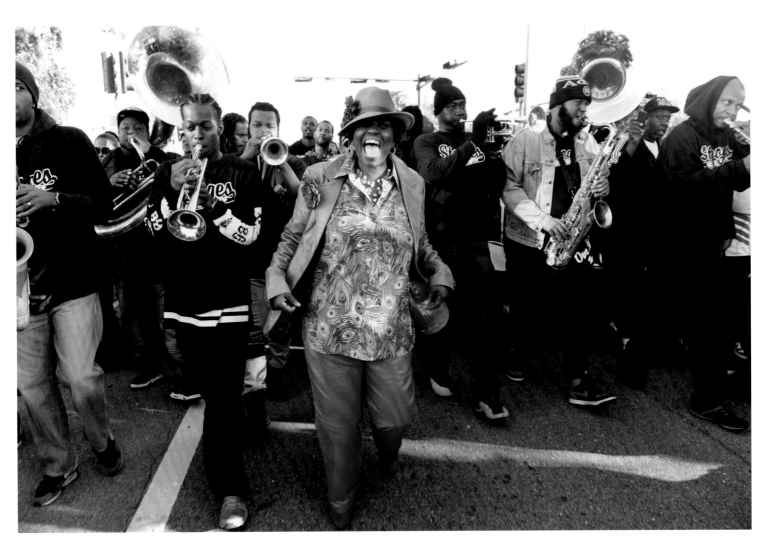

Creola "Jackie" Moon, who co-founded the Lady
Jetsetters second line in 1989, parades with the
Stooges Brass Band, Uptown, 2016

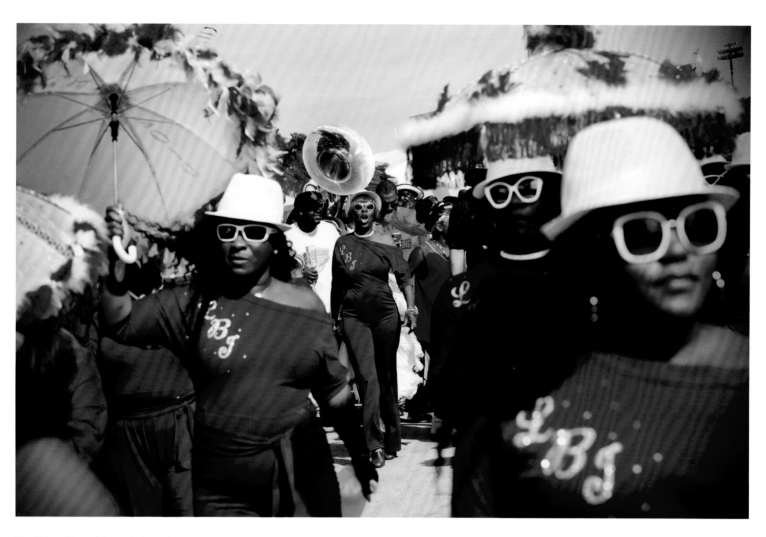

The Original New Orleans Lady Buckjumpers at
Jazz Fest, 2019

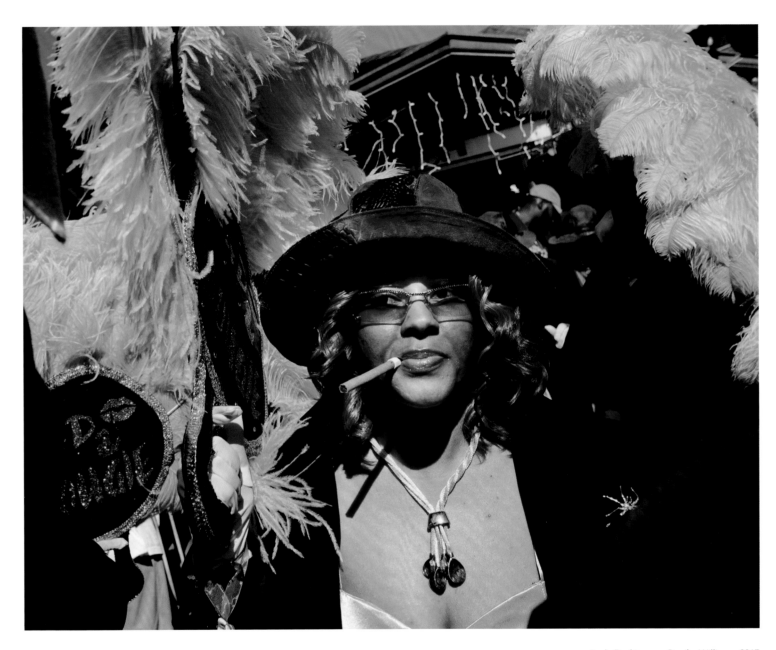

Lady Buckjumper Ronika Williams, 2017

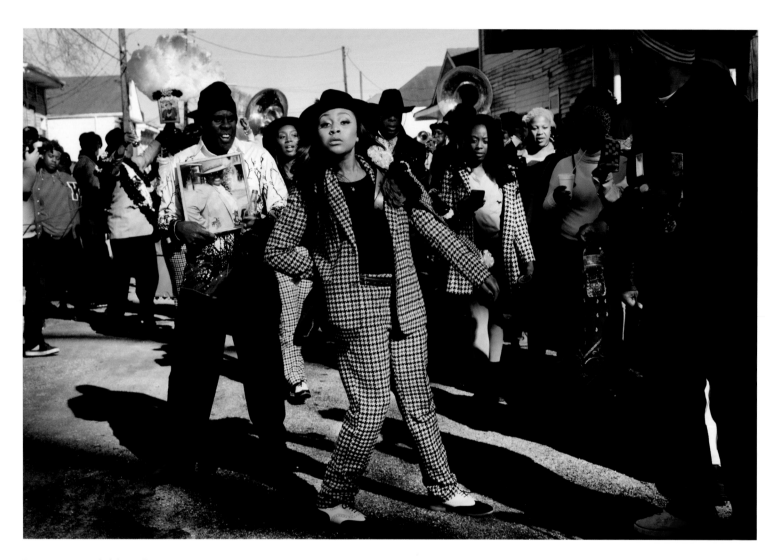

Diamon Raymond of the Lady Jetsetters
second line, Uptown, 2018

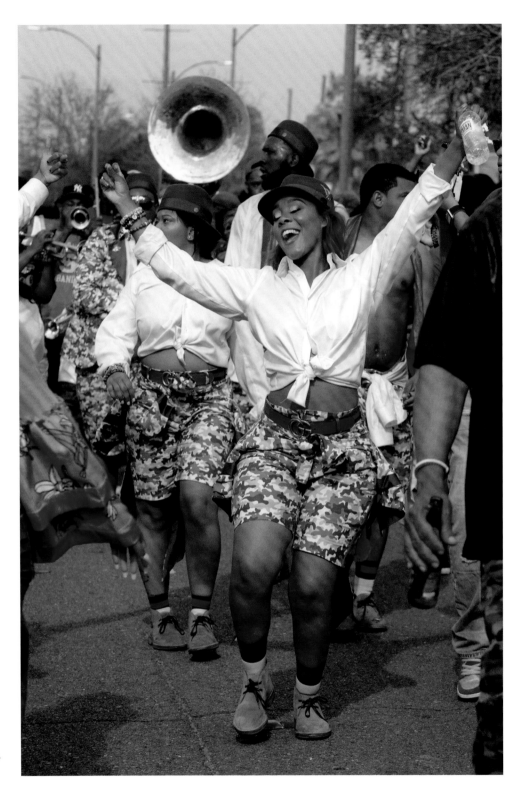

Raina Duncan of the Treme
Sidewalk Steppers, 2018

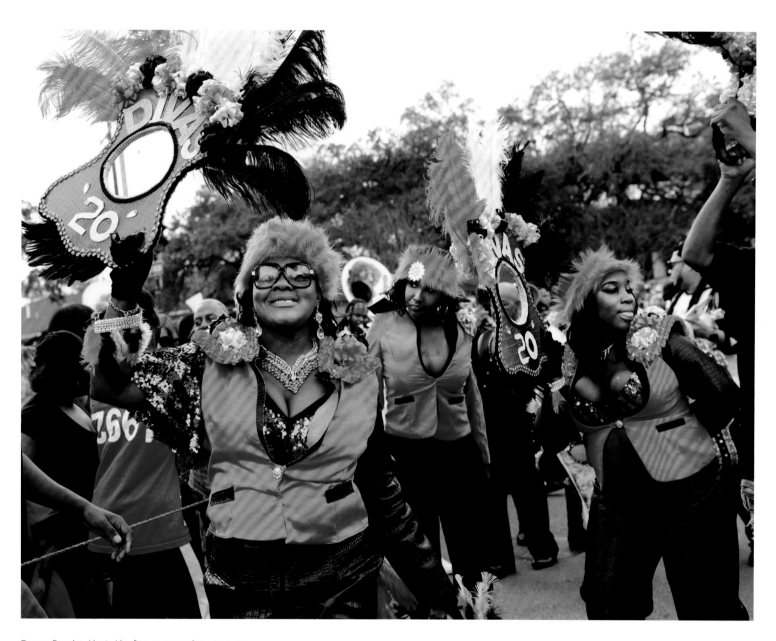

Donna Brooks, Alexis (the first transgender person to openly join a sanctioned second line), and Leiondra Larkins of the Undefeated Divas, 2018

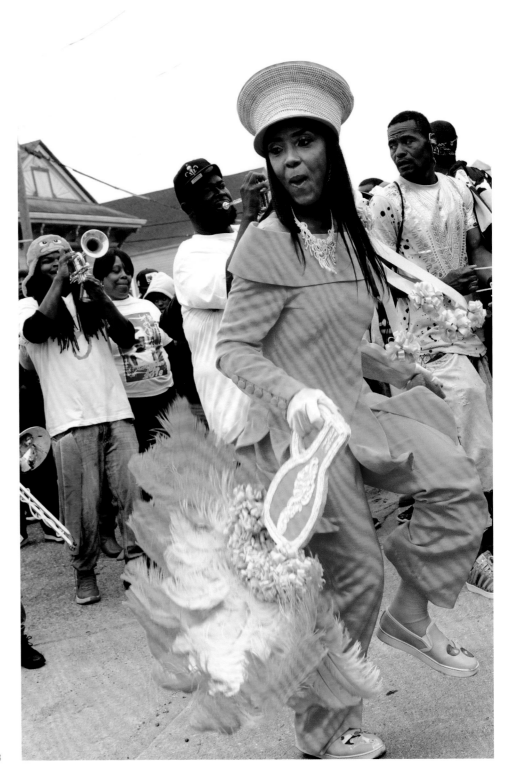

Single Ladies Nicole Tate, 2018

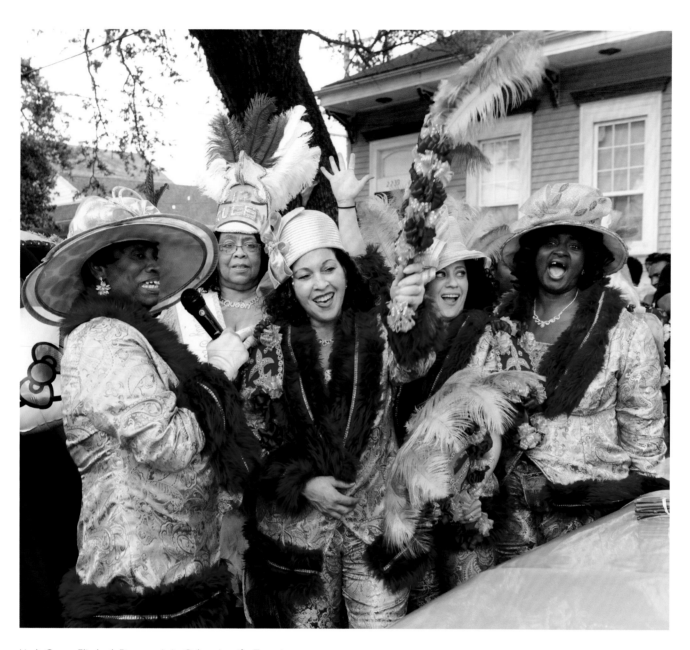

Linda Green, Elizabeth Dunams, Anita Oubre, Jennifer Tramuta,
and Linda Martin of the Lady Rollers, 2015

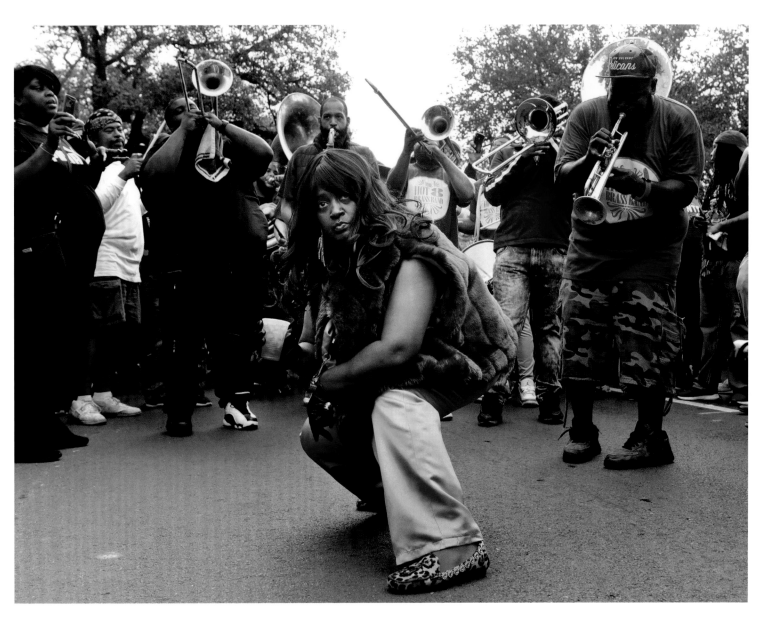

Linda Martin of the Lady Rollers, 2018

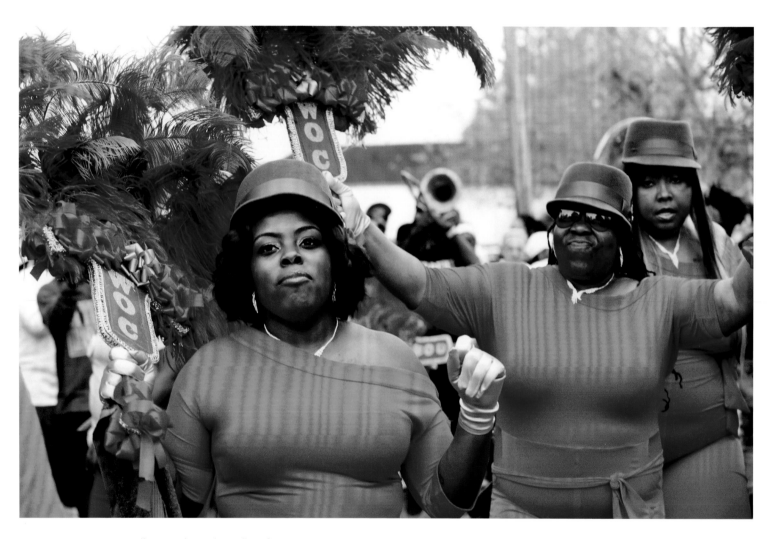

Quintessa Dampeer, Lisa Williams, and Joycelyn Walker of
the Women of Class, 2018

Trella Simone Broussard of the Women of Class, 2018

Ja'Lissa Cockerham of
the Ladies of Unity, 2018

Diamond Walker of the VIP Ladies, 2018

Lady Wales second line, 2017

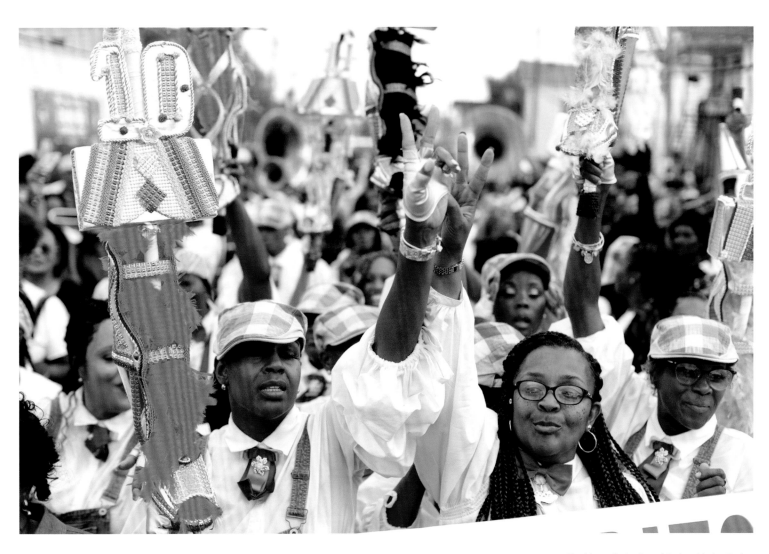

The Versatile Ladies of Style with the Sudan
Social Aid and Pleasure Club, 2017

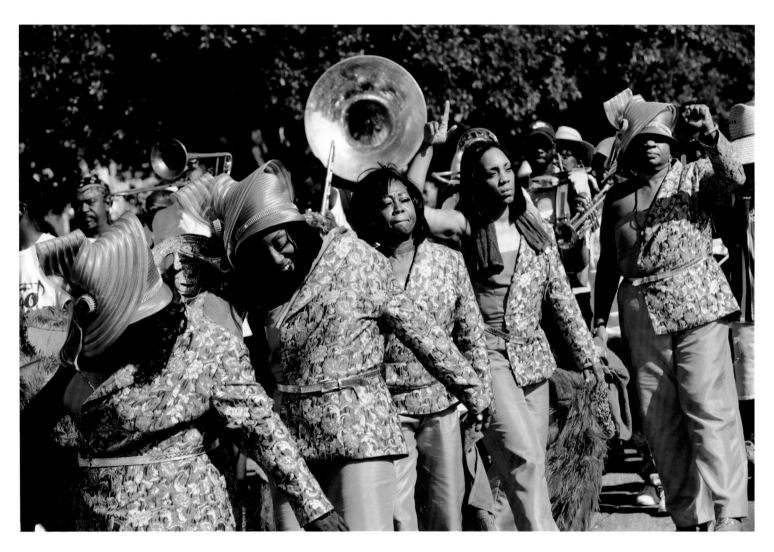

Divine Ladies take a moment during a dirge
to remember Sheketa Baptiste, 2018

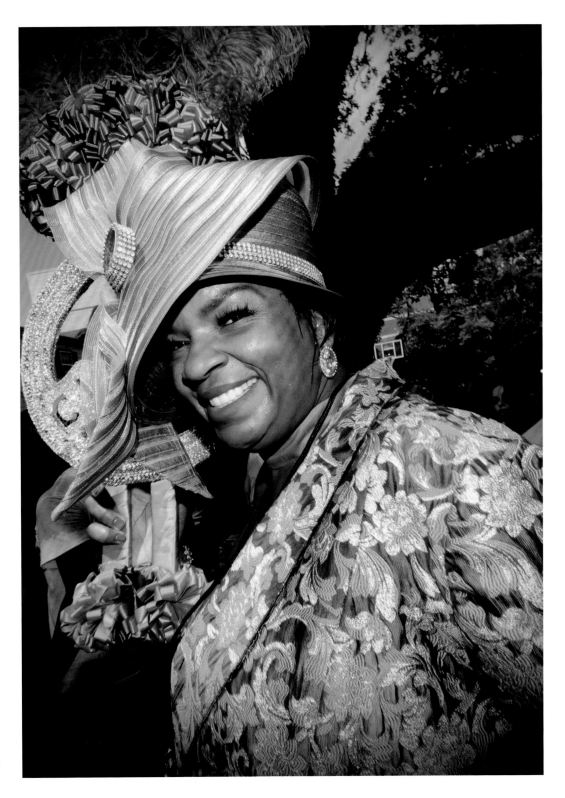

Tion McGhee of the
Divine Ladies, 2018

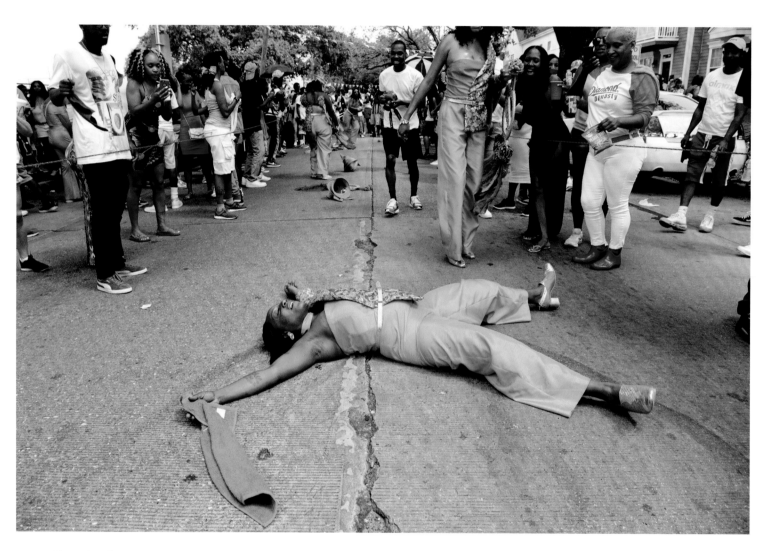

Janitra "Chi" Myles of the Divine Ladies, 2018

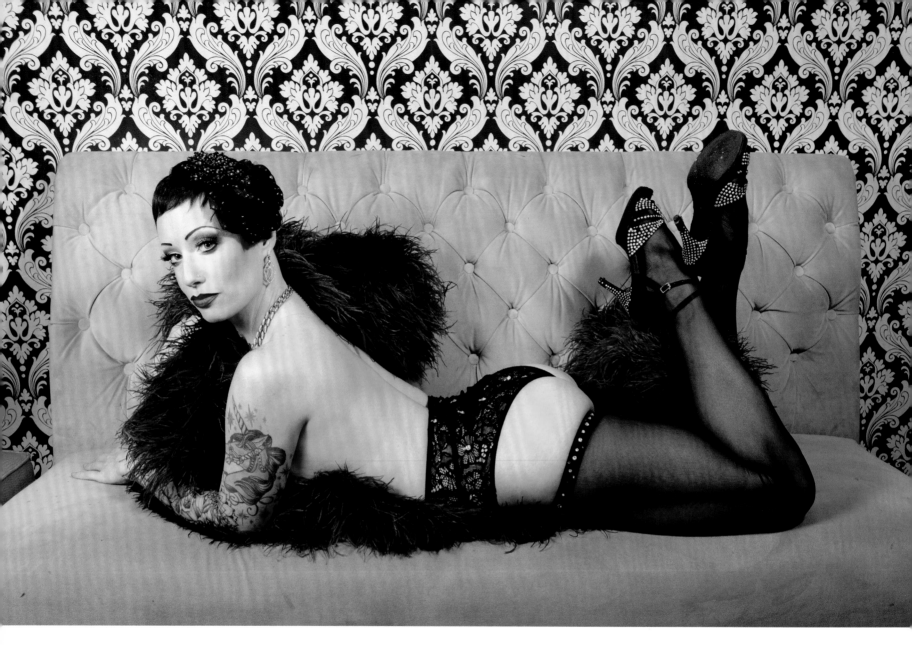

Bella Blue before a show at Whiskey
and Rhinestones, 2018

THE ART OF THE TEASE

MELANIE WARNER SPENCER

Sexy, raunchy, funny, sultry, silly, obscene, and outrageous are the descriptions many associate with burlesque. This particular form of entertainment—combining dance, striptease, music, costumes, acting, glamour, humor, and a lot of feathers and glitter—was perhaps never more popular than in New Orleans in the 1940s and '50s. According to burlesque historian and producer Rick Delaup, the women who became its most prominent performers in its heyday, such as Evangeline the Oyster Girl, Lilly Christine the Cat Girl, and, perhaps the most famous, Blaze Star, were celebrities in their own right and obtained everything fame and money entails, including agents, managers, assistants, and their own maids. Locals and tourists alike visited Bourbon Street clubs dressed to the nines to take in the shows, until sweeps and shutdowns in the '60s effectively killed the local burlesque scene. For decades, burlesque was a distant memory, until in the late 1990s when the Shimshamettes—founded by Lorelei Fuller, who danced as Lorelei Lane—began performing shows at One Eyed Jack's. Since then, burlesque in New Orleans has gone from a couple of shows per month to nearly every night of the week (and some days with the growing popularity of burlesque brunches). Once again, New Orleans is home to a feathered and glittered flock of individual performers, troupes, and schools—the latter of which are overwhelmingly produced and owned by women—shaking and shimmying their way across the city.

"There always will be a place for burlesque in the city," says Bella Blue, dancer, producer and founder, and headmistress of the New Orleans School of Burlesque. "If we can educate people, it doesn't have to go away again."

Trained in classical ballet and modern dance, which she taught for years, the Belle Chasse, Louisiana native and mother of two, worked multiple jobs for years, consistently seeking a way to make a living as a professional dancer. It wasn't until Blue joined Trixie Minx's troupe Fleur de Tease in 2007 that she was able to realize her dream. Combining her skills as a dancer and teacher with business acumen gained through several years in retail, it wasn't long before she started the school and, like Minx, her own troupe and began producing shows.

"Everybody just kind of does their own thing," says Blue. "We stay in our lane and have respect for each other."

Also trained in ballet, Minx, who is originally from Miami, Florida, began her career in burlesque in 2005 as a dancer in Delaup's Bustout Burlesque. She started Fleur de Tease in 2006 and is producer of a bevy of productions in New Orleans that incorporate everything from classical, cabaret style burlesque to performances tailored to the LGBTQ community at the gay club Oz.

Minx, Blue, and other performers and producers, such as Roxie Le Rouge of Big Deal Burlesque, also frequently travel the United States and abroad to perform and are regularly ranked among the top stars and businesswomen in burlesque. These "bad girls" play by their own rules, promoting a message of fun, fabulousness, confidence, and body positivity, while also fostering, promoting, and keeping alive an art form that is as much a part of the history of New Orleans as streetcars and beignets—albeit a dash naughtier.

"No matter what's going on, the stock market crashes, the housing market crashes, people have ten dollars to spend on a show," says Blue. "They want to be entertained."

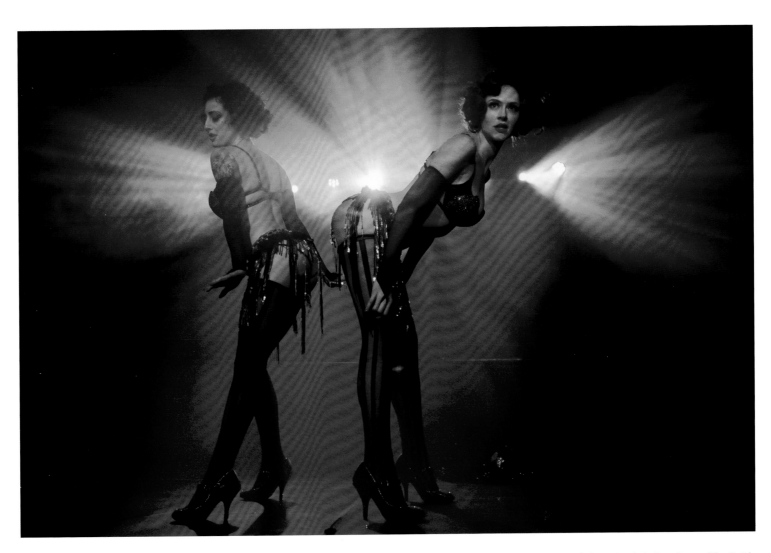

Angie Z and Cherry Bombshell perform at The Parish
with Bad Girls of Burlesque, 2018

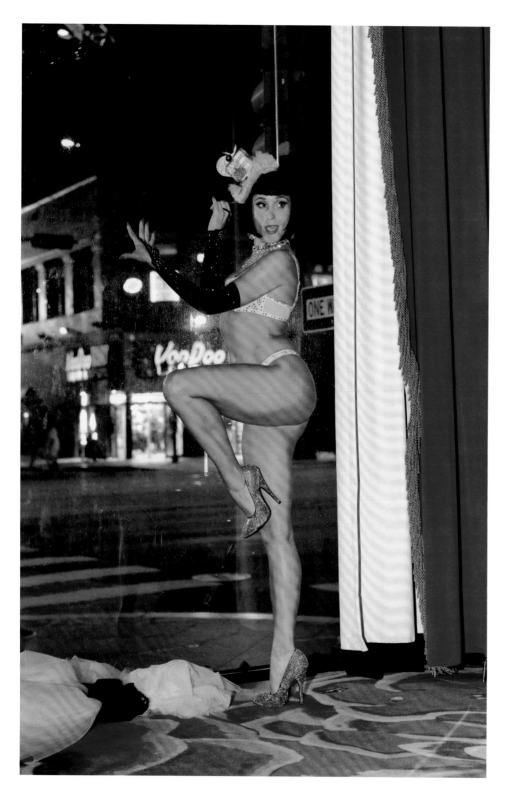

Roxie le Rouge, producer of
Big Deal Burlesque, performs
at The Saint, 2018

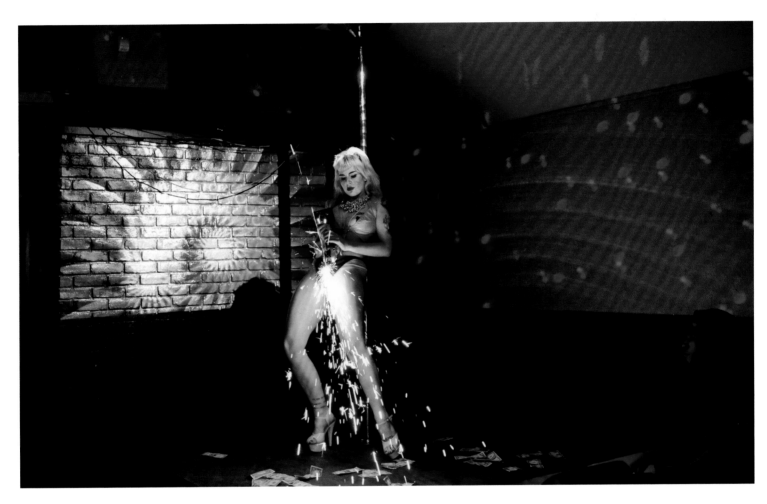

Xena Zeit-Geist performs at a stripper
pop-up at Poor Boys, 2018

Juno performs at The Parish with
the Bad Girls of Burlesque, 2018

Trixie Minx at The Saint, 2018

Madame Mystere at
The Saint, 2018

Cherry Brown at Whiskey
and Rhinestones, 2018

Angie Z checks her phone
backstage at The Parish for the
Bad Girls of Burlesque, 2018

Cherry Bombshell at The Saint attracts
a flasher on Canal Street, 2018

Nikki LeVillain, the Serpentine
Seductress, at The Parish with
the Bad Girls of Burlesque, 2018

CONSTANCE ADLER is author of the memoir *My Bayou, New Orleans through the Eyes of a Lover* (Michigan State University Press, 2012). Her stories have appeared in numerous publications that include *Oxford American, Utne Reader, Spy Magazine,* and *Blackbird.* Her profile of Mardi Gras float designer Henri Schindler in *Gambit Weekly* was honored by the Louisiana Press Association with a first-place award in feature writing. She lives near Bayou Saint John in New Orleans.

KAREN CELESTAN is the author of *Freedom's Dance: Social, Aid and Pleasure Clubs in New Orleans* (Louisiana State University Press 2018) and co-author of *Unfinished Blues: Memories of a New Orleans Music Man* with Harold Battiste Jr. (HNOC 2012). She can be reached at books@mosaicliterary.com.

ALISON FENSTERSTOCK has worked as a staff critic and reporter for *Gambit* and the *Times-Picayune* in New Orleans. Her writing on American music and culture sometimes appears in *Rolling Stone, Pitchfork,* NPR Music, and the *New York Times.*

KATHY FINN is a New Orleans journalist. She is the former editor of *New Orleans CityBusiness* and *Biz New Orleans,* has worked as a correspondent for Reuters News, and is a regular contributor to *New Orleans Magazine* and the *New Orleans Advocate.* She is the author of *Tom Benson: A Billionaire's Journey* (Pelican Publishing Company, 2017), the biography of a controversial NFL team owner.

HELEN FREUND is a New Orleans–based food and features writer. She is the restaurant critic and dining writer at *Gambit Weekly* and a regular contributor at the *New Orleans Advocate,* where she covers news and features.

ANNE GISLESON is the author of *The Futilitarians* (Little, Brown, 2017). Her work has appeared in the *Atlantic,* the *Oxford American,* the *L.A. Times,* and many other places. She teaches in the Creative Writing Program at the New Orleans Center for Creative Arts.

CHERICE HARRISON-NELSON, a former New Orleans public school teacher, is the co-founder of the Mardi Gras Indians Hall of Fame and Big Queen of the Guardians of the Flame Mardi Gras Indians. She performs and presents Mardi Gras Indian culture in New Orleans as well as the rest of the country.

KAREN TRAHAN LEATHEM, historian at the Louisiana State Museum for more than seventeen years, has worked on a broad range of exhibitions related to Louisiana history and culture, including the permanent exhibition *Mardi Gras: It's Carnival Time in Louisiana* and several other carnival-related exhibitions, including *"They Call Me Baby Doll": A Mardi Gras Tradition* and *Iris and the Goddesses of Carnival*. A native of southwest Louisiana, Leathem began researching New Orleans carnival while earning her PhD at the University of North Carolina at Chapel Hill. Every year, she eagerly anticipates Mardi Gras.

KATY RECKDAHL, an award-winning New Orleans–based news reporter, works frequently for the *New Orleans Advocate* and WDSU television. She has written for the *Times-Picayune*, the *New York Times*, and the Weather Channel.

MELANIE WARNER SPENCER is an award-winning lifestyle journalist and photographer whose work has been published in newspapers, magazines, and online outlets all over the world. She also is editor of five magazines and the "Essential Louisiana" cookbook series.

SUE STRACHAN has been covering the New Orleans scene for more than twenty years. She was the editor of *St. Charles Avenue* magazine and *New Orleans Homes & Lifestyles* and has been a contributor to *New Orleans Magazine, Louisiana Life, Time* magazine, and others. She was the society editor for NOLA.com | the *Times-Picayune* for five years, and is now a features writer for the *New Orleans Advocate*.

KIM VAZ-DEVILLE is associate dean of the College of Arts and Sciences at Xavier University of Louisiana, a professor of Counselor Education, a psychotherapist, and a psychoanalyst. She is the author of *The Baby Dolls: Breaking the Race and Gender Barriers of the New Orleans Mardi Gas Tradition* (Louisiana State University Press 2013) and *Walking Raddy: The Baby Dolls of New Orleans*, (University Press of Mississippi 2018).

GERALDINE WYCKOFF is a New Orleans–based music journalist who for more than thirty years has covered modern and traditional jazz, brass bands, rhythm and blues, funk, and the city's African American traditions of Mardi Gras Indians and social aid and pleasure clubs. Currently, she writes for *OffBeat* magazine and the *Louisiana Weekly*, and her work has appeared in *JazzTimes, Downbeat, New Orleans Magazine*, and many other publications.

Photo by Roselle McGrain

CHERYL GERBER is a freelance photographer working in New Orleans, where she was born. She began her journalism career as a reporter but switched to photography after spending a year working in Honduras. In 1992, she began working for Michael P. Smith, who nurtured her desire to document daily life in New Orleans. She has worked as a regular contributor to the *New York Times*, the Associated Press, and *New Orleans Magazine* and has been a staff photographer for *Gambit* since 1994. She has been published in many books including *New York Times* writer Jerry Longman's *The Hurricanes*, Peggy Scott Laborde's *Canal Street: The Great Wide Way*, and Ben Sandmel's *Ernie K-Doe: The R&B Emperor of New Orleans*, just to name a few. She is also the coauthor with Bonnie Warren of the recently published *New Orleans Historic Homes* by Pelican Publishing and *New Orleans at Christmas*. Her 2015 book *New Orleans: Life and Death in the Big Easy*, published by University of Louisiana Press, is in its second edition. During the past two decades, Cheryl has won several awards from the New Orleans Press Club for her work on social issues and news photography.

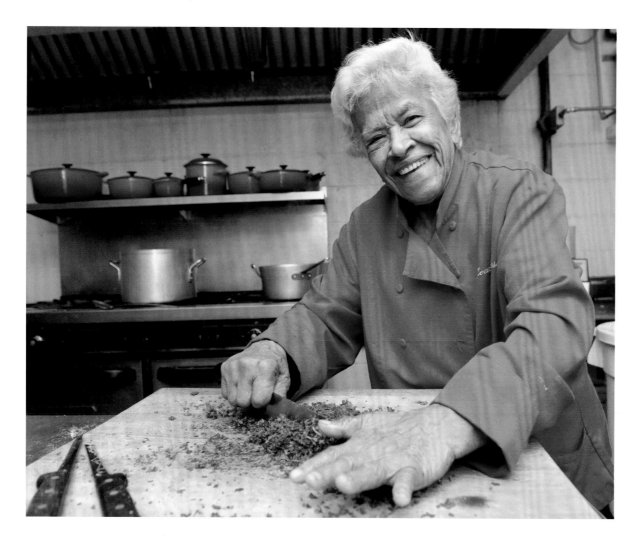

LEAH CHASE (1923–2019)

"I tell people all the time, you have to be in love with that pot. You have to put all your love in that pot. If you're in a hurry, just eat your sandwich and go. Don't even start cooking, because you can't do anything well in a hurry. I love food. I love serving people. I love satisfying people."

The matriarch of New Orleans passed away at ninety-six during the production of this book. Her legacy will live on in the tens of thousands she nourished with her delicious food and wise words.